MAPS
OF
FLESH AND LIGHT

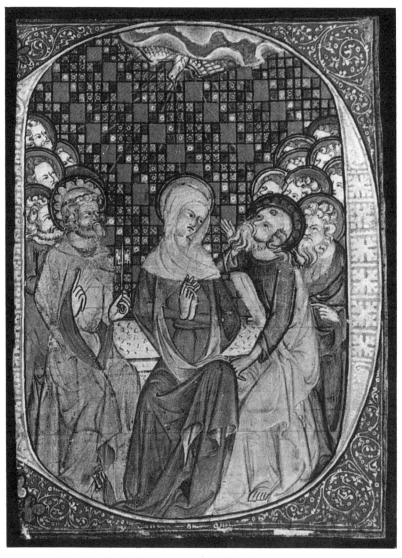

The Gradual of Johannes von Valkenburg, written 1299.
By kind permission of Diözesanbibliothek Köln.

MAPS
OF
FLESH AND LIGHT

The Religious Experience of
Medieval Women Mystics

Edited by
ULRIKE WIETHAUS

SYRACUSE UNIVERSITY PRESS

First Edition 1993

93 94 95 96 97 98 99 6 5 4 3 2 1

Permission to reprint material from *Philological Quarterly* 67 (June 1988) and Rieser Kulturtag is acknowledged with appreciation.

The paper used in this publication meets the minimum requirements of American National Standard for Information Sciences — Permanence of Paper for Printed Library Materials, ANSI Z39.48-1984. ∞™

Library of Congress Cataloging-in-Publication Data

Maps of flesh and light : the religious experience of medieval women
 mystics / edited by Ulrike Wiethaus. — 1st ed.
 p. cm.
 Includes bibliographical references and index.
 ISBN 0-8156-2560-X (alk. paper). — ISBN 0-8156-2611-8 (pbk.: alk. paper)
 1. Women mystics — Europe. 2. Mysticism — Europe — History — Middle
Ages, 600–1500. 3. Experience (Religion) I. Wiethaus, Ulrike.
BV5077.E85M27 1993
248.2′2′082 — dc20 91-33315

Manufactured in the United States of America

For Ann and Lucy, my academic midwives.

CONTENTS

ACKNOWLEDGMENTS

I thank Central Michigan University and Wake Forest University for their generous financial support for this book. I owe special thanks to Dolores Lawrence for her expert handling of the manuscript, to Ron Whalen and Amy Kowalski for preparing the index, to Cynthia Maude-Gembler for guiding the book through the editorial process — her good cheer and consummate skills have saved me from many a pitfall — and to Peiying Mo who aided me in the last stages of this project. Finally, I am very much indebted to my contributors, whose patience and generosity taught me much about that most unsung-of muse of all, collegiality.

CONTRIBUTORS

LAURIE A. FINKE teaches in the English department at Lewis and Clark College. She has co-edited *Medieval Texts and Contemporary Readers* (1987) and *From Renaissance to Restoration: Metamorphoses of the Drama* (1984). She has also published articles in *Theatre Journal, Leeds Studies in English,* and *Tulsa Studies in Women's Literature.* She has recently completed a historical study of feminist literary criticism between 1975 and 1985 and is currently working on the problem of subjectivity in the literature of the twelfth century.

PATRICIA A. KAZAROW teaches in the music department at Gustavus Adolphus College, where she serves as Choirmistress and Associate Organist. Her current area of research is focused on the compositions of Hildegard of Bingen, and she has both produced and directed Hildegard's liturgical morality play *Ordo Virtutum.*

E. ANN MATTER teaches in the religious studies department at the University of Pennsylvania. She is author of *The Voice of My Beloved* (1990) and editor of *De partu Virginis* of Paschasius Radbertus and has published on medieval spirituality and exegesis in essays for edited volumes and in the journals *Traditio,* the *Revue Benedictine,* and *Aevum,* among others.

Jo ANN McNAMARA teaches in the history department at Hunter College, New York. She is the author of *A New Song: Celibate Women in the First Three Centuries* (1983), *Gilles Aycelin: A Servant of Two Masters* (1973), and co-editor of *Women and the Structures of Society* (1984), and also of numerous articles and chapters in books on the history of medieval religious women.

ELLEN Ross teaches in the theology department of Swarthmore College. Her current areas of research include medieval English mysticism and medieval theological anthropology.

MARGOT SCHMIDT teaches in the Catholic theology department at the Catholic University of Eichstätt. She is the author and co-editor of several volumes in German on the mysticism of medieval women, and she has published numerous essays in journals and edited volumes.

ULRIKE WIETHAUS teaches in the religion department at Wake Forest University. She is the author of *Ecstatic Transformations: A Comparison of Mechthild of Magdeburg's "Flowing Light of the Godhead" and Transpersonal Psychologies* (forthcoming from Syracuse University Press), and her articles and translations on medieval women mystics have appeared in *American Benedictine Review, Ökumenische Rundschau, Journal of Feminist Studies in Religion*, and other journals.

JOANNA E. ZIEGLER teaches in the visual arts department at the College of the Holy Cross. She has published numerous articles on the Beguines and their imagery, and her research interests include late medieval religious art and architecture in the southern Low Countries. She is currently co-authoring a book on the art, history, and religious culture of the stigmatized thirteenth-century Beguine, Elisabeth of Spaalbek.

MAPS
OF
FLESH AND LIGHT

INTRODUCTION

ULRIKE WIETHAUS

THIS COLLECTION OF ESSAYS on aspects of medieval religious women's lives presents many different points of view and methodologies. Underlying all contributions, however, is a common heuristic concern that the title of the book, *Maps of Flesh and Light,* expresses in a poetic manner. What were the *maps* that religious women devised to steer themselves and others through the patriarchal landscape of late medieval society? How were they drawn? How were they shared? Were these cartographies of use outside of their circles?

The formulation of these questions presupposes the assumption that medieval women were not passive foils on which men projected their images of womanhood, but active shapers of their lives who refused such stereotypes or succumbed to them not without resistance. *Flesh* and *Light* refer to the gendered religious dimension of their lives. Their flesh, female flesh, was the substance that formed the basis of how they were viewed by others and determined what deck of cards was dealt them at the beginning of their religious careers. It was also the *prima materia* out of which they fashioned many of their devotional symbols and theological and artistic creations. The needs of the flesh are manifold, and one of its strongest desires is perhaps that for human company. As some of the essays show, it is false to conceive of medieval religious women as lonely heroines. Too little work has been done on the nature of women's communities,[1] but there is no doubt that we must approach medieval women as members of closely knit groups. A number of essays investigate the dynamics of these associations and their interplay with other groups.

All the medieval women's lives under examination reveal an experiential religious core that is difficult to trace and to interpret accurately.

What was the relationship between women's religious experiences and their acts of creativity, resistance, and compliance? To fail to ask the question is to ignore what gave their lives their unique quality. But to look for an answer carries the danger of bringing to the text an unexamined psychological or theological perspective that could equally violate the medieval sources. As Michel DeCerteau warned us so accurately, we cannot posit a divine dimension outside of the texts we are working with.

> To set it apart, in isolation from the texts that exhaust themselves in the effort to say it, would be to exorcize it by furnishing it with the residue of already constituted systems of rationality, or to equate the question asked under the figure of the limit with a particular religious representation (one excluded from all of the fields of science, or fetishized as the substitute for a lack). It would be tantamount to positing, behind the documents, the presence of a what-ever, an ineffability that could be twisted to any end, a "night in which all cats are black."[2]

The ambiguity that emerges after a reading of all articles in this volume might well be the most realistic reflection of the role mystical experience played for medieval religious women: in some cases, it freed and inspired them, but the mystical path also left the women in the lurch when it came to battle against yet another attempt at disenfranchising them (as, e.g., in the case of fourteenth-century Beguines in the Low Countries).

Unlike edited works that present a homogenous methodological point of view—be it historiography or literary criticism, art history or theology—this collection of essays is purposely conceived in interdisciplinary terms. The theme of women's cultural contributions takes precedence over an investigation of their economical and political conditions. In most anthologies on medieval religious women, three editorial choices predominate: literary studies on individual outstanding writers, the exploration of the material and political contexts of religious women's lives, and strictly theological inquiries.[3]

This volume is intended to show convergences in themes and findings from different disciplines and to move toward piecing the various parts of the puzzle together. Theology, literary criticism, art history, musicology, history, and religious studies, when used on their own, cleave the organic whole that constituted medieval women's religious lives. Although we are still far away from reconstructing this wholeness (and never fully

will be able to), it is hoped that a step toward an interdisciplinary under-
standing of medieval religious women will encourage more similar work.

In her essay "The Rhetoric of Orthodoxy: Clerical Authority and
Female Innovation in the Struggle with Heresy," historian Jo Ann Mc-
Namara sketches the precarious ecclesiastical context in which medieval
religious women's activities unfolded in the late Middle Ages (approximately
twelfth to fifteenth century). She takes the position that although the church
yielded to a certain extent to the influence of religious women in the be-
ginning of the late Middle Ages, it succeeded in silencing them toward the
end of this period. McNamara carefully distinguishes between a theologi-
cally constructed gender system and its actual application in different ec-
clesiastical contexts. Of prime importance for the shift in attitudes toward
religious women, she observes, was the rising threat of heretical move-
ments to the church. Faced with a true catch-22, however, religiously ac-
tive women found themselves both instruments in the fight of the church
against heresy and all-too-quickly denounced suspects — for the same rea-
sons. The arguments that portrayed women's religious activities as inter-
changeably attractive and dangerous focused on a definition of femininity
as distinctly different from masculinity and inferior to it. It also empha-
sized women's propensity for visionary experiences.[4] McNamara deline-
ates the gradually tightening grip of the male hierarchy by analyzing the
role of bodily purity as expression of female orthodoxy, women's sacra-
mental strategies to ensure active membership in the church, and their part
in the redemptive mechanisms developed to cope with a fear of purgatory
and a growing concern for the afterlife.[5] As do other authors in this vol-
ume, McNamara takes an explicitly feminist stance. She assesses the re-
lationship between male ecclesiastical authorities and religious women
through an analysis of women's range of independence, influence, and
power to shape their lives. Metaphors of war seem appropriate: in this
struggle, it is women who suffer the "scars of battle." During the crucial
period of the Great Schism (1378–1417), for example, slow and heroic self-
destruction legitimized Catherine of Siena's public outspokenness. The
means to this end were nothing unusual in religious women's biography,
but extraneous to religious men who sought a public voice.[6]

The notion of the body and its function in the spirituality of medie-
val religious women is taken up in the next two articles, "Mystical Bodies
and the Dialogics of Vision" by Laurie Finke and "'She Wept and She Cried
Right Loud for Sorrow and for Pain': Suffering, the Spiritual Journey, and

Women's Experience in Late Medieval Mysticism" by Ellen Ross. Although
written from two different methodological perspectives, the themes over-
lap. Suffering rather than ecstatic pleasure takes center stage in both analy-
ses, but so do resistance and creative invention. Finke, a feminist literary
critic, looks at the use of mystical language "as it exhibits at least some
women's ability to speak and be heard within a patriarchal and forthrightly
misogynistic society."[7] The texts Finke uses to demonstrate her point are
the *Vita* of Saint Leoba by Rudolph, monk of Fulda, Gertrud the Great's
Legatus divinae pietatis, Angela of Foligno's *Liber de Vera Fidelium Ex-
perientia*, Thomas de Cantimpré's *Vita* of Christina Mirabilis, and Julian
of Norwich's *Showings*. Julian's *Showings*, together with Margery Kempe's
autobiography, form also the basis of Ross's analysis of suffering and
women's experience in late medieval spirituality. Unlike Finke, Ross uses
the parameter of theological discourse and does not state an explicit femi-
nist agenda. But like Finke, Ross evinces how skillfully medieval religious
women intertwined the experiences of personal suffering and their revela-
tions. Read against the background of McNamara's essay, the women's writ-
ings emerge as texts of resistance that counter an ever-present misogyny.
As a literary critic, Finke pays attention to the metaphorical weavings of
the texts; as a theologian, Ross considers both similarities and dissimilari-
ties of Julian's and Margery's writings with the more voluminous array
of theologies produced by men. If, in Finke's view, the religious women
assert their own existence vis-à-vis a hostile world and create their own,
so, in Ross's interpretations, do they push further medieval theological con-
cepts of suffering. The two projects go hand in hand, as a reading of both
articles suggests.

E. Ann Matter, a scholar of religion, adds an important counterpoint
to the views of Finke and Ross. Her essay "Interior Maps of an Eternal
External: The Spiritual Rhetoric of Maria Domitilla Galluzzi d'Acqui" covers
a later period; Maria Domitilla was a Capuchin nun who lived in Padua
during the Counter-Reformation. Like Finke, Matter analyzes the gendered
imagery in Maria Domitilla's autobiographical writings and letters and pur-
sues the analytical questions laid out so ingeniously by Caroline Walker
Bynum — women and their ambiguous relation to the church, the construc-
tion of a different theology and spirituality, and the role of the body.[8] Like
Ross, she finds the pattern of *imitatio Christi* to be the root metaphor for
Maria Domitilla's spirituality, but can pinpoint its demise as a powerful
means for women to construct a viable theological context for themselves.

"It seems to me that women's experience of *imitatio Christi* which began in the late Middle Ages as a radical, form-breaking type of self-expression became by the sixteenth century a more conformist and less expressive manner of self-interpretation. This form of female piety came to be carefully regulated by the patriarchy of post-tridentine Catholicism."[9]

Matter's judgment is pessimistic: Maria Domitilla could make use of her voice only within the confines of an ossified symbol system now fully controlled by an andro-centric church hierarchy. Unlike Julian and Margery, she was unable to develop it further. What makes Maria Domitilla's identification of herself with a now stereotyped, iconic pattern tolerable and livable, Matter concludes, is the "mythical power [of the *imitatio Christi*] as an eternal truth of human salvation."[10] Matter's interpretation implies a view of Christian symbolism that affirms an element of transcendence untouched by the rhetoric of andro-centric imagery. Her interpretation thus takes the middle road between feminist reformers and revolutionaries in religious studies by pointing out both destructive elements in Christian symbolism and the reasons why it still remained attractive to some women.[11] Her final subtle reading of the *imitatio Christi* complex raises important questions that move beyond medieval studies into the larger domain of a feminist appraisal of Christianity.

The next two articles, by theologian Margot Schmidt and religious studies scholar Ulrike Wiethaus, examine different aspects of religious women's friendships. Friendships, unlike blood relationships, are constructed and achieved rather than given, and are based on values, such as respect, trust, and mutuality. Common goals are reached by reciprocal support, high emotional rapport, and generosity in the sharing of resources and create an equal status among friends. For medieval women, both cross-sex and same-sex friendships represented an antidote to patriarchal structures and functioned as an alternative model to social relations that were subject to the structures of domination and submission described in McNamara's essay. Within the larger context of medieval patriarchy, affectionate friendships between religious women and men could survive and even thrive. Schmidt traces one of these relationships in her essay "The Correspondence between Heinrich of Nördlingen and Margaretha Ebner: An Example of Spiritual Friendship." Schmidt, whose work on medieval women mystics has unfortunately not been translated into English as much as it deserves, points out that Margaretha's and Heinrich's friendship was not an isolated phenomenon in the history of Christianity. Thekla and Paul,

Marcella, Paula, Eustochium, and Jerome, for example, are representatives of early Christian cross-sex friendships that come immediately to mind. It is important to note, however, that all of these alliances unfolded under the aegis of strictly regulated celibacy. Vows of sexual abstinence allowed women and men to experience a greater degree of equal relationships outside of a system of sexual inequality.[12] In addition, spiritual cross-sex friendships flourished in an atmosphere charged with unusual religious intensity and idealism. In the words of philosopher Janice Raymond, who wrote about women's friendships, "a particular friendship was spiritual because a third dimension — God — was present. A sense of transcendence was introduced into the relationship. Spiritual friendship was based on the common knowledge and love for something that at the same time went beyond the friendship and cemented the friendship in daily life."[13] Personal attraction and affection become part of a larger spiritual project that by its very nature attempts to "break boundaries," only one of which is the restraints of a socially constructed reality. Celibacy and intense religious commitment thus created frameworks for heterosexual friendships that were clearly understood as exceptional. They could be maintained as long as they did not adopt cross-sex practices customary for the rest of society. Margaretha's and Heinrich's written testimony to their friendship is instructive in that regard, considering that both spent a great deal of time to define the character of their mutual attraction. Their friendship has been preserved in a collection of fifty-six letters by Heinrich and one letter by Margaretha, a letter that survived only because it had not been sent. Ironically, however, the letters belie whatever editorial negligence of Margaretha's correspondence Heinrich may have intended. Heinrich deeply admired Margaretha and saw her as a mediator between himself and God, superior to him in her spirituality.

 In contrast to Margaretha's single surviving letter as evidence of her friendship to Heinrich, Hildegard of Bingen's correspondence gives ample evidence of both same-sex and heterosexual friendships. Wiethaus focuses on the small fraction of Hildegard's female letter cycles in order to attempt a reconstruction of her same-sex friendships. From a feminist perspective, this reconstruction is based on the assumption that same-sex friendships for women function as a crucial network to counterbalance and to ease women's lives within patriarchy. Because safeguards such as celibacy and spiritual purity were not necessary, women could explore a greater variety of emotional possibilities in their relations than women and men could

in cross-sex friendships.[14] In her essay "In Search of Medieval Women's Friendships: Hildegard of Bingen's Letters to Her Female Contemporaries," Wiethaus attempts to show how Hildegard lived as a woman in a women's community, in which women supported, loved, and—an important aspect of living *communitas*—were self-assured enough to criticize each other.

The next section comprises essays on women's artistic representations and creativity. Art historian Joanna Ziegler investigates the relation between three sculptural themes employed in devotional practice and the nature of institutionalized Beguine life in the fourteenth century in her essay "Reality as Imitation: The Role of Religious Imagery Among the Beguines of the Low Countries." In "Text and Context in Hildegard of Bingen's *Ordo Virtutum*," musicologist Patricia Kazarow posits Hildegard's music drama *Ordo Virtutum*, the first extant liturgical morality play, in its musical, theological, and dramatic contexts. Both essays demonstrate how medieval religious women appropriated artistic conventions and imbued them with new meaning. In Ziegler's analysis of the Beguines, this process served ultimately a repressive purpose.[15] *Imitatio* is the key word in her line of argument, but not the *imitatio Christi* of a Julian of Norwich or a Maria Domitilla. According to Ziegler's analysis of the as yet only scantily explored rules for beguinages (the living quarters of Beguines), Beguines aspired to imitate convent life as closely as possible, although they began as a lay movement.[16] They were supported by the clergy, who found the Beguines' interest in a cloistered and rigidly structured life-style appealing in their concern for orthodoxy and control over lay movements. Ziegler claims that three types of sculpture found frequently in beguinages both expressed a new type of spirituality and its simultaneous cooptation by the clergy who encouraged their use. All three types allowed women to express and explore feelings of spiritual motherhood, be it in the form of nursing or holding the Christ child (the *Christkindje* and the *Standing Virgin with Child* themes), or expressing grief over the death of Christ as depicted in the *Pietà*.

The renewed emphasis on motherhood both opened and closed doors. They allowed more women to affirm their femininity and express their spirituality in a gentle and warm manner. Simultaneously, however, the widely supported invitation to merely imitate clearly circumscribed patterns of worship and prayer discouraged the cultivation of spiritual independence and authority and alternative female role models. Ideologically, the diversity of monastic and secular life-styles for women was thus stream-

lined into just one ideal women could aspire to, namely motherhood. Ziegler's interpretation of the devotional sculptures used by the Beguines thus complements McNamara's essay, and shows how ecclesiastical decisions were at times subtly paralleled on iconographic and artistic levels. She challenges McNamara, however, in that she discloses the ambiguity and subtle persuasiveness present in the dissemination of mother-oriented devotional art. Women were clearly attracted to it and found great satisfaction in it.

Kazarow's article on Hildegard's creative achievements is far less controversial in its findings and interpretations. As a Benedictine abbess and a member of the upper nobility, Hildegard had full control over the means of her artistic productions. This claim cannot be made about the Beguines of the fourteenth century. Her "right to singularity" was well established by the time she wrote the music drama, and she was sufficiently educated to articulate a sophisticated theological vision of her own. Yet her creative process ultimately escapes easy classification. Kazarow stresses that we must believe Hildegard when she noted that the music and theology in this piece are divinely inspired. Kazarow tries to do justice to the religious dimension of the work by carefully suggesting a depth psychological interpretation at the end of her essay.

The two perspectives manifest in Ziegler's and Kazarow's work thus represent the two polarities of medieval religious women's experience, sponsorship and creation of religious art — Ziegler stresses the ideological interests that manipulated spiritual insights and the ambiguity inherent in symbols that can be exploited to the disadvantage of those believing in them. Kazarow, however, delineates a process of creating spiritual art that is genuinely liberating and ultimately mysterious. The fact that within two centuries, both approaches to art were possible in medieval women's communities should make us more careful in formulating general assessments of the relationship between religious art and women — as creators, users, and patrons — in the late Middle Ages.

THE RHETORIC OF ORTHODOXY

Clerical Authority and Female Innovation in the Struggle with Heresy

JO ANN McNAMARA

MYSTICISM FLOURISHES BEST in the silence and solitude the Church has traditionally prescribed for its female members. We have occasional documentation for women mystics before they attracted the attention of male writers and preachers in the twelfth and thirteenth centuries.[1] But any attempt to evaluate the mystical experiences of women must begin with the recognition that our *corpus* has survived a rigorous process of editing and censorship. In this paper, I want to focus on the alliance between men engaged in extirpating heresy in the high Middle Ages, particularly members of the Dominican order, and women whose mystical revelations validated their teachings. Through the second half of the twelfth century, the growth of heresy was paralleled by a virtual "women's movement" in Flanders, Italy, and southern France, dedicated to the defense of orthodoxy.[2] In Languedoc in 1151, for example, a young girl converted a multitude of Henricians, the same heretics who obstinately withstood the powerful preaching of Saint Bernard of Clairvaux.[3]

At best, these women were irregulars in relationship to the professional troops of the clergy. Faced with the defection of a substantial portion of its membership, the church determined to make use of recruits whom they would normally have preferred to silence. They treated visionaries who claimed to have direct communication with God gingerly. They always remained fearful of empowering women to invade the male preserves of theology and liturgy with their own innovations. Despite the success of women's preaching missions in combating heresy, the very idea that

women could preach was often treated as proof of heresy. German councils throughout the thirteenth century restricted the public activity of Beguines and strengthened their subordination to their pastors.[4] Female mysticism, nevertheless, grew in power and authority from the twelfth century through the fourteenth, until many champions of orthodoxy feared it more than heresy itself. Reaction followed the Great Schism in the fifteenth century. The High Middle Ages ended as they began with a great silent void where the voices of women should have resounded.

THE DANGEROUS VOICES OF WOMEN

Every preacher, confessor, and didactic writer taught women that God loved nothing but silence and abject humility from his feminine creatures. They repeated obsessively that Eve's initiative had fatally disrupted God's relationship with Adam and warned all men to shun the blandishments of Eve's daughters as the fatal song of the siren to Adam's sons. Perhaps sensible women dismissed this propaganda. Still, no woman could venture a public statement without the risk of being humiliated and reprimanded. Hildegard of Bingen, the first of the great twelfth-century women mystics, was learned in a wide variety of patristic and contemporary theological sources.[5] Nevertheless, prudence counseled her to pose as a nearly illiterate woman, a passive receptacle of divine revelation. In later years, most women were "illiterate" in that Latin formed little part of their education. Most of the mystics were forced to depend on men to translate and record their revelations. As universities, which excluded women, monopolized formal education, it became ever simpler to discredit women as foolish or hysterical.

Popular theology linked Eve's original sin of curiosity to her seductive powers. In the same spirit, critics interpreted every form of female self-assertion as an invitation to sexual pleasure. The Dominican Humbert de Romans spoke for the majority of the clergy when he warned that women must not be allowed to preach because they would stimulate lust in their listeners.[6] The chastity of Beguines and recluses was constantly questioned by their male mentors.[7] Warnings often turned to self-fulfilling prophecies when their "protectors" turned into predators. A priest, for example, lusted after one of the young women living in Yvetta of Huy's beguinage. He hung about the saint masking his seductive intent by pretending to be a

proselyte. In the end, Yvetta herself was accused of an unseemly interest in his company.[8] Thus men's sexual aggression against women became an instrument for the enforcement of feminine silence.

The convent's protective environment sometimes helped nuns to resist internalizing male concepts so damaging to their self-esteem.[9] Nevertheless, women feared to obey even God's direct commands without the support of the male clergy. Humility kept Juliana of Cornillon silent for twenty years as she attempted to convince Jesus that he should make his revelations to a more suitable recipient. Finally, she determined to obey God's instructions to secure a feast in honor of the Eucharist, when her confessor reassured her that she could do so without fear of unorthodoxy.[10] Nuns themselves often collaborated with the prevailing system. The complaints of her fellow nuns that her piety was hypocritical drove the Flemish Lutgard of Aywières to move to a French-speaking community where she never learned the language. In effect, the gender system was effectively constructed to keep women silent.

Empowerment by divine revelation strengthened their self-confidence but the prohibition was so strong that even when God commanded them to speak, the effort made mystics physically ill.[11] Hildegard concealed her visions for half her life until, in 1141, a sense of irresistible supernatural force overcame her paralysis.[12] Even then she sought confirmation from scholars, from Bernard of Clairvaux, and finally from the pope himself that her work was acceptable to the Church.[13] Lutgard of Aywières maintained that God forced her from a sickbed to go out and save souls.[14] Elisabeth of Schönau, in an exculpatory letter to Hildegard, wrote that an angel had beaten her until she agreed to reveal her visions. Elisabeth was frantic with anxiety that Hildegard (and the rest of the world) should misjudge her and condemn her as a hypocrite or hysteric.[15] Gertrud of Helfta resisted writing until Jesus, with the independent confirmation of the two nuns who recorded her visions, insisted that she do so.

This reluctance did not arise from a simple internalization of male arguments about the inferiority of women. Women depended on the approval of the male clergy for survival, both physically and historically. Mechthild of Magdeburg complained to God that the same men who tried to have her books burned would gladly have paid honor to a priest given the same revelations.[16] Marguerite de Porete actually was burned at the stake while her book, mistakenly attributed to a man, was approved as orthodox and widely circulated for several centuries. Women, publicly ad-

mired for their holiness, were often "exposed" as frauds or as heretics. In 1180, a young girl was burned in Reims because her steadfast dedication to purity enabled her frustrated seducer to accuse her of the Cathar heresy.[17] These punishments were unfortunate enough for the individuals involved but, because of the preconceptions supporting the gender system, the conviction of one woman inevitably reflected on all women.

THE DIALECTIC OF REVELATION

Women needed powerful inducements to overcome the inhibitions imposed upon them by men who identified their voices with folly, seduction and vice. When they spoke, they risked mockery, rape, or even death at the stake. But their willingness to submit to clerical authority did not arise from fear alone. They were anxious to reform their church and defend it from its critics. From the middle of the twelfth century forward, despite their reluctance to expose themselves to the dangers inherent to the *cura mulierum* (the spiritual guidance of women), men associated with the fight against heresy accepted the support of mystical women. In 1147, when Hildegard of Bingen submitted her work to them for approval, Pope Eugenius III and the great abbot Bernard of Clairvaux were in the Rhineland seeking allies against heretics who had driven the pope from Rome. Heresy was also spreading in Germany. Hildegard's humility and loyalty to ecclesiastical authority were indisputable recommendations even to men unsure of·her theological orthodoxy. Her visions were approved, and she was finally licensed to undertake four preaching tours against heretics and unreformed clergy.

At the beginning of the thirteenth century, Cardinal Jacques de Vitry recognized the power of the ascetic women grouped around Marie d'Oignies in the diocese of Liège and made himself their publicist.[18] He linked the whole northern women's movement to Pope Gregory IX, and, through him, to the Dominicans who led the fight against heresy.[19] The Preachers combined their theological studies with the training of women mystics until the period of the Great Schism in the fourteenth century, and several individuals even acknowledged that the process was reciprocal.

These collaborations eventually produced a body of literature which prudently balanced divine revelation with received orthodoxy. With their spiritual experiences so closely bound to the ongoing struggle between the orthodox and the heterodox, these women walked in a minefield. Hilde-

gard's vision of God as the Everlasting Light unnerved her first examiners who were fearful of Cathar dualism. Her *Ordo Virtutum* also reflected a preoccupation with the Devil that might have sprung from Catharist inclinations.[20] The powerful attendant figures of Wisdom and Poverty resonated in ears accustomed to the common heretical criticisms of clerical wealth and ignorance.

Hildegard gained confidence with increasing age and success. She reprimanded her last secretary for his tendency to revise what she had dictated, but she and her fellow mystics never ceased to protect themselves with judicious self-censorship. Elisabeth of Schönau, for example, had a vision of Christ as a woman whose bright light was obscured by sin while her angel explained that he deliberately wished to exemplify the inclusion of women in his humanity. Her brother Ekbert, the Cistercian abbot who recorded her visions, asked her to consider whether Jesus could appear as a woman. Finally, she "realized" that the woman in the sun was actually the blessed virgin.[21] Yvetta of Huy told her biographer that she did not want to confess much of the secret knowledge in her visions.[22]

Orthodox women subjected themselves to clerical authority as soldiers under military discipline. They fasted and mortified their flesh to train their souls for battle. Marie d'Oignies wanted to enlist in the Albigensian crusade, but at the Archbishop of Toulouse's advice she accepted spiritual combat as more suitable to her emaciated condition and increased her mortifications.[23] Yvetta of Huy explicitly connected her personal sufferings with the battle against the forces of evil.[24] Lutgard began the first of three seven-year fasts after the Blessed Virgin told her in a vision that heretics and bad Christians were crucifying Christ anew. They developed their weapons with courage and initiative. Where men fought heresy with theology and the stake, the tangible power of the institution they controlled, women fought with their own bodies. Self-inflicted wounds enhanced their identification with Jesus. Marie d'Oignies was the first in a long succession of women to exhibit the stigmata, a certain sign that divine power endorsed her struggle.

THE PURIFICATION OF THE BODY

Marie's creative concept of the union of flesh and spirit was a formidable weapon against the Cathars who condemned the flesh as irretrievably impure, the enemy and prison of the spirit. Orthodox theology was similarly

inclined to divorce the pure spirit from the corrupt flesh, reinforcing the inherent misogyny by identifying women with the flesh. Boldly accepting the concept, Hildegard of Bingen maintained that woman represented God's humanity as man symbolized divine nature.[25] On the model of Jesus, she argued for the integration of body and soul.[26] This argumentation made possible a strategy against dualism based on acquiring purity through the reciprocal merits of flesh and spirit.

The Cathars saw purity as an absolute and static quality. It could be conferred only once on a practitioner through their sacrament of Consolation. Thereafter, a single false move would condemn the believer to irretrievable damnation. Orthodox men also tended to equate purity with passivity and even helplessness and impotence. Implicitly, they associated purity with virgins. Emphasizing the vulnerability of virgins to scandal and ultimately to rape, clerical advisers urged them to be immobile and inaccessible.[27] While they granted that widows and even married women were capable of salvation, they did not associate them with purity.

Their male mentors urged virgins to be silent and enclosed. In women's experience, however, purity had nothing to do with immobility and silence. Sexual threat and violence overshadowed their biographies. An ardent suitor who had come into her house with her visiting relatives attempted to rape Yvetta of Huy. Even in her convent, a suitor made unseemly advances to Lutgard of Aywières and nearly succeeded in raping her when he abducted her from the road near her own home. Christina of Markyate persuaded her bridegroom to respect her virginity, but her parents sent him back to rape her. She preserved her purity only by flight in male disguise and a long concealment in atrociously painful conditions.

Men envisioned virgins enclosed in cells furnished with white linens, wearing white dresses. Adelheid de Sigozheim preserved her virginity through twenty years of marriage to a man who retaliated by beating and humiliating her.[28] Hedwig de Gundolzheim's sadistic uncle punished her refusal to marry by keeping her in the pigsty and subjecting her to physical tortures that deformed her permanently.[29] Christine of Stommeln was buried in dung and stuffed full of toads and other disgusting things by diabolic forces. In spirit at least, her body was so thoroughly violated and mutilated by demons that there would seem to be little purity left. Nevertheless, she complained fiercely when human men put their hands on her to rescue her from a well.[30]

Thus to women, purity was dynamic, not a pristine state but a goal

never fully achieved. Like embattled soldiers, they defended one another, and their training made them skilled at procuring divine assistance. Yvetta's prayers were powerful enough to protect one of her companions from seduction and rape after a deceptive confessor convinced her that her concern for her purity had exposed her to the sin of pride.[31] Their triumphant self-defense linked them to the virgin martyrs who resisted the lust of their persecutors. The Virgin Mary, Ursula, Agnes, and other exemplars stepped out from the pictures and books which devout women contemplated and protected them in their need. Faced with would-be rapists, they sought the help of Margaret, who overcame a lustful dragon. Clemence of Barking wrote the life of Catherine of Alexandria, whose victorious weapons were purity and preaching. The militant purity of these legendary women had once converted multitudes to the faith. In the same spirit, thirteenth-century women opposed their own flesh, doubly purified by association with Jesus and by their own efforts, to the threats of heretics. They deliberately exposed themselves to the most unclean elements to test the power of their own purity over the forces of corruption. Having persuaded her husband to renounce their sexual union, Marie d'Oignies devoted herself to the service of lepers as did the widowed Elisabeth of Thuringia. Yvetta of Huy lived among lepers and prayed regularly that she might become one of them.[32] Catherine of Siena drank the water in which she washed a leprous woman. Alice of Scarbeck, who was a leper, counted the loss of her limbs as so many blows against the enemies of the faith. They made flesh at its most despicable a purifying agent. This behavior is particularly remarkable in view of the reputation of lepers for spiritual, particularly sexual, impurity and the argument of modern historians of medicine that "leprosy" in the twelfth century may well have been syphilis.[33]

The visions of these steadfast heroines included abundant evidence of divine approval for their enterprise. Adelaide Langmann's husband fell mortally ill on their wedding day and God informed a second suitor that he would kill anyone who tried to marry her.[34] After her death, Elsbet Mairin of Nürnberg appeared to one of her sister nuns at Engelthal wearing a crown and a clasp on her breast where all her merits were displayed as a badge of honor.[35] Even while they were alive, Dominican nuns in various German convents appeared to their sisters transparent as crystal, gleaming with inner light, so pure that they literally floated into the air.[36] This purity was not reserved for virgins alone. Among the women whose outstanding purity was rewarded by mystical marriage with Christ during

their lifetimes were widows like Birgitta of Sweden. Her example confirms the idea that purity was not an absolute but an attainable condition. The foundress of Unterlinden, a widow with two sons, maintained that she escaped all impurity during her marriage because whenever she felt herself in danger of succumbing to sexual gratification, she turned all her desire and love toward God.[37] Margery of Kempe's fierce determination to wear the white dress of a virgin despite the many children who bore witness to her earlier sexual relations with her husband was validated by Jesus himself.[38]

Commitment to poverty was one of the chief ideals of many heretics and a point of continuing friction between the secular clergy and the new mendicant orders. Clare of Assisi's clerical superiors opposed her desire to practice pure Franciscan poverty because begging was inconsistent with their conception of purity as a passive quality requiring the enclosure of women. But women strove for economic purification as they sought sexual purity. Widowed from the man she had been forced to marry, Yvetta of Huy tried systematically to cleanse herself of his wealth as well as to purify her body from the effects of marriage.[39] At first, she let her father invest her funds for her sons but ultimately, revolted by the filthy lucre, she gave everything to the poor.[40]

Fasting became a vehicle for transmitting the body's purity to the unclean world. Conrad of Marburg connected Elisabeth of Thuringia's fasting with her rejection of food obtained through the exactions of mercenary officials from the poor.[41] Ida of Louvain refused to accept anything from her merchant father, working night and day to feed the poor who came to her while fasting herself. Once, for eleven days, she ate nothing but the flowers from a lime tree. Marie d'Oignies chose to live on herbs and soups from vegetables she gathered herself in order to avoid eating food donated to her hospital which might have been purchased with "unjust" profits.[42] Birgitta of Sweden, who was wealthy enough to support an enclosed community, claimed that she could guard the purity of her nuns by a miraculous ability to sense and refuse offerings that were the fruit of usury.[43]

Thus from the purified spirit of the chastened body, the food that supported it and the money that paid for it, visionary women trained themselves for their ultimate mission to purge the world of sin and error. Against the Cathar rejection of the corrupt flesh as the prison of a pure spirit, women pitted devotion to the Eucharist, the pure flesh and blood

of Christ whose redemptive sacrifice ultimately assured the resurrection of the body purged through penitence.

SACRAMENTAL STRATEGIES

In a letter to the Prelates of Mainz, Hildegard of Bingen characterized the Rhineland heretics as "men who deny the most holy humanity of the Son of God and the sanctity of the body and blood which are in the offering of bread and wine."[44] Having embraced that humanity, women set out to defend the inner citadel of clerical authority. They commanded a powerful arsenal of revelations and miracles centering on the sacraments of penance and the Eucharist.[45] Cathars rejected the sacraments as vehicles of salvation and denied that loss of purity after initiation could ever be retrieved through penitence. Heretics in Antwerp, described by Thomas of Cantimpré about 1252, claimed that priests in mortal sin were unable to consecrate the host or absolve penitents.[46] Though showing every respect for priestly offices and sacraments, women opposed their own purity to clerical corruption and even used the failings of the clergy to justify their own public activity. In a sermon preached at Trier for Pentecost in 1160, Hildegard ascribed the Cathars' success to lack of pastoral care, condemning the German clergy for their effeminate weakness in the combat.[47] Elisabeth of Schönau wrote to Hildegard, "you are sent by God to work in his vineyard since the head of the church is immobilized and its limbs are dead."

At the same time, they strove not to intrude on the liturgical monopoly of the priesthood. A dying nun at Unterlinden received Extreme Unction from Jesus himself, who then said to her, "Although you have received the sacraments of the church from me, take them from the priest according to ecclesiastical rites lest you seem to refuse."[48] But the confessional, in particular, was easily transformed into a two-way avenue of teaching and repentance. A mystic's approbation could validate and enhance the confessor's position. It became fashionable for abbots and abbesses to ask Hildegard for divine endorsement of their elections. The Cistercian order requested her to secure a list of items from the Holy Spirit for incorporation into their statutes.[49] Their power to rebuke unreformed priests was obviously reinforced by such tangible signs of divine approval.

Orthodox women's vision often specifically enhanced the sacramental power of the clergy. Raymond of Capua stressed that when Catherine

of Siena converted sinners, she warned them all to go immediately to con-
fession. But women under Dominican tutelage often developed the capacity
to discern hidden sins and bring erring clergy to repentance.[50] This was
a daring reversal of the roles of priest and penitent. Yvetta of Huy enjoyed
a series of visions exposing the avarice and other mortal sins of various
priests whom she tried to correct in the secrecy of the confessional. Once
she was divinely shown that a certain sacristan was taking advantage of
his office to sleep in the church where he was conducting a secret liaison.
When she confronted the clerk, he scorned her and soon died without the
sacraments.[51] When her parish priest refused to give her the sacraments,
John the Baptist took his place and then revealed that the priest was afraid
that her famed insight would reveal that he had polluted himself with a
prostitute. The priest repented when she revealed in confession what had
happened.[52] Catherine of Siena also practiced this reversal of the sacra-
ment. Whenever she heard anything bad about a priest, she would berate
him under cover of confession, but she reserved her own confidences for
her Dominican confessor and biographer, Raymond of Capua.[53]

Dominican willingness to undertake *cura* of women who were not
enclosed nuns in their own order directly challenged the prerogatives of
the secular clergy. In the thirteenth century, William of Saint Amour, the
defender of their privileges against the incursion of the mendicants, sought
to excommunicate uncloistered women who followed the religious life in-
dependent of their parish priests.[54] In 1254, Innocent IV's "terrible bull,"
Etsi Animarum, forbade the friars to hear confessions without permission
from parish priests or to compete with parish services by preaching in their
own churches. The Dominicans launched a campaign of prayer against
the bull and claimed success when the pope died within a month of its
publication.

Even the Dominicans, however, had misgivings about their involve-
ment in the spiritual adventures of women. Catherine of Siena and other
saints placed their confessors in the center of their religious lives, consulting
them over every scruple. Elsbet Stagel, for example, recorded her faults
on a wax tablet when she could not see her confessor personally and sent
it to him for absolution of her failures.[55] Their directors justifiably feared
the scandal that invariably attended such intimacies. Probably they also
feared their own susceptibilities to the charms of women. Further, women's
enthusiasm for the sacraments tended to outstrip the constraints of the ad-
ministering clergy. Repenting their real or imagined sinfulness, women

purged their bodies through fasts, flagellations, and other self-imposed penances. They tried to preserve their perfect purity by subsisting solely on the Eucharist. They shocked the sensibilities of their confessors who tried to curb their excesses.

The danger that men might be distracted by their penitents was a small one, however, compared to the danger that the penitents might avoid men altogether. As it was, the tendency of mystics to pick and choose their confessors suggests an attitude more befitting a mistress than a servant of the clergy. Elsbet Stagel maintained that God had sent Heinrich Suso to her in answer to her prayer for a good confessor. Didactic writers urged the brides of Christ to maintain a stance of wifely submission and reticence, and so they did. But at the same time their claims to intimacy with Christ enhanced their sense of authority with his ministers. They sometimes acted as their spouse's partner and regent in much the same way that noble women acted for their husbands on earth.

The drama of the Eucharist in particular rested largely upon their personal relationship with Jesus. In 1152, Elisabeth of Schönau fell into ecstasy when she saw a crucified Christ pouring his blood into the cup at the elevation of the chalice. Thereafter, many women developed their skills to experience the mass mystically. Some could correct the priest whose timing failed to coincide with the moment of transubstantiation. Mystics receiving communion could distinguish unconsecrated from consecrated hosts. More broadly, they sometimes distinguished between worthy and unworthy recipients and even celebrants.

Personal purification preparatory to receiving communion became ever more elaborate, and a dynamic concept of reception dissociated the communicant from the formal liturgy. Christine of Stommeln overcame an army of violent demons to reach the altar.[56] The struggle left her no opportunity to attend to the increasingly irrelevant behavior of the priest on the altar. After receiving the sacrament, many women enjoyed an extended time of interior communion with their divine spouse. The church retaliated by preaching moderation, curtailing the frequency of communion, and prohibiting priests from giving the Eucharist to women in ecstasy.

But refusal of the sacraments was a dangerous course against women already directly in communion with God. A Dominican nun barred from the community's services on account of epilepsy began to commune with Jesus in her isolation, and he promised to guarantee her the last sacraments.[57] A bedridden nun in the convent of Unterlinden was regaled with

the singing of heavenly choirs when the sisters left her to attend Mass.[58]
John the Baptist, who had performed a similar service for Yvetta of Huy,
obliged Mechthild of Magdeburg with a supernatural mass. Her clerical
critics complained that the saint was a layman and had no right to say
mass even in heaven.[59]

REDEMPTIVE STRATEGIES

The doctrine that the sufferings and devotions of one person could pay
for the crimes of another gave the church enormous power in supervising
prayers, masses, and alms for the dead. At the same time, it became a cen-
tral target for dissidents. Waldensians, Cathars, Lollards, and anticlericals
of every sort down to Martin Luther himself condemned the whole the-
ory.[60] Orthodox women defended its efficacy in visionary meetings with
suffering souls.[61] They extended the range of their purification techniques
beyond caring for the poor and preaching to sinners in this world to the
next, contributing the mortifications imposed on their own flesh to the
purgation of the sinful dead.[62] Tears, fasting, and poverty purged the beau-
tiful body that led Margaret of Cortona into sin as the concubine of a local
magnate, but she soon passed beyond penance for her own sins to the re-
demption of others. Even virgins offered themselves as penitents identified
with Mary Magdalene, weeping for the sins of the world.

Priests sometimes seemed to be reduced to mechanical conduits for
the movement of grace between women, God, and the suffering souls
who became their clients. Their most powerful weapon in the struggle
against dissident Christians, excommunication, became a two-edged sword
when it deprived their enthusiastic penitents of the sacraments they de-
fended so passionately. In the thirteenth and fourteenth centuries, women
became accustomed to releasing souls from purgatory by the hundreds
through the agency of their own prayers and sacrifices. Excommunication
sometimes triggered women to circumvent the sacramental ministrations
of the priest and intervene directly with God for the souls in purgatory.
One of the founding nuns of Töss, a wordly widow named Beli von Lieben-
berg, saw the worms falling from the coffin of her unburied husband who
died under the ban and determined thereafter to devote herself to acts
of penitence for his sake. Her prayers saved many souls.[63] Mechthild of
Magdeburg, who was always close to the edge of orthodoxy, carried her

passion to save the dead to the point of demanding that God give her even the souls of persons damned to hell.[64] This was an error and would be considered heretical in the fifteenth century.[65]

In this area, women were very close to the dangerous boundaries of their enterprise. Purgatorial piety seemed to give them a direct channel to God, thus challenging clerical powers of mediation. As they had reversed the relationships of priest and receiver in the Eucharist, of confessor and penitent in confession, so did they circumvent the power of the clergy over the road to salvation. Whole communities of nuns at Töss and elsewhere devoted themselves as penitents to fasting, flagellation, and prayer to rescue souls from purgatory, particularly the souls of priests. Indeed, priests and prelates were seen to suffer more than the laity.[66] Lutgard of Aywières envisioned Innocent III in purgatory pleading that without her prayers he would be condemned to remain there until Judgment Day.[67]

The opposition between sinful priests and saintly mystics claiming to reach God without benefit of priestly intervention was particularly dangerous in times of interdict, a practice whose use was increasing as heresy spread out of control.[68] Stephen of Tournai complained that an interdict of Flanders (1193–1203) had greatly weakened the faith of the people and opened the way for heretics.[69] Possibly, it also opened the way for orthodox Beguines to act publicly. The interdict coincided with the pastoral careers of Christina of Saint-Trond, Marie d'Oignies, and Lutgard of Aywières. After Milan was interdicted in 1262, the prophetess Guglielma said that her own body (as Holy Spirit) had been sacrificed and consecrated to Christ.[70] She appears to have thought of herself as a bridge between the church and the suffering laity. Cistercian support for her canonization indicates that she was considered orthodox in her lifetime. However, after her death her followers were finally condemned as heretics because they construed her message to mean that she was the herald of the age of the Holy Spirit that would supplant the old worn-out church with a new one whose apostles were women.

Dominican nuns, forced to move from Nürnberg to the relative isolation of Engelthal because of the interdict against Fredrick II, complained that "God tested them as men do gold in the fire and they had hard labor and had to gather their own corn and wash and bake and do all sorts of menial labor."[71] Thereafter, the *Book of Engelthal* records the marvelous visions and divine contacts many of the nuns enjoyed. During the German interdict of the early fourteenth century, several nuns in the Rhine-

land, collaborating with Dominican friends and confessors, wrote the accounts of their sisters' accomplishments that were circulated along the networks known as the "Friends of God."[72] Interdict could not help but reinforce the tendency of mystical women to develop alternative routes to God. Even private services during interdicts, which were sometimes authorized for enclosed religious women, did not satisfy their hunger to perform redemptive offices.

THE SCARS OF BATTLE

Flagellation, fasting, private Eucharistic ecstasies, the complex personalized rituals of purgation, penance, and salvation—all of which came to characterize the *devotio moderna* in the fourteenth century—were meant to reinforce the strength of the sacraments. But they fostered an alarming independence. At the council of Lyon in 1274, German bishops complained that German nuns tended to rely on their inner light with its attendant ecstasies and visions.[73] The Council of Vienne condemned women who preached or even dared to live an uncloistered religious life without the strict supervision of the clergy.[74] In 1317–18, the bishop of Strassburg organized an inquisitorial visitation of his diocese to uproot this "Beguine heresy."[75] Uncloistered women were obliged to wear bright colors, and those believers who retained their sober habits were harassed and criticized.[76] John XXII's bull condemning "certain women calling themselves Beguines" was implemented by the burning of religious women in the Rhineland and southern France between 1318 and 1328 by Dominican inquisitors.[77]

The Dominicans who still clung to the *cura mulierum* were becoming themselves suspect of loosely defined concepts like the heresy of the Free Spirit or the "Beguine heresy" whose devotees were said to be opposed to the sacraments or to believe that they could attain a degree of perfection through their own efforts that would obviate the need for them.[78] Meister Eckhart died out of favor with the church though he was merely classed as an "unconscious heretic."[79] In 1317, he was criticized for *suspecta familiaritas,* which was obscurely defined as association with women or heretics.[80] In effect, it was becoming more dangerous for men to become too closely associated with women.

Apparently, this isolation encouraged some women to attempt to substitute themselves for priests as ministers to one another. After John XXII's

attempts to extirpate them had failed, the Beguines were left largely in peace. The clergy and the secular power were distracted by war, plague, and economic instability throughout the fourteenth century and had little time to concern themselves with the vagaries of female communities. In 1332, the inquisition uncovered a network of Beguine houses headed by Heylwig of Prague, their "supreme mistress," who visited them over large distances.[81] The sisters believed that their poverty and the punishments they inflicted upon themselves made them more perfect than other people. They distrusted sacraments administered by priests, confessing to their own mother before going to regular confession. In 1368, Aleydis of Nürnberg confessed to a vow of obedience to a "supreme mistress" named Martha who heard confessions and granted absolution to the Beguines.[82]

Thus despite dangers, the prestige and self-confidence of religious women reached an all-time peak in the fourteenth century. It was an age of terror and disarray for the church and its congregation. During the papacy's long sojourn in Avignon, female and male mystics enjoyed a period of unparalleled popularity in England. Popular conviction that the plague was intended to punish erring humanity gave strength and increased power to the calls of preachers and visionaries for repentance from the Netherlands to Italy. In the wake of the Black Death, mass movements of Flagellants, men as well as women, claimed that they could secure absolution by their own penitence without a confessor.[83]

The long Babylonian captivity of the papacy in Avignon further undermined the prestige of the clerical hierarchy, but mystics continued to devote themselves to the twin causes of reform and orthodoxy. Birgitta of Sweden, a powerful noblewoman, publicly denounced the popes in Avignon for lust and avarice. At the same time, she labored tirelessly to bring the papacy back to Rome, supported by prophecies and visions. After her death, the struggle was successfully taken up by the formidable Catherine of Siena. But this victory for feminine innovation and independence in the context of a disordered church was sadly undermined by the resulting disaster of the Great Schism. Catherine became consumed by the frenzied mortifications aimed at ending the disaster that brought on her early death.

Raymond of Capua, Catherine of Siena's Dominican confessor, praised the pope's reliance on her efforts at mediation.[84] But he was the last representative of the alliance between the clerical and mystical defenders of orthodoxy. His contemporaries widely criticized the pope for send-

ing Catherine, a mere girl, on diplomatic missions, and one nobleman even accused her of witchcraft.[85] Ursulina of Parma, whom God instructed to visit both popes to end the schism, narrowly escaped being tried for sorcery when she tried to obey.[86]

The Preachers who had aligned themselves with women had always been a minority. Most Dominicans had always felt that the *cura mulierum* was at best a waste of the order's energies and at worst a threat to their religious and sexual security. At times, only papal sensitivity to the risks of leaving religious women unsupervised had procured confessors for them. With the schism, the order was thrown into disarray, split between the rival claims of two popes and their respective generals. They effectively abandoned the guidance of women; the collective biographies of nuns which they had encouraged disappeared as did the networks that produced them.[87] At the Council of Constance, a Dominican of Wismar, Matthew Grabon, presented Martin V with twenty-four articles to prove that all associations outside of approved religious orders ought to be abolished, and people living in the world should be forbidden to embrace vows of poverty, chastity, and obedience.[88]

Secular rulers, weary of the disorder that troubled the fourteenth century, for the first time took an active role in the struggle against heresy.[89] But public powers were more concerned with public order, and religious women were increasingly seen as inherently disordered. No one wanted an attack on heresy that would revive popular religious enthusiasm. The orthodoxy of women and men who preached publicly was less significant to them than their potentially unsettling effect on a population increasingly prone to rebellion in the late fourteenth century.

JEAN GERSON AND THE PRIMACY OF CLERICAL AUTHORITY

The long resentment of the secular against the monastic clergy, particularly the mendicants, began to tell as the combined effects of plague and schism undermined the strength of the orders. By the middle of the fourteenth century, Birgitta of Sweden failed to win approval for her new order, even though her impeccably conservative rule had purportedly been dictated by Jesus himself. Clerical officials, in effect, claimed that Jesus was controverting church regulations against the proliferation of new orders. The chancellor of the University of Paris, Jean Gerson, took the lead in advancing the revived claims of the hierarchy. He expressed reservations

concerning the validity of Birgitta's revelations during her canonization process and maintained that, on his death bed, Gregory XI admitted that he had been too credulous in allowing female prophets to influence him to return to Rome.[90] Gerson blamed the schism itself on this imprudent judgment: a pope misled by silly women, laden with sin and distracted by various lusts, ever seeking but never attaining knowledge of the truth.[91] His vision of properly constituted hierarchy rudely lumped unordained religious with the laity at the bottom.[92]

In the spirit of Hildegard of Bingen, Gerson acknowledged that the corruption of the church had obliged God to look to the laity and even to women for preachers whom he had authorized through signs and miracles.[93] He blamed the laxity of bishops for having allowed women to encroach on the clergy's functions of purgation and illumination.[94] In this spirit, he and his lifelong friend, Pierre d'Ailly, wrote tracts criticizing the visions of women and other charlatans.[95] Gerson urged bishops to appoint certain approved persons "officially and permanently" to discern spirits and test visions.[96] He argued that neither a proliferation of visions nor of saints should be encouraged because God did not require repetitious and superfluous interventions in the regular course of events.[97]

As disapproval of female mysticism mounted in the fifteenth century, a soul in purgatory told a visionary nun that she could be freed by thirteen masses to be said by six priests whom she named. The visionary was thus reduced from direct saving intervention to a simple role of messenger to the priests. In 1414, a new group of Flagellants were accused of preaching that the sacraments had lost their virtue to be replaced by flagellation.[98] Gerson criticized their reliance on individual penance outside the control of the confessor.[99] In this spirit, female mysticism became irrelevant. Women could only validly receive illumination from the priesthood and could not practice purgation except as prescribed by their confessors.

During the schism, the University of Paris, led by Gerson, condemned Alexander V's bull confirming the confessional privileges of the Mendicants.[100] In a sermon, the chancellor listed "tyrants, heretics, the Mendicants and the Antichrist" as the four chief plagues of the church. His behavior suggested that he saw the Mendicants and their female friends as more dangerous by far than the heretics they had hitherto been encouraged to contest. At the end of the schism, in 1421, Martin V complained of groups of religious living in Cologne without a definite rule cultivating sectarianism and heresy under a cloak of piety.[101]

Gerson warned that men could never safely associate with women

because the love that originates in the spirit tends to be consummated in the flesh. Divine love is often confused with carnal love by "naïve women who through ignorance were more attached to God or to holy men by sensual affection than through love."[102] He claimed to know a monk whose close spiritual friendship with a nun blossomed, until her absence revealed how dangerous his preoccupation had become.[103] He criticized the relations between religious women and their confessors: "Nothing is worse than continual time wasting in this sort of conversation and consultation."[104] And he revived the familiar warning, "Also, you must realize that a woman has something else: an unhealthy curiosity which leads to gazing about and talking (not to mention touching)."[105]

Even the ideal of purity came under attack. Gerson revived ancient arguments that pride in spiritual achievements, particularly virginity, is itself a source of error.[106] Joan of Arc was perhaps the last significant standard bearer for the heroic concept of purity. Her appearance on a physical field of battle bearing her white banner, accompanied by the militant virgin saints Margaret and Catherine, was the ultimate statement of the medieval virgin warrior. The formidable Gerson let his patriotism overwhelm his distrust of female visionaries in her case, but other church officials were not impressed with his endorsement. Though her conviction for witchcraft was overturned, her canonization was delayed until the present century.

The Rhineland mystics' concept of mystical union with God had always been difficult to express without falling into heresy.[107] For women, particularly, it was most easily fitted into the concept of the mystical marriage. But this idea also came under attack when Gerson criticized Ruysbroeck's *De Ornatu spiritualium nuptiarum,* as open to heretical misinterpretation.[108] In 1435, Johannes Nider described the trial of a woman in Regensburg who claimed that she was perfect in spirit, a virgin who had committed no sexual acts, and could not sin.[109] By the end of the century, the marriage of the bride with Christ was giving way to the lurid image of frenzied women copulating with the Devil. The Dominicans who had once been the great allies of mystical women were increasingly fixated on the threat of witchcraft, and it seems that they no longer believed in the divine union between pure women and a loving God.

The partnership that some members of the Dominican order had formed with mystical women had been condoned because it had been effective in the struggle with heresy. When women went too far and their in-

novations encroached on clerical prerogatives, the clergy's customary mi-
sogyny regained its strength, and women were once again relegated to
silence and humility by threats of the stake. Their purity, which had been
so effective a weapon in defense of the church, turned into a reproach.
Because they were excluded from the structure of the church, they en-
dangered it even when they were defending it.

3

MYSTICAL BODIES AND THE
DIALOGICS OF VISION

LAURIE A. FINKE

The mystic is by no means that which is not political. It is something serious, which a few people teach us about, and most often women.

— Jacques Lacan

The soul is the prison of the body.

— Michel Foucault

N HIS DISCUSSION OF TORTURE in *Discipline and Punish*, Michel Foucault reverses one of the central beliefs of Christianity — the belief that the body is the prison of the soul, a miserable container that constrains the freedom of its far more valuable contents. One lesson Christianity since Augustine has consistently drawn from the Genesis story of the Fall is that humans have bodies that experience pain, desire, and mortality; God does not. The body is a limit; its vulnerability and weakness impede the soul in its progress toward God.[1] Foucault challenges these beliefs by suggesting that the body has instead been constrained by — been the prisoner of — its representations that necessarily follow from Christian dualism and the privileging of the soul. What Foucault misses in his analysis, however, is that this dualism has a gender component that guarantees that men and women experience the limits of their bodies in quite different ways. Medieval Christianity construed man as spirit and woman as body. Like the body, woman is accident to man's essence, despite claims of the spiritual equality of all believers. This essay explores some of the consequences of this difference for women of the later Middle Ages who attempted to achieve spiritual authority through mystical experiences.

28

Women in the later Middle Ages were more likely than men to gain a reputation as spiritual leaders based on their mystical experiences.[2] Perhaps because they were in an "oppressed social situation," women were especially drawn to radical forms of religious experience. Some scholars have argued that, because religion was the dominant mode of expression in medieval Europe and the church such a powerful socioeconomic institution, that political dissent almost invariably took the form of religious dissent — heresy, but also the kinds of extreme religious practices associated with even orthodox mystics.[3]

My concern in this essay, then, is the discourse of late medieval mysticism as it exhibits at least some women's ability to speak and be heard within a patriarchal and forthrightly misogynistic society. My point is not to make outlandish claims for these women's anticipation of feminist concerns or to condemn ahistorically their conservatism or slavish capitulation to patriarchal religion. Rather, I wish to examine the discourse of mysticism as a site of struggle between the authoritative, monologic language of a powerful social institution and the heteroglossia[4] of the men and women who came under its sway and sometimes resisted it. Mysticism, as I describe it, is not a manifestation of the individual's internal affective states but a set of cultural and ideological constructs that both share in and subvert orthodox religious institutions. Furthermore, linguistic empowerment for women was tied to certain attitudes about the body prevalent in the Middle Ages. The discourse of the female mystic was constructed out of disciplines designed to regulate the female body, and it is, paradoxically, through these disciplines that the mystic consolidated her power. Specifically, I examine the ways in which several mystics of the thirteenth and fourteenth centuries developed a means of transcending their own secondariness out of cultural representations of the body and technologies designed to contain and suppress it. Although the women I look at in this essay are widely separated by time, geography and class, and while further research will undoubtedly disclose many of these differences, I wish to consider them as a single group for several reasons. These women did not live and write in total isolation. They were aware of the existence of other famous mystics. Indeed, they saw themselves as part of a tradition of exceptional religious women. Younger mystics often modeled their lives and writings on those of their predecessors.[5] I want to insist upon this dialogism — this "intense interaction of one's own and another's voice" — that I see as central to the visionary experience.[6] Furthermore, I

want to emphasize the continuous power of the cultural representations that paradoxically confined these women and enabled them to challenge their cultural figurations.

Although it falls outside of the scope of this essay, the *Life of St. Leoba* — written by a monk of Fulda named Rudolph about an eighth-century Anglo-Saxon nun who participated in the Christianization of Germany — recounts a curious visionary dream that strikingly illustrates the major concerns of this essay. One night the saint sees a purple thread issuing from her mouth, "as if it were coming from her very bowels." When she tries to draw it out with her hand, she cannot reach the end of it. As she pulls it out she begins to roll the thread into a ball. Finally, "the labour of doing this was so tiresome that eventually, through sheer fatigue, she woke from her sleep and began to wonder what the meaning of the dream might be.[7] Because this is a "true vision," the dream demands authoritative interpretation. Its meaning must be made publicly manifest by someone empowered to reveal the "mystery hidden in it." It is another woman — an older nun residing in the same monastery at Wimborne, "who was known to possess the spirit of prophecy" — who offers the definitive gloss on this dream.

> "These things," she went on, "were revealed to the person whose holiness and wisdom makes her a worthy recipient, because by her teaching and good example she will confer benefits on many people. The thread which came from her bowels and issued from her mouth, signifies the wise counsels that she will speak from the heart. The fact that it filled her hand means that she will carry out in her actions whatever she expresses in her words. Furthermore, the ball which she made by rolling it round and round signifies the mystery of divine teaching, which is set in motion by the words and deeds of those who give instruction and which turns earthwards through active works and heavenwards through contemplation, at one time swinging downwards through compassion for one's neighbour, again swinging upwards through the love of God. By these signs God shows that your mistress will profit many by her words and example, and the effect of them will be felt in other lands afar off whither she will go."[8]

Two things strike me as noteworthy about this vision, a rather obscure example from the so-called dark ages of a woman's speech empowered to produce consequences in a man's world. First, it calls into question

our usual stereotypes of women in the Middle Ages as either the subject of a clerical misogyny that saw woman as the incarnation of every evil, on the one hand, or as the docile and virginal saint and martyr, on the other, suggesting that the dichotomy between Eve and Mary oversimplifies women's position in the Middle Ages. The dream reveals that St. Leoba's words will be powerful and authoritative. Her "wise counsels" will not only be spoken publicly and listened to, they will be realized in actions — hers and others'. More importantly, her words — the ball which she fashions from the purple thread — become the means by which "the mysteries of divine teaching" are realized in human and social terms; they mediate between the human and divine (turning "earthwards through active works and heavenwards through contemplation"). According to the male author of the *Life*, Leoba's speech will have powerful material effects on the social institutions of which she is a part — in this case the institutions of nascent Christianity. The dream's prophecy is indeed fulfilled. At the request of Saint Boniface, Leoba travels to Germany as a missionary to aid in its Christianization. She presides over a convent at Bischofsheim. Her miracles include the calming of a storm, and the exposing of an infanticide. In the latter episode, her assumption of the authority of a judge in what is virtually a trial by ordeal exonerates an accused sister and saves the reputation of her convent. Leoba counted among her powerful friends not only spiritual leaders like Saint Boniface, but temporal rulers as well, including the emperor Charlemagne and his queen, Hiltigard.

The second striking aspect of this vision is the fact that it locates Leoba's power to speak specifically in her body. The thread "issues from her very bowels." Leoba regurgitates her powerful words in a process that has its source in her body but seems beyond her control. This episode violates our sense of the decorum required of religious speech, which traditionally separates the disembodied voice of spirituality from the material body. It also transgresses the ideological boundaries between the classical "discursive" body — viewed as closed, homogenous, and monumental — and the grotesque body, with its materiality, orifices, and discharges. Leoba (or some other because the dream challenges the autonomy of the individual subject), speaks the body of her text through the text of her body.

Saint Leoba is only one of a number of women throughout the Middle Ages whose mystical visions gave them an unprecedented authority to speak and write, indeed to preach and instruct. This fact may come as a surprise to feminists more used to proclaiming women's historical si-

lences. Saint Leoba's biography suggests that the "fact" of women's exclusion from the discourses of power in any period may be more complicated than it originally appears. But although they share the condition of patriarchy, as well as the misogynist attitudes inherited from early Christianity, there is much that separates an eighth-century visionary like Leoba from her counterparts in the thirteenth and fourteenth centuries.

Religious women in the eighth century enjoyed more institutional power, better education, and were more likely to assume duties and privileges that after the twelfth century would be reserved solely for men. Women could preside over convents and even over double monasteries, as the Saxon abbess Hugeberc did. The range of their learning was remarkable for the so-called dark ages, including Latin, the classics, Scriptures, the church fathers, and canon law. Often they were instructed not by men but by other women. Leoba was sent to Wimborne to study under its erudite abbess, Mother Tetta. Perhaps because the early church afforded women — at least aristocratic women — a greater scope for their talents and abilities, these women were less likely to indulge in abuses of their bodies. On the contrary, they preached — and practiced — moderation in all things pertaining to the body. Leoba's biographer, Rudolph, for instance, stresses her moderation in eating, drinking, and sleeping, in everything, indeed, except her studies.[9]

The twelfth, thirteenth, and fourteenth centuries produced an even larger number of texts by and about women whose speech was imbued with an authority of divine origins. "This is the only place in the history of the West," the French theorist Luce Irigaray writes hyperbolically, "in which a woman speaks and acts so publicly."[10] While it is possible to argue that female mystics merely ventriloquized the voice of a patriarchal religion,[11] it is worth asking why and how these particular women were empowered to speak with an authority that rivaled, and at times seemed to surpass, that of the misogynist male clerics who ruled the institutional church.

Elizabeth Petroff gives a sense of the kind of social and political power women with the status of orthodox mystic enjoyed. "Visions led women to the acquisition of power in the world while affirming their knowledge of themselves as women. Visions were a socially sanctioned activity that freed a woman from conventional female roles by identifying her as a genuine religious figure. They brought her to the attention of others, giving her a public language she could use to teach and learn. Her visions gave

her the strength to grow internally and to change the world, to build con-
vents, found hospitals, preach, attack injustice and greed, even with the
church."[12] Even heterodox mystics like Marguerite Porete and more mar-
ginal religious figures like Margery Kempe enjoyed something of the same
privileged status and following.[13] As Petroff's analysis makes clear, the
basis of the power the female mystic enjoyed was both discursive and pub-
lic, not private and extralinguistic. The mystic's possession of a "public
language" gives her the ability to act not just within a "woman's culture,"
but in a "man's world" as well.

What Petroff's analysis fails to make clear, however, is how the
mystic's identification as a "genuine religious figure" freed her from "con-
ventional female roles" that mandated docility, passivity, subservience, and
reticence and how her public activities came to be "socially sanctioned"
by a church anxiously guarding its spiritual and temporal power. These
questions can only be answered by examining the relation of mystical dis-
course, institutional structures, and ideology by taking into account not
only the subversiveness of mystical discourse but also its cooptation by the
institutional church. It is, after all, not just a matter of discovering why
women were turning to mysticism and other kinds of religious experiences
—both sanctioned and condemned—but also why the church, in certain
cases, tolerated and even encouraged the female visionary, who occasion-
ally seemed to undermine its own claims to authority. The needs served
by mysticism must be understood in the context of a Foucauldian *dispositif*,
or "grid of intelligibility," a nexus of social, cultural, and historical prac-
tices, both discursive and nondiscursive, encompassing not only institu-
tional morality, theological statements, and philosophical propositions but
such things as architectural arrangements, the arts, regulations, laws, ad-
ministrative procedures, medicine, and customs as well.[14] In the case of
mysticism, such a *dispositif* might be constructed from three primary
sources: the political situation of the church after the twelfth century that
resulted in the institutionalization of religious women, the cultural repre-
sentations of the female body, and the disciplinary technologies that at-
tempted to realize these representations. Within the *dispositif*, these three
threads form an interconnected web; but to see each of the various strands,
it will be necessary to unravel them and treat each separately.

The political situation of the church in the thirteenth century bore
little resemblance to that of its eighth-century counterpart. Concerned with
consolidating its own authority by stressing the special power of the priest-

hood, the Catholic church, from the twelfth century on, had little use for women in official positions of either spiritual or temporal power. The church's jealous guarding of its prerogatives is evident in its numerous calls to pastoral care, its emphasis on the sacraments, particularly the Eucharist and confession where the priest most directly exercised his authority, and in conflicts between advocates of a monastic life of contemplation and those of an active life of pastoral care that often erupted into full-scale political conflicts over spiritual "turf." The growing distance between the clergy and the laity coincided with a resurgence of lay piety that left both men and women searching for outlets to express their own religious sentiments. The privileged status of the mystic reflected this tension between clerical centralization and lay expressions of piety. On the one hand, her claims of authority could easily be seen as subversive of clerical prerogatives. On the other, they could, when necessary, be coopted by the church to strengthen its own spiritual and temporal authority. Although women were officially banned from preaching or administering sacraments (like penance), many of the female visionaries had disciples and followers whom they instructed, counseled, and even reprimanded for their sins. The line between preaching and instructing, between hearing confessions and concern for the sinfulness and spiritual welfare of others is thinly drawn in the writings of many of the medieval mystics, as the following example suggests.

The Herald of Divine Love by the thirteenth-century mystic of the convent of Helfta, Gertrude the Great, is permeated by a sense of ministry articulated in specifically clerical terms.[15] Gertrude's disciples most frequently questioned her about the Eucharist, specifically whether they dared approach communion without penance. She counseled those whom she thought to be in a correct intention to approach the Lord's sacrifice confidently and even constrained them to do so.

> And another time when she prayed for someone . . . the Lord replied: "Whatever anyone hopes to be able to obtain from you, so much without a doubt she will receive from me. Moreover whatever you promise to someone in my name, I will certainly supply. . . .
> After several days, remembering this promise of the Lord without forgetting her own unworthiness, she asked how it was possible . . . the Lord replied: "Is not the faith of the universal church that promise once made to Peter: Whatever you bind on earth will be bound in heaven, and firmly she believes this to be carried out by all ecclesias-

tical ministers. Therefore why do you not equally believe because of
this that I can and will perfect that which, moved by love, I promise
you by my divine mouth?" And touching her tongue he said, "Behold,
I give my words into your mouth."[16]

Gertrude justifies her ministerial activities using the very same scriptural
text (Matthew 16:19) that the church used to establish its clerical author-
ity. Her exchange with the Lord has all the force of an ordination ritual;
the language is ritualistic, even liturgical: "Behold I give my words into
your mouth." Caroline Bynum minimalizes the subversiveness of Gertrude's
claims to clerical authority by arguing that such claims did not "under-
mine the structure and rituals of monasticism or the church but rather . . .
project[ed] women into one of those structures, the pastoral and mediating
role, which is otherwise denied to them."[17] But this analysis misses the
audacity of Gertrude's claim to speak for God. If anyone — even a woman —
could communicate directly with God, bypassing the prescribed forms of
clerical mediation, and even serve as a mediator for others, then the priest-
hood becomes meaningless as a special and privileged class. That the
church felt this transgression of the boundaries between clergy and laity
to be a real threat is attested to by its struggles in the thirteenth and four-
teenth centuries with lay spiritual movements like the Beguines and here-
sies like Catharism and the Free Spirit, all of which attempted to bypass
clerical mediation to claim a more direct relationship between the laity
and God. However orthodox and conservative her religious vision, Ger-
trude's daring claim to speak for God challenged the hierarchies of a
male-dominated clergy that jealously guarded its monopoly on religious
discourse.

 But if the mere existence of female mystics enjoying an unmediated
relationship with the divine successfully subverted clerical authority, it could
do so, paradoxically, only from within the institutional church and only
to further that institution's ends — the consolidation of its power. The church
strictly defined and controlled the nature and content of mystical experi-
ence. While it is easy for the twentieth-century reader to see the mystic's
visionary claims as a reflection of highly private and personal experiences
brought on by heightened affective and psychological states, for the Mid-
dle Ages, mysticism was a public discourse. It was neither private nor
passive, but communal, dialogic, and active. The mystical experience was
highly structured, and it was the church that provided both structure and
content because it controlled through various means the lives and learning

of women in religious communities. Increasingly after the twelfth century, the church attempted through strict cloistering to bring religious women more firmly under its control, to enforce women's silence, to institutionalize their powerlessness, and, most importantly from its own point of view, to isolate itself from women's supposedly corrupting influence.[18] Orthodox mystics with few exceptions were, after the twelfth century, cloistered, in keeping with the church's sense of women's spiritual role. To be sure, not all mystics were nuns. A mystic could express her religious ecstasies as a nun, abbess, wife, mother, tertiary, anchoress, Beguine, or itinerant. Often, when they were not cloistered, religious women tended to be tertiaries — like Catherine of Siena — or Beguines. But the model upon which all spiritual organizations for women were based was the cloister. And quite clearly its primary purpose was isolation. The rule Pope Honorius III handed down to Saint Clare, for instance, required that "no sister is to go out of the convent for any purpose whatever except to found a new community. Similarly, no one, religious or secular, is to be allowed to enter the monastery. Perpetual silence is imposed on all members of the community, and continuous fasting, often on bread and water."[19] Architecturally, the convent fostered maximum isolation from the society outside it, and access to these communities of cloistered women was strictly controlled. Life within the convent was structured by the liturgy and rituals of the church including "the seven canonical hours of daily prayers that followed the cycle of the liturgical year . . . [and] specific prayers for special saints' days and major feasts."[20] The spiritual disciplines that filled out this life included such practices as mantric prayer, flagellation, fasting, and vigils which, when carried to excesses, as they sometimes were, seemed designed to produce an emotional state conducive to mystical experience.

These technologies both resulted from and fed back into medieval cultural representations of the female. Woman had to be enclosed, restricted, and isolated because, in the eyes of the church, she was the quintessence of all fleshly evil, a scapegoat whose expulsion allowed the church to purge itself of the corruption of the body.[21] This loathing for the female flesh, expressed in countless official church documents, must be understood in light of its cultural meaning. To do so, we must abandon our usually biologistic understanding of the human body. Ordinarily we attribute to the body an *a priori* material existence without considering how our experience of our bodies is organized by cultural representations of them. Such representations are not universal but have historical specificity. Similarly,

the material body can itself be one of those discursive practices. It is itself a sign, imbued with meaning that can be glossed. We might argue, then, drawing upon Mikhail Bakhtin's distinction between the "classical body" and the "grotesque body," that two antithetical representations of the body structure discursive norms in any culture.[22] This opposition between the classical and grotesque bodies is meant to draw attention to those discursive practices that may have structured medieval women's understanding of their bodies. As I use it, the classical body denotes the *form* of official high culture. Medieval "high" culture was Latin, male, and extremely homogeneous, including such discourses as philosophy, theology, canon law, and liturgy. In the medieval church, the classical body was harmonious, proportionate, and monumental; it attempted to represent a sort of disembodied spirituality and, as such, it never existed except as cultural representation. The grosser, more material aspects of "the body" were displaced onto the "grotesque body." Woman (along with other marginal social groups, the lower classes, for example) is constructed by this dominant culture as the grotesque body, the other, whose discursive norms include heterogeneity, disproportion, a focus on gaps, orifices, and symbolic filth.

This sketch describes accurately the writings of many female mystics whose emotionalism and intense personal involvement, polyglot mixture of genres, and open-endedness contrasts markedly with the monumental rationalism and harmonious proportion of classical theological writing by men.[23] Indeed, the emotionalism so often attributed to female piety, its so-called affective nature, as compared to the rationalistic nature of male piety, may in fact be expressed through violence on the body — tears, inflicting of elaborate injuries, screams, and howls. In this passage from Angela of Foligno's *Liber de Vera Fidelium Experientia* (Book of the Experience of the Truly Faithful), Angela, who was herself a notorious "screamer" ("Even if someone stood over me with an axe ready to kill me, I could not have prevented myself [from screaming]"), measures her "fire of love" exclusively by the bodily injuries she wished to endure.[24]

> And so I disposed myself on account of his love that I wished that all my limbs might suffer a death unlike his passion, that is, a more vile death. And I was meditating and desiring that if I could find someone to kill me, in some way that it would be lawful to kill me, on account of his faith or his love, that I would beg him to do this favor

for me, that is, that since Christ was crucified on the wood of the cross
he should crucify me in a low place, or in some unsavory place or
with a loathsome weapon. And I could not think of death as vile as
I desired, and I grieved deeply that I could not find a vile death that
would in no way be like those of the saints, for I was totally unworthy.[25]

Piety, for Angela, as for virtually all the female mystics, is palpably physi-
cal, as palpable as Angela, like a nursing baby, drinking the blood of Christ
from the wound in his side. Their writings feature representations of gro-
tesque bodies that open up and spill forth their contents — blood, milk,
excrement — bodies that endure wounding and mutilation. The mystic's own
body becomes the site of contested discourses about the body — and about
culture.

Frequently, these conflicts emerge in rituals designed to chastize the
flesh. In this passage from Angela's *Liber*, for instance, we see an intense
loathing for the "lower-bodily stratum" and the grotesqueness of the physi-
cal body expressed through the desire to inflict humiliation on it. "I do
not blush to recite before the whole world all the sins that I ever com-
mitted. But I enjoyed imagining some way in which I could reveal those
deceptions and iniquities and sins. I wanted to go through the squares and
the towns naked, with fish and meat hanging about my neck, saying,
"Here is that disgusting woman, full of malice and deception, the sewer
of all vices and evils, . . . behold the devil in my soul and the malice of
my heart."[26] The metonymic association of the female body with the cor-
ruption of rotting meat and fish invokes the grotesque body paradoxically
to exorcize it. The female mystic's only means of escaping her body was
to indulge in an obsessive display and denouncing of its most "grotesque"
features. This suggests the extent to which, in her writing, the female mys-
tic has internalized the discursive norms of the dominant "high" culture.

We might compare this cultural construction of the grotesque fe-
male body with a very different, if related, representation of the classical
body. In hagiographies of women saints, written primarily by men, the
elaborate inflicting of bodily pain often leaves the saint's body miraculously
untouched. The classical body of hagiography is closed, miraculously im-
pervious to wounding,[27] invulnerable to penetration in this passage from
Thomas de Cantimpré's *Vita* of Christina Mirabilis.

Then Christina began to do those things for which she had been sent
back by the Lord. She crept into fiery ovens where bread was baking

and was tormented by fires just like any of us mortals so that her howls were terrible to hear. Nevertheless when she emerged, no mutilation of any sort appeared in her body. When no oven was at hand, she threw herself into roaring fires which she found in men's houses or else she thrust her feet and hands into fires and held them there for so long that they would have been reduced to ashes had it not been a divine miracle. At other times she jumped into cauldrons of boiling water and stood there immersed either up to the breast or the waist, depending on the size of the cauldron, and poured scalding water over those parts of her body which were untouched by the water. Although she howled as if she were suffering the pangs of childbirth, when she climbed out again she was quite unharmed.[28]

Several details in this passage suggest the need to discipline the flesh so prominent in Angela's writing. Although it is more subtle, there is the same emphasis on what is specifically female about the saint's body. The reference to the "pangs of childbirth" calls attention to the sexual function which Christina, as a virgin, has specifically renounced, as well as to the "opening up" of the body that both sexual activity and childbirth entail. (It is probably worth mentioning that while Christina remained a virgin, Angela of Foligno was both a wife and mother.) The immersion of her breasts and genitalia (up to the breast or waist) — the signs of her sexuality — into boiling water reminds the reader that Christina's body is a female one, subject to all weaknesses of femininity. But Christina's chastisements differ in one significant respect from Angela's. If the torturing of the classical body produces pain, it does not wound; there is "no mutilation of any sort." Indeed, the saint's voluntary endurance of pain in imitation of Christ's bodily suffering invokes the Eucharistic miracle. The ovens into which Christina casts herself are ovens for baking bread, suggesting, without explicitly stating it, a Eucharistic connection, but the symbolism is reversed. In the Eucharist, the bread is transformed into the body of Christ. The central act of Christianity is Christ's assumption of a body that can be — and is — wounded, opened up by torture. Christina is transformed in the oven from body to "bread," she escapes her body into the monumentality of a cultural symbol. She cannot be wounded.

The mystic internalized the disciplinary technologies evolved by the church to subject and contain the female body, not just discursively, but physically as well. As one might guess, these technologies, misogynistic in their intent, were designed to suppress and control a female body the

church deemed disruptive. In the case of the most famous mystics, these disciplines often became spectacular examples of self-torture in which the mystic indulged in extravagant abuses of their bodies. Rudolph Bell described Angela of Foligno's struggle to control her flesh.

> Demons filled her head with visions of her soul being strung upside down so that all her virtues turned to vices; in anger, pain, tears, desperation, she pinched herself so hard that her head and body were covered with bruises, and still the torture continued. Human vices, even ones she never had known before, tormented every member of her body. Even when these desires may have shifted away from her "intimate parts" to places where she felt the pain less, so on fire was she that until Friar Arnaldo prohibited it, she used natural fire to extinguish the internal burning. As her spiritual understanding deepened, her wish changed from instant death to a drawn out physically painful and tormenting ending, one in which she would experience all the sufferings of the world in her every limb and organ. Her love had sacrificed and so would she. Earlier she had undertaken a detailed examination of each part of her body, judging them member by member and assigning to each its due penance.[29]

One can only assume that those penances would have been much like those practiced by Catherine of Siena, another Italian visionary, who wore rough wool clothing, an iron chain bound around her hips so tightly that it inflamed her skin, and flagellated herself three times a day with an iron chain for one and one-half hours. Angela of Foligno's obsession with the grotesqueness of the body is strikingly illustrated by another anecdote, also related by Bell. "She and her companion one Holy Thursday had gone to the local hospital of San Feliciano to wash the feet of sick women and the hands of men who were there. One leper they tended had flesh so putrefied and rotten that pieces peeled off into the wash basin they were using. Angela then proceeded to drink this mixture, giving her almost the sensation of receiving communion, and when a bit of flesh got stuck in her throat she tried to swallow it too until against her will she choked it out."[30] In this anecdote, the juxtaposition of the putrefied rotten flesh and the Eucharist calls up again the opposition between the grotesque and the classical bodies.[31] Indeed, it vividly and powerfully merges these two cultural representations of the body.

What, one might be tempted to ask, does the female mystic gain from

such spectacles of self-abuse? My initial answer might be, like Petroff's, quite simply, power. But I would like to explore more specifically the nature of the power claimed by the female mystic, beginning, as I began this essay, with a reminder of just how audacious some female mystics' claims to power proved to be. If Marguerite Porete was burned at the stake for self-deification, several orthodox mystics made strikingly similar statements: "My Me is God," wrote Catherine of Genoa; Hadewijch of Brabant wished "To be God with God"; Angela of Foligno wrote that "The Word was made flesh to make me God." Surely these are not the statements of women who have accepted the traditional religious roles allotted to women. These women claim a virtually divine authority that they frequently exercised. Nevertheless, I am not suggesting that these women "intended" in any conscious way to seek their temporal or spiritual power. Rather my analysis depends upon what Paul Ricoeur has called a "hermeneutics of suspicion." The fact that none of the mystics *says* her intention is empowerment cannot be accepted at face value; it must be interrogated. I am assuming that these women were capable of entertaining as part of their cultural ideology motives of which they were not fully conscious. The whole point of embedding the discourse of medieval mysticism within a network of other discourses, within the Foucauldian *disposatif*, is precisely to interrogate "intention" from the perspective of cultural ideology.

Mystics took disciplines designed to regulate and subject the body and turned them into what Michael Foucault has called "technologies of the self," methods of consolidating spiritual power and authority, perhaps the only ones available to women.[32] Foucault argues that individuals often effect by their own means a certain number of operations on their bodies, souls, thoughts, and conduct—all to transform themselves and to attain a certain state of perfection, happiness, purity, and supernatural power.[33] Although he is describing the medieval Catholic discipline of confession, he might just as well be describing the lives of many medieval mystics. Michel DeCerteau takes Foucault's argument about technologies of the self even further and argues that these mechanisms, which he calls "poaching," enable those subjected to disciplinary technologies to manipulate and evade them, or even shape them to their own ends, by seeming to conform to them.[34]

To understand how self-torture could become a technology of the self, a means of empowerment, we must understand the place of torture in medieval society. In the Middle Ages, torture was not regarded simply

as a form of punishment. It was, as Foucault has shown, a technique and a ritual, a semiotic system which "must mark the victim."[35] Torture inscribed on the victim's body the "signs" of the ruler's power. It was one of the most visible displays of that power, an art, "an entire poetic" that competed with other visual displays of theocratic rule.[36] The marking of the victim's body signifies the power that punishes. "In the 'excesses' of torture, a whole economy of power is invested."[37] In her excesses, the mystic becomes at once both torturer and victim. This, it seems to me, is the whole point. The mystic's pain — her inflicting of wounds upon herself — grants her the authority to speak and be heard, to have followers, to act as a spiritual advisor, to heal the sick, and to found convents and hospitals. Her body bears the marks, the "signs," of her own spiritual power. The mystic's progress, then, is discursively organized by the disciplines authorized by religious tradition and performed on her body. She changes, however, the meaning of the physical forces that oppress her. She assumes for herself the power to define what they mean. It is important to recognize that the church at no time advised or condoned such severe fasting and self-flagellation. It advised moderation in all penance. In fact, the mystics themselves did not urge such extremes on others. The mystics were never seen as models to be imitated. They were always special instances of God's grace because they chose their own suffering and thus were free to define what it meant. That is why Angela of Foligno could desire such a violent and painful death, why Julian of Norwich could beg God for a terrible illness, and why Catherine of Siena starved herself to death. Technologies which, in the hands of a powerful church, were meant to limit severely the autonomy and authority of women became for the mystics a source of self-determination, virtually the only one available to women during this period.

It is this power to construct cultural meanings that creates the mystical text's dialogism — the interanimation of its words, its signs, with other ambiguous words and signs. The mystic does not merely call upon what she has read or seen to give words to an essentially wordless experience; I am not invoking here merely a one-way form of intertextuality. Rather these "spiritual exercises," and the meanings she gives them, are constitutive of her visions, as the following example from the Long Text of Julian of Norwich's *Showings* demonstrates. The fourteenth-century English mystic meditates on Christ's suffering during the Crowning with Thorns.

And during the time that our Lord showed me this spiritual vision which I have now described, I saw the bodily vision of the copious bleeding of the head persist. The great drops of blood fell from beneath the crown like pellets, looking as if they came from the veins, and as they issued they were a brownish red, for the blood was very thick, and as they spread they turned bright red. And as they reached the brows they vanished; and even so the bleeding continued until I had seen and understood many things. Nevertheless, the beauty and the vivacity persisted, beautiful and vivid without diminution.

The copiousness resembled the drops of water which fall from the eaves of a house after a great shower of rain, falling so thick that no human ingenuity can count them. And in their roundness as they spread over the forehead they were like a herring's scale.[38]

At first glance, this passage seems idiosyncratic, its metaphors positively bizarre. What perhaps most repels the twentieth-century reader is the disjunction between Christ's pain and suffering at the hands of his torturers, the ostensible subject of the vision, and the artifice with which it is conveyed. The images of the pellets, the rain drops falling from the eaves of a house, and particularly the herring's scales work against the impression of suffering; they detach the reader from any realistic sense of pain. Instead, they point to the symbolic nature of Christ's suffering. In Julian's vision, although the torturers attempt to leave their mark of temporal power on Christ's body, she shows that the "signs" contain messages other than those intended by the torturers, symbols of divine power that transcend mere physical pain, that shade over into the decorative, into art.

Indeed, the scene reminds me of nothing so much as a painting. Although Julian calls it a "bodily vision," suggesting a vision appearing to her eyes, reading the passage one is put in mind of an intense meditation upon a visual image—a picture in a book of hours, a station of the cross, or some other church painting Julian might have seen. As she meditates even closer on particular details, they lose their relationship to the whole composition and begin to remind her of other inanimate objects. As she traces the brush strokes, following the change in color from brownish red to bright red, finally vanishing from the canvas, other images—pellets, raindrops, herring's scales—suggest themselves to her, transforming the suffering into something artistic. Hence the contradictory description of the vision as "beautiful and vivid," "hideous and fearful," "sweet and lovely." The mystical vision, seen from this perspective, takes on the character less

of a chance event, whether the sign of psychosis or spiritual grace, than of a calculated event, carefully prepared for and highly structured by the religious experiences available to medieval women, including those designed to chastise the flesh and imitate Christ's suffering.

The female mystic of the Middle Ages did not claim to speak in her own voice. Because women could serve no ministerial or sacerdotal functions within the church, they could claim no spiritual authority in and of themselves, nor could they claim it — as the clergy did — from the institutional church. Rather, the source of the mystic's inspiration was divine; she was merely the receptacle, the instrument of a divine will. Hildegard of Bingen, for example, describes her authorship in precisely those terms: "She . . . utters God's miracles not herself but is being touched by them, even as a string touched by a lutanist emits a sound not of itself but by his touch."[39] But women like Hildegard of Bingen, Angela of Foligno, and Julian of Norwich were not nearly as disingenuous as they had to appear in order to win the church's toleration and acceptance. Any visionary experience made public is always, *ipso facto*, a revisioning of that experience, an attempt to represent the unrepresentable. These women claimed the power to shape the meaning and form of their experiences. Their words, and even their bodies when necessary, became the sites of a struggle to redefine the meaning of female silence and powerlessness.

4

"SHE WEPT AND CRIED RIGHT LOUD FOR SORROW AND FOR PAIN"

Suffering, the Spiritual Journey, and Women's Experience in Late Medieval Mysticism

ELLEN ROSS

FROM THE TIME of Christ's own life, and most visibly in Christ's crucifixion, suffering has been a major theme within the Christian tradition. But attitudes toward suffering and the functions of suffering in the Christian life have changed over time. In the early church, for example, martyrs, who were among Christianity's most respected religious figures, often suffered extreme pain in their loyalty to the Christian faith. Records of martyrs' deaths, however, do not generally focus on their suffering; rather, texts highlight the martyrs' obliviousness to pain and complete absorption in reflecting on the world to come.[1] Martyrs are frequently referred to as "regaining the bloom of youth," or expressing joy and tranquillity in what must have been situations of agonizing pain. Narratives about martyrs evoke a sense of the awesomeness of the martyrs' determination by suggesting the power of this determination to render suffering impotent.

The vivid portrayal of suffering in *The Book of Margery Kempe*, the autobiography of a fifteenth-century English laywoman, suggests a stark contrast. "When they came to Mount Calvary, she could not stand or kneel but fell down and turned and twisted her body, spreading her arms out, and cried with a loud voice as though her heart would break; for, in the city of her soul, she saw vividly how our Lord was crucified . . . she felt such deep compassion and such pain to see our Lord's pain that she could not keep herself from crying and roaring [even] though she might have died from it."[2]

45

During her own lifetime, Margery Kempe was well known for her boisterous crying triggered by anything that reminded her of Christ. She wept at the sight of crucifixes, images of Christ, animals being beaten by their owners, and even at the sight of small boys with their mothers. Her loud and public sobbing on the street or in the midst of sermons not only led many of her contemporaries to dismiss her as crazy but has led many present-day scholars to view her spirituality with skepticism.[3] Be that as it may, I will suggest here that although more dramatic than some of her contemporaries (but not all),[4] Margery Kempe's identification with the suffering Jesus represents a phenomenon common to fourteenth- and fifteenth-century spirituality.

Reflection on forms of twelfth-century religious devotion reveals an emerging shift from an emphasis on the glorified Christ to an increasing focus on the humanity of Jesus; by the fourteenth century reflections on the suffering Jesus moved to the fore. From the twelfth century to the fourteenth century, growing numbers of theological texts pondered the nature and effects of Christ's crucifixion; in painting and sculpture, depictions of the suffering Christ in agony replaced the majestic Christ of resurrection and judgment, and liturgical dramas reenacted the circumstances of Jesus' suffering and death.[5] Fourteenth-century church walls were brightly painted, often with the popular topic of the events leading up to Christ's crucifixion so that the churchgoers were surrounded by vivid depictions of Christ's life, death, and resurrection.[6] In Norwich Cathedral, in the city of the residence of Julian of Norwich, one of the mystics I consider here, was housed one of the most spectacular fourteenth-century artistic renderings of Christ's Passion. Also, around the turn of the fourteenth century a new form of religious portrayal, the pietà, emerged; fascination with the relics of Jesus' suffering increased, and artistic representations of the instruments of Christ's crucifixion multiplied — all indicative of increasing attention to the humanity of Christ, and even more specifically to his Passion and death.[7]

One of the most popular fourteenth-century artistic and literary representations of the incarnate God was the portrayal of the infant Jesus and Mary; the child and mother depiction emphasizes Jesus' humanity at the beginning of his earthly mission. Yet although for the mystics considered here the incarnation embodies God's love for humankind, it is more specifically the image of the suffering Jesus in the concrete, physical events from arrest to crucifixion that functions as the primary scriptural symbol

for conveying the depth of God's love for humanity. Jesus Christ's endurance of agony and death revealed a God of immeasurable love who was willing to go to unimaginable lengths to heal the breach between humanity and God. The Passion of the adult Christ offers a vivid narrative startling portrayal of God's love for humanity.

As a stage passed through, infancy was a useful analogy for charting the initial steps of the human person's relationship to God (so Paul in 1 Cor. 3:2, e.g.). But the visual recollection of the suffering Jesus offered to many religious people something closer to home — an adult like themselves, someone suffering, an experience common to all of them (although perhaps differing in form), someone whose suffering was with them and for them, and who endured pain in order to restore the visage of a loving God to them. The willingness to suffer on another's behalf provided a ready example of love, and the actuality of that suffering in Christ signaled the reality of God's love for humanity.

Still, this explanation does not answer the question that troubles the modern skeptic suspicious of the practice of so-called spiritual suffering: why did the mystics like the ones discussed here seek to imitate the suffering of Jesus? The answer lies in one of the underlying tenets of fourteenth- and fifteenth-century spirituality; namely, that one understands through experience. Comprehension at an intellectual level is superseded by a deeper level of understanding through experience or feeling. Further, there was the conviction that one of the best ways to learn to experience is by way of imitation. Much as an athlete now might watch videotapes of sporting stars to learn to imitate their techniques and manners, so many medieval religious figures set out to imitate the Christ who redeemed them from sin and made God present to them.

The life of imitation took many forms. In the fourteenth century, most Christians did not have a desire literally to imitate Jesus' suffering and death to the extent that individuals would hope to die on a cross (Margery Kempe did, though, express a desire to be martyred); there was, however, the strong and living desire to share in the sufferings of Christ. By participating in the events surrounding Jesus' suffering and learning to feel and experience as Christ had felt and experienced, one explicitly linked oneself with the salvific work of Christ. For a worldview that connected the suffering Jesus with the way and work of Christ in the world, modeling oneself after Christ provided believers a way to change their own spiritual demeanor. The imitators of Christ could learn to act in the world

as Christ did; and perhaps most importantly for the figures considered here, by imitating Christ, believers could understand something of who Christ was as both human and divine.

I take this to be at the heart of the pervasive references to Christ's Passion in the late Middle Ages: identification through suffering with Christ's humanity leads to an understanding of Christ's divinity.[8] But the question remains of precisely how an understanding of the suffering Jesus leads to a more complete relationship to God. This article is a theological exploration of how the image of the suffering Christ and Christians' identification with the suffering Christ functioned in some forms of medieval spirituality.

To this end, I consider two women mystics of late fourteenth- and early fifteenth-century England, Julian of Norwich and Margery Kempe. Julian (b. ca. 1342), about whom very little is known, lived for at least some time as an anchoress, a solitary in a small cell adjoining a parish church in Norwich. In addition to cultivating her own spiritual life through private devotions and participating in liturgical services visible through a window in her cell, and praying for humanity generally, Julian also offered spiritual advice to people, among them Margery Kempe, who journeyed to see her. Her *Showings*, the book discussed here, grew out of an experience she had at age thirty, a series of sixteen revelations she first described in a short text.[9] About twenty years later, she wrote down her subsequent reflections on the meaning of the revelations in order to guide other Christians in their spiritual pursuits. Her literary style and the theological sophistication of her writing suggest that she had extensive knowledge of scripture and classic theological and spiritual texts. Some scholars hypothesize that her education and access to texts were gained in a monastic context before she took up the anchoritic life. She is speculated to have died soon after 1416, the date of the last recorded bequest to her in a local will.

In contrast to Julian who lived out the monastic commitment to stability in the anchoritic form popular in fourteenth-century England, Margery Kempe's life-style reflects another growing trend in late medieval spirituality, that is, the emergence of religious leaders from among laypeople with no ties to religious orders. Although we know nothing about her mother, Margery Kempe (b. 1373) seems to have come from a respected family in Lynn in Norfolk in that her father, John Brunham, held a variety of public offices including those of mayor and justice of the peace. At the age of twenty, she married John Kempe, also of Lynn, and records that

after the birth of a child she suffered a great physical and emotional ill-
ness, made worse by the fact that she had not confessed all her sins. With
Christ's intercession she recovered from the affliction and increasingly de-
voted her life to God, eventually (after the birth of fourteen children) con-
vincing her husband to take a vow of chastity with her. In her lively book,
she narrates the journey of her spiritual growth, and describes the adven-
tures and adversities of her pilgrimages throughout England, to Jerusalem,
Rome, Norway, Venice, and Germany, among other places. Her loud cry-
ing and weeping of devotion and her frank tale-telling method of teaching
gained her many loyal friends, but also many enemies (her companions
stole her sheets on one occasion and set off from a foreign town without
her on another). She was accused of heresy numerous times, but she suc-
cessfully defended her orthodoxy and the charges were never substanti-
ated. Unlike Julian of Norwich, Margery Kempe could not read, but as
was common in the fourteenth century, she had a developed capacity for
memorization, regularly had priests read to her, and enthusiastically at-
tended sermons of local and renowned visiting preachers; and so, not sur-
prisingly, her book exhibits a remarkable familiarity with scripture and
church tradition.[10] She apparently began dictating her *Book* to the first
of her two scribes in the early 1430s, and finished it sometime before her
death in about 1438.[11]

In considering these two mystics who are, I suggest, united by a spiri-
tual focus on the suffering of Jesus Christ common to many Christians
in the late fourteenth and early fifteenth centuries, I investigate what iden-
tification with the "suffering Jesus" teaches, and explore why experiences
of the Lord's Passion, whether through sorrow or physical duress, play
such an important role in the spiritual life.[12]

The writings of both Margery Kempe and Julian of Norwich depict
a Christian life journey directed toward an experiential love and knowl-
edge of God. For both authors, the wealth of imagery, metaphors, and
stories used to describe God are united in the central theological affirma-
tion that God is love. Margery and Julian are typical of most medieval
mystics, in that they guide their readers toward a deepening relationship
of love and knowledge with the God of love. They do not seek momen-
tary ecstatic experiences of God, nor do they write disinterested ontotheo-
logical analyses of the divine life, but rather they envision a holistic lifelong
path on which a growing relationship with the Divine is coupled with a
deepening love of self and neighbor.

Suffering functions within this larger context as a part of the process

by which the human person learns to perceive God as love. The experience of pain functions as a way to God, as a means to religious understanding. My claim is that, underlying the manifestations of spiritual and physical duress in medieval authors, there is a recognition that the believer's Jesus-identified emotional and physical suffering is not an end in itself. This tradition consistently critiques situations where pursuit of pain is viewed as an autonomous goal to be pursued; rather, an experiential understanding of the suffering of the earthly Jesus is always directed toward—and complemented by—an understanding of the divinity of Christ. This eventual recognition of Christ as the God-Human who re-presents the God of love to humanity enables the believer's physical identification with Christ's Passion to be a fundamental part of the human person's spiritual journey to the God who is love, even though this identification is never an end to be pursued for its own sake.

For both Julian of Norwich and Margery Kempe, Jesus Christ is the most important guide in furthering the relationship between God and humans. As human, Jesus is accessible, someone with whom individuals can identify; as divine, Christ presents God to humanity. Exclusive focus on either the humanity or the divinity of Jesus Christ misses the integrated relationship of the loving God to humankind. Different from an ethical mystic like their contemporary Walter Hilton (d. 1396), these authors center their spirituality not so much on the general life and service of Christ in the world but more specifically on the suffering of Jesus in his Passion and death on the cross.

Sin ruptures humans' ability to perceive the loving God, alienating humans from their proper end. Julian emphasizes, though, that even when people do not experience the Divine's nearness, God remains always with them. In the Incarnation, God presents the greatest possible sign of love to the world. In his Passion and death, Christ overcomes the fiend, the sign of evil's power over humans, cleanses sin by the shedding of His blood, and frees the human to experience the loving God once again. Thus Christ's Passion is the critical restorative act in the God-human relationship.

Julian of Norwich's *Showings*, the collection of Julian's sixteen revelations of 1373 and her subsequent theological reflections on them, records the stages of Jesus' suffering and death on the cross, from the crowning of thorns, the discoloration of Jesus' face, the scourging of the Lord's body, to the shedding of his blood. Significantly, each stage reveals something of the nature of God and God's relationship to humans. The process of

reflection begins with consideration of what Christ suffered and for whom He suffered; then leads to reflection on why Christ suffered; and finally and most importantly, leads one, in Julian's words, to "come to see that He who suffered is God."[13] The images of Jesus' agony and death which appeared to Julian and which she records in the *Showings*, graphically convey images of Christ's suffering. Meditation on the details of the suffering heightens awareness of what Christ endured for humanity, and along with this, prompts the observer to reflect on why Christ chose to undergo such pain and death. As the answer that Christ suffered out of love for humanity emerges, the believer reflects on the nature of the love which undergirded the events of Christ's death, and is led to recognize, in the magnitude of love, Christ's divinity. Recognition of the love that motivated Christ's work reveals Christ's divinity; once believers perceive the motivating love, they are reminded that, at Christ's Resurrection, suffering is transformed to joy and bliss. And in the world to come humans will be heirs to the joy effected through Christ's suffering.

It might be noted at the outset that much as Augustine's *Confessions* records his spiritual autobiography and does not dwell on his day-to-day activities or his family relationships except insofar as they contribute to his spirituality,[14] so Julian of Norwich and Margery Kempe treat suffering always within the parameters of their relationship to God. They do not linger over cataloging the varieties of sufferings that plague humans because they are not interested in the pain that accompanies discipleship for its own sake. Margery Kempe was a mother of fourteen, yet she rarely mentions her children, except to talk about the late conversion of one of her sons. She speaks often of herself as a mother, but almost always as a spiritual mother to religious figures. The physical suffering that may come readily to a contemporary person's mind was often far from what the most important suffering was about. In fact, when Margery Kempe tells of being struck by a falling beam in a church, the story is told not because of the suffering, but because she did not suffer.[15] The suffering that most concerns these figures is the physical and emotional (including mind and affections) anguish that emerges in their relationship to God. And it is this identification that produced these women's exhortations to have compassion for the suffering of the world around them.

In the work of Margery Kempe and Julian of Norwich, three distinct types of suffering emerge in the relationship of the human person to God: suffering born of contrition, of compassion, and of longing. Suffering in

each of these progressive stages correlates with the process of coming to understand that the Christ who suffered is God by contributing to a comprehensive perception of the God who is love.[16]

In Margery Kempe's text, the constellation of suffering of contrition, compassion, and longing can be further correlated with her understanding of the social roles that describe her relationship to God. In one of her dalliances with God, God says to her: "Thou art a very daughter to me, and a mother also, a sister, a wife and a spouse."[17] As a daughter she experiences contrition; as a mother and sister she experiences compassion; and as a spouse she experiences the suffering of longing to be with her beloved. Margery's *Book*, in a way that is consistent with Julian's *Showings*, describes her deepening experience of God in which progression from one type of suffering to another plays an integral part in the changing relationship to the Divine. I will explore each of the three types of pain briefly here and suggest the nature of the interrelationship among them.

CONTRITION

The focus on contrition and confession had a long and varied history in the medieval tradition, with papal involvement dating particularly from the seminal pronouncement *Omnis utriusque sexus* of the Fourth Lateran Council of 1215, requiring all persons to attend confession at least once a year.[18] Large numbers of manuals were written to guide priests in leading people through confession, which functioned in many cases as a catechetical as well as a penitential event; and repentance and the call to penance were among the most popular sermon topics of the day.[19] The importance of compulsory confession raised the question of who had the responsibility for the care of souls and led to heated disputes between the Mendicants and secular priests over the right to hear confessions. Confession's central place in the religious culture is reflected also in the fact that many of the fourteenth century's leading religious figures struggled with what they called "scruples," that is, the ever-present danger of a failure to balance acute awareness of sin with acceptance of forgiveness.[20] Contrition and confession were frequently accompanied by visible displays of emotion: a contemporary of Julian of Norwich, Peter of Luxembourg, sometimes wept so profusely at confession that "he would leave a puddle where he knelt, as if someone had poured water in front of him."[21] Bridget

of Sweden and Dorothy of Montau, two critical influences on Margery Kempe, both sobbed and grieved loudly at their sinfulness in the face of God's mercy.[22] Although the use of indulgences and excessive legalistic cataloging of sins led at times to abuses, the most theologically aware literature and the highly regarded spiritual leaders of the time (like Julian, Bridget, and Dorothy) did not advocate penance for its own sake; rather, penance and the contrition associated with it was consistently promoted as a way to draw humans' attention to God, and toward reflection on the God-human relationship.

Although at times Margery Kempe, louder and more demonstrative than Julian in her contrition, struggles painfully with scruples (a spiritual problem that does not seem to have afflicted Julian of Norwich) and is constantly reassured by God that her sins are forgiven, both Margery Kempe and Julian of Norwich are agreed in affirming the critical place of contrition and its associated suffering in the God-human relationship.

Initial reflection on humanity's relationship to the Divine reveals only the vast gulf of human sinfulness separating humanity from God. Confrontation with this sinfulness exposes believers to their weaknesses; but meditation on sinfulness alone can lead to despair, the greatest of all medieval sins, unless contrition opens one's eyes to the merciful God who forgets sin from the time that one repents.[23] When one clearly sees the futility of sole reliance upon the self, then one can recognize that God is the foundation of all being and can seek the help offered by the God who reminds humans when they are going astray, yet mercifully protects them in spite of it.[24] Repentance in the face of a merciful God initiates the healing of the breach between God and humankind. The healing process is painful and beset not only with the sorrow and shame of having offended the Divine but also with further suffering which may occur as the contrite person willingly accepts penance in the form of physical illness, sorrow, or the world's contempt—all of which are part of the cleansing process. While acknowledging its importance in initially drawing attention away from the world and toward God, Julian does not dwell long on the matter of contrition, advising her readers against unreasonable depression or despair. She suggests that one meditate rather on the manifestation of the merciful God, advising that one proceed from being made clean by contrition to being made "ready" by compassion to come to God.[25]

Margery, writing within a generation of Julian's *Showings* and repre-

sentative of the common tendency to highlight contrition in late fourteenth-
and early fifteenth-century spirituality, deals at length with this early stage.
Suffering functions both as a signal and as a response to the presence of
sin. She associates her experience of intense suffering with the presence
of unrepented sin within her;[26] and like Julian, she also depicts suffering
of contrition as remorse brought about by the repentant recognition of
her sinfulness. Margery describes the early stages of her conversion as a
time when she struggled with temptations, falling back into greed as she
pursued careers as a brewer of ale and running a grain mill; but as the
years passed, she more successfully centered her life around God: "And
this creature had contrition and great compunction with plenteous tears
and many boisterous sobbings for her sins and for her unkindness against
her Maker."[27] Throughout her spiritual autobiography, Margery Kempe
weeps for her sins, suffering great anguish at how she could have offended
the loving God.

 She associates her suffering of contrition with her growth in her rela-
tionship as daughter to God: "When thou studyest to please Me, thou are
a very daughter."[28] Margery maintains that at the initial stage of reforma-
tion the obedience of a child to a parent is the most efficacious remedy
for the distortions of the human's sinful relationship to God.

 For both Julian of Norwich and Margery Kempe, contrition signals
the reorientation of the human person toward God. At this first stage suffer-
ing arises from sin, while repentance reveals the God of mercy. Suffering
emerges in the environment of contrition as a person experiences the dis-
junction between glimpses of what the healed relationship with God could
be like and the present perception of sin hindering that relationship.

 COMPASSION

Once a person has set her or his priorities on God, the next stage of mak-
ing oneself ready for life with God can begin. Through compassion and
its related suffering one experiences the depth of one's love for Christ,
Christ's unity with humanity, something of what it means to say that Christ
is divine, and a sense of Christ-identified unity with other humans.

 Julian advises her readers not simply to recall the suffering of Christ
but actively to remember what Christ suffered: "Christ showed me part
of His Passion, close to His death. I saw His sweet face as it were dry and

bloodless with the pallor of dying, and then deadly pale, languishing, and then the pallor turning blue and then the blue turning brown, as death took more hold upon his flesh . . . the sweet body as so discolored, so dry . . . so deathly and so pitiful that He might have been dead for a week, though He went on dying."[29] She remembers Christ's Passion as if she were there, identifying her love of Christ with that of Mary, Mother of Jesus, the disciples, and all "true lovers of Jesus."[30] In imaginatively reenacting the Passion of Christ, the believer suffers with Christ just as the contemporary friends of Jesus had.[31]

The practice of active remembering characterizes medieval spirituality. The purpose of this recollection was to arouse the meditator's affections, to bring the message of Scripture into the present.[32] Julian relives Christ's crucifixion, saying at one point, "I felt no pain except Christ's pains . . . It seemed to me my pains exceeded mortal death."[33] She experiences the pain of physical identification with the suffering Christ but also experiences the agony of watching a loved one suffer: "Here I felt unshakeably that I loved Christ so much more than myself that there was no pain which could be suffered like the sorrow which I felt to see Him in pain."[34] The intensity of her pain in watching Christ suffer reveals to her the depth of her love for Christ.

As well as revealing the believer's love for Christ, suffering also forms a bond between Christ and the world. The unity extends not only to those who immediately observed the Passion of Christ but to the whole cosmos: when Christ was in pain, not only did humans suffer, but "the firmament and the earth failed in their natural functions because of sorrow at Christ's death . . . [even] those who did not recognize him suffered because the comfort of all creation failed them."[35] As Christ suffered for human beings, linking himself with humanity, so individuals link themselves with the benefits of that suffering by suffering with Christ. The pain is salvific: "But of all the pains that lead to salvation, this is the greatest, to see the lover suffer."[36] The more believers identify with Christ's pains, the greater will be their reward in heaven.

For Julian, the most important point to grasp about Christ's Passion is that the "one who suffered is God," a perception conveyed by the nature and intensity of this suffering. Christ suffered in response to the physical agony inflicted upon Him as He redeemed the sins of humanity. The perception of the immensity of Christ's suffering to deliver humankind from sin that undergirds Julian's reflections on the crucifixion is apparent in a

fifteenth-century devotion in which Christ speaks to an unrepentant sin-
ner, a devotion Julian herself could well have written:

> I formed you and set you in Paradise. You despised my command-
> ments and have deserved the damnation of death. I, having mercy
> on you, took flesh, that is, became human. See the wounds that I bore
> for you. See the holes of the nails with which I was hung on the
> cross . . . I was buffeted and spat upon to deliver to you the sweetness
> of Paradise . . . I suffered pain to give glory to you. I suffered death,
> that you might have the inheritance of life. I lay hidden in the sepul-
> chre, that you might reign in heaven. What greater things than these
> should I do? Where is the fruit of my great wounds? . . . Where is
> the price of my blood, that is, where is your soul? Where is the service
> you have done to me for the price of my blood? I held you above my
> own glory, appearing as human when I was God.[37]

Christ suffered on account of human sin and expects believers to respond
to that suffering. But Christ suffered also, and no less significantly for Ju-
lian, in compassion for human sorrow and anguish at His suffering. He
"saw and sorrowed for every man's sorrow, desolation and anguish, in His
compassion and love. For as much as our Lady sorrowed for His pains,
so much did He suffer sorrow for her sorrows."[38] Christ's suffering in com-
munity with believers as they suffer in witnessing Christ's pain manifests
God's compassion for humanity. The God revealed in the Passion of Christ
is a God of mercy but also a God of compassion, reminding believers that
they never suffer alone.[39] Meditation on the nature of the love expressed
in Christ's suffering leads Julian to recognize that "although the . . . hu-
manity of Christ could suffer only once, his goodness can never cease offer-
ing it."[40] Christ's willingness to suffer reveals that Christ is, as Julian says,
"the endless love which was without beginning and is and always shall be."[41]

Meditation on the compassion of Christ, and the experience of com-
passion for Christ, leads the believer to live with compassion in the world.
Compassion toward others is "Christ in us."[42] Although this theme of com-
munal love is present in Julian, she does not dwell on the painful nature
of this compassionate identification with our neighbors to the extent that,
as we shall see below, Margery Kempe does.

Margery Kempe's suffering of compassion also functions to deepen
her understanding of Christ by leading her to reflect on Christ's motiva-
tion in suffering for humans; this results eventually in a recognition of

Christ's love for humanity and in a perception of Christ's divinity as well
as humanity. Kempe presents her growth in understanding of Christ's hu-
manity as a precursor to her eventual understanding of the Godhead: "after-
ward . . . when she [Margery] . . . [had] suffered much despite and reproof
for her weeping and her crying, Our Lord . . . drew her affection into His
Godhead, and that was more fervent in love and desire, and more subtle
in understanding than was the Manhood."[43] After perceiving the Godhead,
Margery, often filled with demonstrative sorrow over Jesus' life and death,
notes that the violence of her weeping was mitigated: "it was more subtle
and more soft."[44]

 As for Julian, but even more dramatically for Margery Kempe, com-
passion extends beyond compassion for Christ's suffering to compassion
for the sin and pain of other Christians.[45] This is paralleled by Christ's
compassion for the suffering witness of those who love him. Margery's
emotional and physical suffering of identification with Mary, of compas-
sion for Jesus' suffering, and of suffering with and for other sinners in her
world, functioned dramatically in a public way to re-present Christ's work
to the world. As Christ had appeared different from those around Him,
and had been ridiculed by many of His contemporaries, so Margery herself
becomes a "fool for Christ."[46] This sense that suffering on behalf of Christ,
or in identification with Christ, strengthens the believer's bond with Christ
pervaded late medieval spirituality and is evident, for example, in the fol-
lowing fifteenth-century medieval poetic rendering of the beatitudes:

> Blessed are they that mourn for sin,
> They shall be comforted their souls within. . . .
> Blessed are they that suffer for right
> The realm of heaven for them is prepared.
> Blessed certainly shall you be
> When they persecute you for me . . .[47]

 Christ volunteers that if Margery no longer wants to suffer, God will
take the "gift" of tears away. Margery Kempe refuses to relinquish the gift
that not only brings her pain but also the "merriment" of doing Christ's
work in the world. God explains to her why she suffers so visibly by say-
ing that her anguish should remind people of Christ's suffering; she should
also make Mary's sorrows known, again, maintaining as Julian does, that
the service of sorrowing is a way to salvation.[48] Margery Kempe's public

commitment to bring other people to God extends to weeping for the souls in Purgatory, those in mischief, in poverty and disease, for Jews, Saracens, and heretics. In this suffering of compassion, Margery experiences her relationship to Christ as that of caring sister and loving mother: "When thou weepest and mournest for My pain and My Passion, then art thou a very mother having compassion on her child. When thou weepest for other people's sins and adversities, then art thou a very sister."[49]

In the stage of suffering borne of compassion the experience of pain reveals the believer's love of Christ, fosters unity with Christ and the world, and begins to draw the believer beyond the physical Jesus who suffered on the cross to understand the immensity of the love that motivated Christ in the world to suffer on humanity's behalf.

LONGING

Contrary to what the emphasis on pain here might suggest, Julian and Margery Kempe's appropriations of Christ do not stop at Jesus' death on the cross: "And I watched with all my might for the moment when Christ would expire . . . but just at the moment when by appearances it seemed to me that life could last no longer . . . suddenly He changed to an appearance of joy."[50] Yet perception of the risen and joyful Christ also gives rise to a further and final form of suffering.

Christ suffers for humanity from compassion, but He also suffers from thirst; Julian interprets this as spiritual thirst, a longing "to gather us all here into Him, to our endless joy."[51] Believers' responses to Christ's longing for them by longing to be with God draws them toward God. The longing for the joy made possible by Christ's suffering creates its own pain of desire which can be satisfied only after this life: "I had great longing and desire of God's gift to be delivered from this world . . . if there had been no pain in this life except the absence of our Lord, it seemed to me sometimes that was more that I could bear, and this made me to mourn and diligently long."[52] She knows the painful longing will remain until "we see [God] clearly"; yet God encourages her to endure, reminding her that eventually she will be filled with joy and bliss.[53]

Margery Kempe's description of longing to be with God parallels Julian's. At this stage Margery Kempe relates to God as spouse, growing out of her experiences of both the humanity and the divinity of Jesus

Christ. She desires to be with God, even going so far as to say that she longs to leave this world. God reminds her, though, of her social commitment and responsibility to testify to the goodness and work of God in the world. But God also reminds her that her sorrow will be transformed into joy. The intimacy of this stage of the relationship is noted when God says to Margery: "And when thou sorrowest that thou art so long from the bliss of heaven, then art thou a very spouse and a wife, for it belongeth to the wife to be with her husband, and to have no very joy till she cometh into his presence."[54]

The pain here is pain of separation from the risen Christ, who longs "to gather us all here . . . to our endless joy," an event which can never be fully experienced in this world, a longing that cannot be fully satisfied until the world to come.

CONCLUSION

In conclusion, then, this discussion of Julian of Norwich and Margery Kempe suggests that experiences of emotional and physical suffering can lead to and be a part of deepening love of God and neighbor. And yet pain is not pursued for its own sake, but rather emerges as a part of a spiritual process of renewal. The revelation and deepening perception of the God of love that emerges out of suffering is critical because Kempe and Julian suffer first in the face of their own sin and distance from God. They move from this suffering to experience the suffering of Mary and particularly to experience the suffering of Jesus. The process of cultivating compassion for Jesus' work awakens them to Christ's love for humanity — but the process does not stop here. As they experience the suffering of Jesus they come to recognize Jesus Christ's love for humanity; this leads both, but Margery Kempe especially visibly, to testify publicly to that love in the world. Through a transformation of suffering, Julian of Norwich and Margery Kempe move beyond the historical figure Jesus to speak of the God of love, who is merciful and compassionate and who longs for humanity, and with whom humanity longs to be united.

5

INTERIOR MAPS OF AN ETERNAL EXTERNAL

The Spiritual Rhetoric of
Maria Domitilla Galluzzi d'Acqui

E. ANN MATTER

NE OF THE MOST INTERESTING aspects of recent scholarship on medieval women's mysticism is the discovery of a continuum of female spiritual experience from the Middle Ages into modern Christianity. As the forms of devotional life developed by medieval Christian women become more clearly articulated, the reformulation of motifs and practices of this tradition can be recognized in later centuries, among both saints and sinners. The "immodest acts" of Benedetta Carlini in the seventeenth century, the intemperate asceticism of Veronica Giuliani in the eighteenth, and the amorous raptures of Thérèse of Lisieux in the nineteenth — all have historical foundation in Christian women's experience of the high Middle Ages.[1] These medieval "maps of flesh and light" are also fundamental guides to the autobiographical testimony of an influential female religious figure of the Counter-Reformation in Lombardy: Suor Maria Domitilla, Capuchin nun of Pavia.

Maria Domitilla's life is richly documented by her own writings, the testimony of associates after her death, and more than eighty letters written to her during her lifetime. Her autobiographical accounts originally took the form of short chapters addressed to her confessor, later revised and widely copied as two distinct but related books: the *Vita* and the *Pas-*

My research on the spirituality of Maria Domitilla, still very much in progress, is facilitated by a grant from the National Endowment for the Humanities. I would like to thank Angela and Carla Locatelli for their most learned and generous, if sometimes horrified, advice on the language and the interpretation of this material.

sione.[2] Many of the manuscripts of these treatises (which, like all the works of Maria Domitilla, never appeared in print) end with copies of contemporary letters to and about her; they, like the codex of letters preserved by her community, give evidence of the holiness of her life, the extremes of her devotional raptures, and the efficacy of her intercessory prayers.[3]

It is likely that these materials were copied and collected as part of an unsuccessful attempt to canonize Maria Domitilla. But the very content of Maria Domitilla's testimony of self is carefully, and I would argue, consciously, cast in hagiographical form. The details of her childhood are wrapped in the traditional garments of the girl saint: born in 1595 to a modest but well-connected family of Acqui, Piedmont, Severetta Galluzzi showed many of the stock traits of mystical vocation. Her birth was a result of divine assistance in a difficult pregnancy; her earliest enthusiasms were for prayer and good works; her natural inclination was to shun finery and frivolity. When her father and a younger sister died, she saw and talked to them in dreams.[4] A powerful spiritual influence was Severetta's Aunt Domitilla, widow of Hortensio Beccaria of Genova, with whom she spent several years of her adolescence, and whose name she took upon entering religious life. The fact that both parents were Franciscan tertiaries doubtless influenced Severetta to choose the Capuchins, the strictest reform of the Poor Clares, when she finally entered religious life. But it was Domitilla Beccaria who introduced the girl to the devotional ideal which became central to her mystical expression: fusion with the body of Christ in His anguish on the cross.

From about her twelfth year, the *Vita* describes an increasing desire to be crucified with Christ. Her first discussion of this longing is poignant with the spiritual and sexual confusions of puberty:

> After the death of my father, my aunt placed me in the care of the Barnabite Fathers, so that I might come to better please and better serve my Lord. She took for her and my confessor one of those Venerable Fathers, who began to educate me in the service of the Lord as His Divine Majesty [i.e., God] inspired him; but my simplicity, or perhaps rather impiety, did not understand this most holy virtue and perfection. I only did each thing thinking to do good, and wondering if I loved these things as much as I could, according to my inclination and meanness, doing everything that Father said for love of His Divine Majesty; and to please him I was obedient and believed simply everything that he said. So when he said that on the Feast of Saint

Andrew he wished to crucify me in a dark room of his religion [sic]
on a great cross which he had already prepared, and he told me to
ask permission to do this from my aunt, I got this permission with
such great joy that my aunt became fervent for martyrdom. I had never
thought that this Father had not told me the truth, and I was so naïve
that I did not think that little girls could not enter the Convent of the
Friars; and when he told me that he no longer wished to crucify me
because I was not worthy, I cried bitterly.[5]

This guileless yet alarming account is equally remarkable for the
sadism of the confessor, the fanaticism of the aunt, and the interpretation
given to the story by the mature nun who speaks of her younger self em-
phasizing her desire to be worthy of crucifixion with Christ. She offers
no criticism of this priest—in fact, the next paragraph goes on to favor-
ably compare his devotional teachings to those of her aunt. But it is her
Aunt Domitilla who places her niece, literally, before the cross:

At this time I began to take communion three times a week and on
the feasts of saints to which my aunt was devoted (who were very
many) as well as on Sundays and the days of obligation. My aunt
was accustomed, in the morning before dawn, after having finished
reciting with me the hours of the Divine Office and of the Madonna,
the litanies of the saints and of the Most Blessed Virgin and other spo-
ken prayers, to take me tightly between her hands and arms and ten-
derly offer me to the feet of the Crucified Beloved, and in such love
she often cried, and I felt tenderness and internal consolation.[6]

The autobiographical account begins at this point to elaborate a theme
of discongruity between Severetta's religious aspirations and the expecta-
tions of her mother and others that she would lead a more normal life.
The author emphasizes her own apparent frailty: "My mother worried that
I suffered so, especially since I appeared a little girl of six or seven years,
though I was going on twelve; and all were amazed that I was able to ac-
complish such great, dutiful things."[7] (Included in this category are the
successful catechizing of more than fifty poor girls which led to the virtual
conversion of Acqui, and the conversion of two Jewish boys.) This tension
between the world and religious vocation, another common theme of holy
women's lives, does not appear here with the drama that often accompanies
it. But, even if without a kidnapping or forced marriage, the *Vita* relates

a series of minor skirmishes between a call to religious life and the expectations of others until, at the age of twenty-one, Severetta Galluzzi of Acqui took the name of Suor Maria Domitilla. This journey to conventual life is essentially the story of Book I of the *Vita*.

Two related and very striking aspects of this transformation are first the intensity and consistency with which the protagonist willed it and second the subtlety with which the autobiographical account concealed this fierce will. The story of the Barnabite confessor, for example (whatever a modern reader may make of it), seems to be told in order to introduce early on a longing for *imitatio Christi* and to emphasize a sense of unworthiness for this honor. Throughout the *Vita*, confessors who encouraged Severetta's incipient vocation are praised. The one poor parish priest who tried to stem the tide of this devotion by ordering Aunt Domitilla to dress her niece in flowers and ornaments and take her out to the carnival dances died a sudden death — which the girl foresaw. In spite of Severetta's professed love for this "old and God-fearing man," he was quickly replaced by a confessor who guided her back to daily communion and thrice-weekly corporal penance. Again, the *Vita* stresses God's will rather than Severetta's: "After this, it pleased the Lord to grant me as confessor Father Nicolo Lodolo, religious canon of the cathedral, well-educated in the things of the Spirit by the Barnabite Fathers."[8] Even if she never intended it to show, Maria Domitilla left a clear trail of her own power in the choosing of her spiritual teachers and in the formation of her religious life.

This trail leads inexorably to the Capuchin monastery of Pavia, a venerable house originally founded in the shadow of the Lombard royal chapel of Santa Maria alle Pertiche, later reestablished as a Cistercian and then, with the patronage of the Beccaria family, a Capuchin congregation.[9] When Maria Domitilla entered the house in 1616, it was called Santa Franca, a name that dated from the Cistercian period; but within five years the chapel of the community had been rebuilt and dedicated to the Most Blessed Sacrament, the name by which it was known until its dissolution in 1782.[10] This emphasis on Eucharistic piety is closely related to Maria Domitilla's career as a visionary. The young nun began to show signs of mystical favor almost immediately, receiving an illumination about the *Rule of Saint Clare* in 1619, when barely out of the novitiate.[11] But the type of rapture for which she became famous began the year after the house was rededicated to the Most Blessed Sacrament, with a dramatic out-of-

body experience before the crucified Christ. The narrative of this experi-
ence, which appears in two of the extant writings of Maria Domitilla, the
Vita and the *Passione*, is lengthy and complicated, but well worth quoting
in its entirety:

> One time in the year 1622, being retired to my cell at night,[12] I saw
> (I do not know if with the eyes of the mind or rather in one of those
> dreams which come to me in prayer) a servant of God who is very
> far from this city and has a great name in virtue and holy customs,[13]
> and she, in that nocturnal hour, was beating herself severely. I saw
> this so clearly and manifestly that I began to sigh greatly and (I be-
> lieve) to cry like her, of whom I had great envy, seeing myself lacking
> in such true virtue, for the acquisition of which I continually hunger
> to do similarly rigorous penance, but Your Reverence[14] does not allow
> it to me since you and my Reverend Mothers Superior recognize my
> meanness. Indeed, I cried out loud to the Lord. With this lamenting
> of myself, exhaling my desire with the greatest love that was granted
> to me, I said: "O Lord My God, how is it possible that you tolerate
> me, so worthless among the great number of your servants who exert
> themselves out of duty in works of true penance? And how do you
> bear it that this your servant I now see beats herself so severely while
> the fame of her great virtue and sanctity is spread about; yet I, miser-
> able both because of my sins, and because I am deprived of such
> penance that I need to do to acquire holy virtue, how then might I
> please you and become your servant, as I desire, since Your Divine
> Majesty deserves it?"
> In this sort of internal collogy in which the soul communicates with
> God far better than can ever be told, I saw come before me a most
> beautiful and lovable Crucified Christ who, with His rays of infinite
> love, set me on fire with the great flames of his divine love. At this
> I made the sign of the cross and invoked the most holy name of my
> sweet Jesus. Because of this, it seems to me that I cannot doubt that
> it was He,[15] for He did not flee, but rather came down with such great
> sweetness and clearness of His Divine goodness that He united His
> most blessed head to my unworthy one, His most holy face to mine,
> His most holy breast to mine, His most holy hands to mine, and His
> most holy feet to mine, and thus all united to me so very tightly, He
> took me with Him onto the cross, so that I seemed to be crucified with
> Him, and that all of the stains of His most holy body stained my un-
> worthy one. And feeling such pain from Him, I felt myself totally
> aflame with the most sweet love of this most sweet Lord. Little by

little, He lifted me up on high, thus uniting Himself to this, my unworthy body. At which, thus in the air for a great piece, I was made to feel, enjoy, and suffer His pains from head to foot (as if the most holy wounds of all of His most holy body were imprinted on me) but in particular those of His most holy hands, feet, and side.[16]

Maria Domitilla's childhood desire to be crucified with Christ was thus fulfilled in her early years as a nun. Visible, tangible marks of this encounter gradually appeared on her body. These signs are attested by her assistant Beatrice Avite of Cumello immediately following this revelation of 1622; during the Fridays of Lent of 1624, they took the expected forms of and came to be described in the traditional language of Franciscan spirituality of the stigmata. "And the sign was seen to appear on the hands and the feet, very large, and like the color of iron, and so raised up that they resembled the form of those nails made with corners, like they used to stick in the crucifixes. Thus, by the evening I was not able to stand on my feet nor to wear slippers because of the swelling and pain, and this was the major pain of the second Friday."[17] From her stomach, where a red mark showed the wound of the lance in Christ's side, Maria Domitilla sweated blood, especially on Holy Thursday and Good Friday. Small pieces of linen placed on her stomach to staunch the flow were collected by her confessors and became relics for the community.[18]

The body obviously figures prominently in this mystical experience, yet Maria Domitilla's narrative reveals a deep ambivalence about the relative participation of body and soul, about the *boundaries* of her spiritual graces. To some extent, she was conscious of this problem of boundaries. In a reflection on her sufferings of Fridays in Lent, she wrote to Mons. Alemanno Alemanni, the general confessor of the community:

But whether this grace was given only to the soul, or whether the body had also participated in it, I do not know. I do well know that to renew the memory and the pain of the Lord on each Friday, I remain very afflicted for several days and feel much corporal weakness. And after this received grace my miserable body remains so invigorated, and my face so lit up that the sisters wonder all that day long that such color lasts, and wonder where it comes from. And I have the grace of never leaving the church in all that day, except in the hour in which I go with the others to the community of the refectory. I feel no difficulty in always remaining in church but rather continue in medi-

tation and desire to serve and please His Divine Majesty and His Most
Holy Mother.[19]

As the account continues with a description of the odor of roses and
lilies which emanated from Maria Domitilla's radiant face, it becomes clear
that all of the senses are involved in her experience of divine favor: the
touch of Christ's body on hers, the sound of the heavenly voice, the sight
of the nails of the stigmata, the smell of flowers, and (implied in the Eu-
charistic piety of this woman and her community) the taste of the body
of Christ in the sacrament. Ambivalence is embedded in all of these ex-
periences, at once rapturous and painful. And, all in all, Maria Domitilla's
repeated questioning of her bodily involvement in spiritual graces func-
tions to draw the reader's attention to it. And so the structure of the auto-
biographical narrative itself raises an important aspect of this analysis:
Maria Domitilla's attitude toward her own body.

Attitudes toward the body in medieval women's visionary narratives
have increasingly drawn the attention of modern scholars. Rudolph Bell's
study of women saints in Italy from 1200 to the present adapts the lan-
guage of modern psychology to an analysis of the corporal rigors of holy
women to define a special, culturally predicated form of anorexia, "holy
anorexia." This condition can be called "holy," Bell argues, because of its
special goal and because of the way that traditional Western Christianity
has understood and used it.

> The suppression of physical urges and basic feelings — fatigue, sex-
> ual drive, hunger, pain — frees the body to achieve heroic feats and
> the soul to commune with God. . . . Certain holy women set upon
> a path of rigorous austerity, encouraged to this course by the very same
> patriarchy that then unsuccessfully ordered them to turn back. Once
> they did, starvation steadily amplified symptoms which these anorexics
> and their confessors, friends, families, and followers came to under-
> stand as signs of heavenly favor. . . . We who seek to understand these
> women and to explore what that understanding may tell us about our
> own world can do so best if we keep in the foreground not only the
> psychological dimensions of self-starvation but also the cultural im-
> peratives of medieval holiness, for it is the intersection of the two that
> results in holy anorexia.[20]

In some notable ways, Bell's description of the "holy anorectic" fits
Maria Domitilla's revelation of her own bodily reactions to the call to

holiness. This is particularly striking in her "heroic response to painful ill-ness" and her self-defense from suspicion of demonic possession, both concerns that Bell finds characteristic of women saints of the seventeenth century.[21] It is important, however, to note that there is no claim, either on the part of Maria Domitilla or her many admirers, that her holiness depended on self-starvation; indeed, she is careful to point out (perhaps to protect herself from the very charges Bell describes) that her raptures were broken only for "the community of the refectory." This very difference raises two important questions that need to be addressed in the light of Bell's thesis. First, exactly what constitutes extreme self-deprivation in Maria Domitilla's religious world? And second, how does a broader context of holiness and deprivation, in her particular historical situation, present a background for the examination of Maria Domitilla's self-understanding?

The *Constitutiones* of Maria Domitilla's community are quite clear about the rigors involved in the Capuchin life. The prologue of the version of 1648 warns aspirants of "the harshness of the life, the continual fasts, the Lenten food, the roughness of the habit, the going unshod, the sleeping on planks, the cold and heat to be born, the disciplines, the vigils, the matins of midnight, the mental prayer, the retirement from those of the world, and even from their families, the punctual obedience, the extreme poverty, and other fatigues of humble exertion and of penance."[22] "The disciplines" mentioned are later specified as thriceweekly self-flagellations, undertaken on Monday for the souls in Purgatory, on Wednesday for the benefactors of the community, and on Friday for each nun herself and for sinners in general.[23] Details of the "continual Lenten fasts" had already been established in the Constitution of 1610. "At collation, which takes place in the evening, each one is given, equally at all times, four ounces of bread, or rather three ounces and a bit of fruit to those who wish it, excepting the fast days of the Church in which they will not exceed three ounces of bread, or rather two of bread with some bit of fruit to those who wish it."[24] This stringent diet was somewhat relaxed on Sundays and Christmas Day, when the nuns were allowed to eat twice a day, "but never meat or dairy products."[25] The *Rule of Saint Clare* had already established (although only in the barest outline) continual Lenten fast as the norm for women in Franciscan monastic life, a diet Bell describes as "monotonous and sparse but not unhealthy."[26] One must wonder, though, how "healthy" a diet totally lacking in protein, calcium, and most vitamins could possibly be, especially over the course of years spent routinely enduring cold, heat, deprivation of sleep, and various forms of corporal

punishment. It seems, rather, that the nuns of the Monastery of the Blessed
Sacrament of Pavia lived in a continual state of semi-starvation; one that,
while chosen (in Maria Domitilla's case, ardently so), was nonetheless
hardly a *personal* expression of religious striving. This life of continual
Lenten fast was rigidly formalized and carefully regulated in respect to a
pattern of religious expression on a broad cultural level. In choosing this
life, women were doubtless acting out various aspects of their own psy-
chological histories, as Bell argues, but they were also conforming to an
established norm of a holy life.

The outline of this pattern of sanctity has been described by Caro-
line Walker Bynum in detail that has several points in common with the
spirituality of Maria Domitilla, in particular the quest for union with the
suffering body of Christ. "Women's inedia was therefore not so much bi-
zarre behavior afflicting a few individuals, as part of a broader pattern
that included eucharistic devotion, food multiplication miracles, devotion
to Christ's humanity, the theology of purgatory, and care of the sick. Such
fasting can be understood only if we understand the late medieval notion
of *imitatio Christi* as fusion with the suffering physicality of Christ, and
late medieval notions of the female as flesh."[27] In a still more recent article,
Bynum has pointed out that "female *imitatio Christi* mingled the genders
in its most profound metaphors and its profound experiences." The va-
riety of ways in which religious women related to Christ, from embracing
Him as a lover to cradling Him as a mother, were all manifestations of
the fact that "women mystics often simply became the flesh of Christ,
because their flesh could do what His could do: bleed, feed, die, and give
life to others."[28]

Maria Domitilla's spiritual map is thus more accurately read by means
of a broad cultural code of the imitation of Christ than by the intensely
personal psychological code of "holy anorexia." This is not to say that Maria
Domitilla was known for bodily robustness; in fact, manuscripts of her
works often display title page woodcuts of an almost skeletal woman whose
sunken cheeks and stern eyes proclaim her disdain for the body.[29] Yet Maria
Domitilla was profoundly aware of her female body, and in one vision
saw herself likened, even united, to the life-giving and miraculous womb
of the Virgin Mary:

> Considering the happiness which the Most Holy Virgin Mary must
> have felt in that birth by which the Supreme God was made in her

most blessed womb, I was overwhelmed by the happiness of Paradise, where it seemed to me that the Most Holy Virgin, with maternal affection, made my head lean against her most blessed womb, making me feel and know with so many innumerable joys that God was within; so that my soul, knowing itself unworthy, said to the Most Holy Virgin: "O Most Holy Lady, if it were once more necessary (which it is not nor will ever be) that God should be made man anew in the womb of a virgin, and I became that one by his grace, I would gladly deprive myself of this great good so that you, Most Worthy Lady, would again enjoy this most happy joy, as the most capable and worthy subject of such great majesty and felicity found in God.[30]

One could argue, of course, that Maria Domitilla's willingness to give up a chance to bear Christ in her womb (however remotely possible) indicates a rejection of her womanhood. But the identification of her "virgin womb" with Mary's is equally striking; this revelation of an *imitatio Virginis* should be related to accounts of a number of holy women who at one point or another met Christ in a maternal role, among them Veronica Giuliani, Agnes of Montepulciano, Catherine of Siena, and Margery Kempe.[31] Once more, it is a cultural pattern that emerges as the crucial element for an interpretation of the life of Maria Domitilla. This pattern may in fact be most accurately seen as a subset of the more pervasive *imitatio Christi*, for in at least one vision Maria Domitilla is taken to the Virgin's breast and offered precious drops of the milk that nourished the infant Jesus.[32]

Because the theme of suffering with Christ stands out so clearly as central to Maria Domitilla's holiness, it is important to note that this suffering, although extremely personalized and encoded in her bodily experience, also manifests an *externalized* and culturally bound aspect. Suor Beatrice, the young nun assigned to assist Maria Domitilla in her hours of mystical transport, recorded for the benefit of the community the pious exclamations of the holy woman in rapture.

Then she broke into soft weeping and said: "O my Dear Lord, what dischord was this? O Eternal Father, how your Most Wise Son is seen to suffer for us! . . . O Lord cleanse me from all my sins/O Eternal Father, is He not the one of whom it is written 'Beautiful among the sons of men'[33] and who is now made a spectacle for us?/Hard cords bind those hands that made the universe! O Eternal Father, how I see

you take pleasure in seeing your son so ill-treated./O infinite Love!/
O Good Jesus, with what toil/Ohime, how could you move your
steps?/O most unjust Pilate, who gave such a sentence!/O what cruelty
is this?"[34]

This testimony of Maria Domitilla's spontaneous speech in mystical
rapture bears a striking resemblance to the more formal didactic discourse
found in her guidebooks to devotional practices, works removed by sev-
eral steps from her visionary outpourings. For example, a highly charged
emotional recounting of the stages of Christ's Passion figures just as promi-
nently in Book I of the *Vita*, in a chapter on how to achieve mental prayer:

> Entering into knowledge of myself, I say: "First I will speak to my God,
> I who know nothing." . . . Ten. Ohime. What cruelty is this with which
> they despoil you, my sweet love? Eleven. Then turn to the ministers
> and say: "O impious ones, do you not know that my beloved is the
> Lamb, but most worthy? Why do you put the chain around His neck?"
> . . . Twelve . . . O my Good, what pain did you feel in moving your
> feet and making so many afflicted steps? Ohime how I see you drag
> yourself and fall with your face in the earth! Ohime how can you raise
> yourself, my God, with your hands tied and your body weak and tor-
> mented? . . . O Eternal Father, look at your son made infamous by
> men! Haime that I see you take pleasure in the pains of your son![35]

Finally, Maria Domitilla's *Forty Hours of Mental Meditation* devel-
ops this agitated christocentric devotion on a level without any claim to
visionary grace. Instead, this is a book of instruction on meditation about
the life of Christ. Each hour or meditation begins with a short recount-
ing of a Gospel passage, and then breaks into passionate exclamations ad-
dressed directly to Jesus. It should be noted that in this work the discourse
takes place totally as *recollection*, that is, in the past tense. Nevertheless,
the following selections from the chapter on Christ before Pilate recapitu-
late many of the themes and images, and the emotional tone, of Maria
Domitilla's visions:

> O Most Afflicted Lord, with what meekness you received that final
> sentence of death . . . and innumerable people and soldiers all run-
> ning to see such a lamentable spectacle, cursing and blessing your Great
> Majesty, so abased and ill-treated for us; O My Jesus, who were they
> pushing you, scolding you, hitting you, throwing at you mud, stones,

and filth, all rushing to the doors and the windows to see you and to torment you? And Your Majesty bore it all with the greatest patience, humility, and charity. . . . These inhumane ministers with kicks, with punches, with clubbings, and by pulling you, some by the cords, some by the chains, and some by the most blessed hair, they carried you from the place in which they found you. . . . With this you conformed wholly to the will of the Heavenly Father who had ordained this for the salvation of us miserable sinners.[36]

On the rhetorical level, these three passages have in common a frame made up of the historical account of Christ's Passion, through which breaks a series of repeated apostrophes. The frame recedes with the immediacy of the account; thus, in the testimony of Suor Beatrice, the Gospel narratives are essentially understood but never spelled out, while in the *Forty Hours*, they are the overt and reiterated basis of each meditation. In either case, though, the apostrophes turn the discourse directly to Jesus, exclaiming with most human sorrow, and with hypnotic repetition, on His divine suffering.

The themes spelled out by these rhetorical devices are characteristic of the tradition of *imitatio Christi*. The agony of Christ is held up for wonder, pity, and identification; it is repeatedly stressed that this suffering was for the sake of humans. The injustice of the sentence and the humiliation of this injustice are developed as major themes. Finally, it is consciously stated in each account that Christ's Passion took place according to the will of God the Father, who not only allowed it but even *took pleasure* in seeing His innocent son suffer because this was His divine economy for the salvation of the world.

The three accounts are presented here in the order in which Maria Domitilla identified with them, from the most interior to the most exterior. The first part of this essay, in fact, stresses her individual will and strength of personality in the molding of her personal expression; it could be argued that her teachings on the life of prayer were formulated out of her life experience, especially the repeated experience of mystical rapture into the presence of the suffering Christ. The argument articulated in the latter part of this article, however, suggests that the opposite could be true. As close scrutiny of Maria Domitilla's writings has revealed, many of her most personal expressions were formulated in molds communicated to her from her childhood by the Christian culture in which she lived. On the most general level, the imitation of Christ, and more specifically, the teachings

of Catholic Reformation authors, such as Teresa of Avila, her confessors, and other Italian spiritual writers of the sixteenth and seventeenth centuries all provided models of devotion.[37] These models can account for not only Maria Domitilla's devotional teachings but even her own most personal and directly revealed experience.

The mentioning of these models is not to suggest that Maria Domitilla did not really *have* these experiences, or that they are to be valued less because they are "unoriginal." Maria Domitilla's personal experience must be understood as equally "true" as any autobiographical accounts, even if expressed in tropes she held in common with an entire religious culture. This is, of course, the case with all autobiography; but the extent to which Maria Domitilla employs cultural tropes to describe her own life raises a problem that must be faced by historians of Christian women's lives.

It seems that women's experience of *imitatio Christi*, which began in the late Middle Ages as a radical, form-breaking type of self-expression, became by the sixteenth century a more conformist and less expressive manner of self-interpretation. This form of female piety came to be carefully regulated by the patriarchy of posttridentine Catholicism. As Bell has suggested, this supervision was a result of the fact that female *imitatio Christi* came to be seen as more potentially dangerous than it had seemed to the confessors of Catherine of Siena. But, as Bell's extensive discussion of the life of Veronica Giuliani shows, the tradition did not die out because of the suspicion of the hierarchy. In that she came to be a saint, Veronica Giuliani was an exception to the course of this tradition after the sixteenth century, a fact for which Bell does not provide a satisfactory explanation. But if one looks beyond the category of canonized saint, it is almost astonishing how many Christian women can be easily found who molded their lives in the same pattern, and who left autobiographical testimony to the spiritual grace of their rapturous union with the suffering Christ: in Pavia alone, within fifty years of the life of Maria Domitilla, there are another two, one in her own house.[38] This circumstance may well explain why the period that Bell considers a decline of the tradition is precisely what Romano describes as the peak of the tradition.[39] That these women, along with Maria Domitilla, were never canonized is a fact worthy of further exploration. And it is an irony of historical study that Maria Domitilla survives for modern analysis precisely because her community, nuns and confessors alike, had carefully prepared fair copies of her writings for the process of canonization.[40]

For a modern evaluation of Maria Domitilla's interior map, it is therefore necessary to take into account the problem of voice. That is, we need to consider the extent to which her most personal and interior expressions of self were spoken through, if not muted by, the external realities through which they were allowed expression. Maria Domitilla speaks of her own body frequently, but she perceived her body, in fact she shaped her perception of her body, as the executioner of an exteriority. If we look at her autobiography with the question "who was she?", we find her own narrative telling us that she was, as far as possible, someone else: Christ. Perhaps this was an expression of personal striving for a Christian woman of sixteenth-century Italy: to be yourself, be another, Christ, in the suffering common to all humanity. No one could stop a woman in this quest of individual expression, as long as there were still religious communities which glorified the model of *imitatio Christi* and so long as the self-modeling was carefully controlled by the patriarchy of the church. By working within the limits of this control, even choosing it, Suor Maria Domitilla Galluzzi survives as an individual woman, a personality we can imagine and reconstruct. But she survives in great part as the internalization of another's reality, of the passion of Christ. This external reality has its appeal and draws its power, not from the precise events and experiences of Maria Domitilla's life, but from its mythical power as an eternal truth of human salvation.

6

AN EXAMPLE OF SPIRITUAL FRIENDSHIP
The Correspondence Between Heinrich of Nördlingen and Margaretha Ebner

MARGOT SCHMIDT

Translated by SUSAN JOHNSON

AS A LIVING TESTIMONY of a spiritual exchange, collections of letters have a special place in the history of Christian mysticism, bearing witness both to an elevated love of God and to the friendship between a man and a woman. Because they were originally not intended for publication, the letters are a highly personal and individual representation of a person's inner life stretched between the world and God, when friend speaks to friend, heart to heart; as such they are a much more direct witness of mystical life. They reveal the subtlety of inner experiences and the cultivation of spiritual friendship. We become acquainted with the mystics in their personal surroundings as feeling, suffering, struggling individuals who, despite the lofty strivings of their spirits, are frequently persons of action imbued with a sense of realism. Heinrich of Nördlingen's correspondence is the earliest such testimony to survive in Germany that can be considered an exchange of letters in the modern sense. (The correspondence of Suso, his contemporary, is in fact more like a collection of sermons in letter form.) But older collections of letters written in Latin and documenting spiritual friendships are to be found in the letters addressed by Jordan of Saxony to Diana of Andalo and in the correspondence between Peter of Dacia and Christine of Stommeln, who was called "die Kölsche" after her native Cologne. The numerically largest collection of Latin letters is made up of those written by Hildegard of Bingen to various addressees. These letters, however, are mostly of a didactic nature, behind which all personal, individual inner life disappears.

74

It can be assumed with certainty that such a lofty spiritual cross-sex friendship was not without precursors. Cooperation and friendship between men and women, for example, between Saint Paul and Thekla, already existed among the early Christians, although they left no letters. From the fourth century there are letters written by Saint Jerome to Marcella, Paula, and Eustochia, far less personal and tender, but rather doctrinal in character; they do, however, bear witness to a spiritual exchange between man and woman. In the eighth century, the highly educated Benedictine nun Hugeburc, who was born in the South of England and who accompanied Saint Walburga to Heidenheim (Diocese of Eichstätt) on the mission to the Germans, wrote the remarkable biography of the first Bishop of Eichstätt, Saint Willibald. It was written in about 780, probably in Heidenheim, the oldest abbey of Benedictine nuns in Germany, and was based largely on the Bishop's own accounts of his eventful travels, which took him as far as Palestine. Although not epistolary in form, this biography is another example of close cooperation between a man and a woman on the highest spiritual level. Research has shown that Hugeburc's biography contains "astonishingly precise details,"[1] and so this description of the life of the first Bishop of Eichstätt also prevented the early history of his diocese from falling into oblivion.

In addition, the famous Strassburg Guta-Sintram Bible Codex (completed in 1154) testifies that a nun called Guta and a priest and canon called Sintram, who are depicted together in an illumination, produced this magnificent manuscript together and thus must have worked in close cooperation. These scattered early testimonies teach us that in the early and high Middle Ages relations between men and women, more precisely between priests and nuns, were probably taken for granted as quite natural. This circumstance did not impair their high ideals regarding their priestly or religious state, but it also took into account that they were above all human beings who could be a gift to each other.

It is against this background that Heinrich's correspondence, written in German in the fourteenth century, is examined.

In 1345, he wrote in a letter to Margaretha Ebner and her fellow nuns in Medingen:

> I am sending you a book which is called 'The Flowing Light of the Godhead'. . . . It is the most wonderful German and the most profoundly touching fruit of love that I have ever read of in the German language . . . and those words that you do not understand you should

mark and send to me, I will explain them to you. For it was handed
down to us in a most unfamiliar German so that we had to spend a
good two years of hard work and effort before we could put it a little
more into our own German. Read it attentively three times, in the book
it says nine times. I trust that the book will give your souls a much
more eager striving after grace. I would also like to lend it to Engelthal.[2]

On the initiative of Heinrich of Nördlingen, the lost original of
Mechthild of Magdeburg's *Flowing Light of the Godhead*, written in Mid-
dle Low German, was translated into Upper German in Basle in the mid-
fourteenth century and a copy of it sent via him to Margaretha Ebner with
the request to lend it to further monasteries, for example, to Kaisheim.[3]
This explains why passages from *The Flowing Light* found their way into
Heinrich's correspondence with Margaretha Ebner and influenced both his
style of letter writing and her written record of her *Revelations.*

The original version of the letters has not been preserved. The fact
that there must have been more of them than have survived is to be con-
cluded from the contents of Margaretha Ebner's *Revelations,* and because
there is only one letter written by Margaretha as opposed to fifty-six by
Heinrich. The only collection of the letters that is likely to be the most
complete is a manuscript in the British Museum (Add. 11430) dating from
the sixteenth century. When he edited the collection in 1882, Philipp Strauch
added two letters addressed to two of Margaretha's fellow nuns. To this
total of fifty-nine letters he appended another eight letters from Heinrich's
and Margaretha's circle of friends, all of which were addressed to Mar-
garetha: five written by Abbot Ulrich III of Kaisheim, one by Tauler, one
from Margaretha of the Golden Ring, and one anonymous letter.

How did this friendship between Heinrich and Margaretha come
about? When the secular priest Heinrich of Nördlingen, a well-known
"Friend of God" (*Gottesfreund*), visited the Dominican nuns in Medingen
on 29 October 1332, Margaretha was in a state of intense mourning. With
marked reserve, she hesitated to follow the advice given her to seek con-
tact with Heinrich.[4] She finally overcame her reluctance and noted after
his visit that she had listened to him "very gladly." She drew solace from
his words without suspecting how fateful this meeting was to be for both
of them. At this time, Margaretha was forty-one years old. On his second
visit in 1334, she received him as a gift from heaven, "as if he had been
sent to me by God. . . . When I came to him, immeasurable grace shone

out from him toward me and there was an inner bliss of true sweetness in his words."[5] She writes in her *Revelations*, "The desire wells up in me to discuss all my concerns with him."[6] In order to preserve a sense of propriety and seemliness on this unusual path, she examined their friendship with the promise to give glory to God alone. The unassailable trust that she put in Heinrich for the next twenty or so years is described later in Margaretha's depiction of the dream revelation at the beginning of their relationship. "I felt a yearning in me to be loyally devoted to him. I said, 'I will gladly do so provided that you mean this to serve the glory of God'. He replied that this was exactly what he intended. This is what I have since truly found."[7] His occasional visits — eight in twenty years — were for Margaretha always times of spiritual invigoration and fortification. His presence made her feel spiritually and physically so light that she thought herself to be removed from the earth.[8]

Born in the Free Imperial City of Nördlingen, Heinrich kept up regular contacts with the monks in the Cistercian abbey at Kaisheim just north of Donauwörth, with the monasteries of nuns under the jurisdiction of Kaisheim and with the Dominican nuns in Medingen near Dillingen. He would gladly have taken over a parish belonging to Kaisheim Abbey. However, the altercations between Emperor Louis the Bavarian and the pope, which resulted in a papal interdict and excommunication, led the emperor to pass a law on 6 August 1338, which made compliance with the interdict a breach of the peace punishable by law (i.e., persecution by the state). This forced Heinrich to leave his home. Heinrich was on the side of the pope, whereas remarkably enough, his deeply respected spiritual friend, Margaretha, remained fully committed to the cause of Louis the Bavarian. The reasons for imperial sympathies remain unclear; what is important in the present context is that the support of different parties by no means impaired the friendship between Heinrich and Margaretha. At the end of 1338, Heinrich left Bavaria via Constance and Königsfelden and went to Basle; from there he went on to the Alsace, Cologne, and finally Aix-la-Chapelle. As a result of his travels, a lively exchange of letters came about. He spent ten years in Basle, where he gathered a circle of "Friends of God" around him and became a well-loved preacher and pastor. Most of the letters date from his time in Basle. Once he was commissioned by the Diocese of Basle to go to Bamberg and request relics of Emperor Henry II for the cathedral of Basle. Heinrich would occasionally interrupt his journeys to visit Margaretha. Hence it was matters of church

politics that turned a chance acquaintance into a personal exchange of letters that was to continue for decades.

In his letters from Strassbourg, Heinrich urged Margaretha to set down a written record of her visions, the first part of which she sent to him in 1345. Thus her *Revelations* came to be written down; they, in turn, became one of the topics treated in her correspondence with him.

The relationship between Heinrich and Margaretha was marked by the utmost mutual respect. She refers to Heinrich as given to her by God for her solace and entrusts her inner inspirations, her mystical experiences, and visions to him alone. To her, he seems to have been sent by God from heaven, like "an angel in the light of truth."⁹ Heinrich, for his part, is totally enraptured by her strength of heart and begins to look up to her more and more as a prophet on account of the divine grace that she has received. From his letters we learn how he loves writing to Margaretha or hearing from her: "When I read what you write or when I concentrate my heart on writing to you, a gently flowing spring usually wells up in my heart."¹⁰

"I longed to receive your dear letter and read it with all the yearning of my heart when I saw the great longing with which you touchingly remind me and have inwardly so moved me to visit you."¹¹ He assured her: "God knows how much I would like always to be with you."¹² "I would like to be with you, my consolation in God, and I trust in Him that this will soon be the case. Pray to your almighty, beloved Jesus Christ that He, knowing my indigence, will take pity on me in all things and that He will teach you what I should and should not do."¹³ Margaretha replies in her only surviving letter that she longs for his presence and needs it, while he assures her, "I always derive solace and divine strength from you."¹⁴ Heinrich adds, moreover, that he needs her a thousand times more than she needs him.¹⁵

While Margaretha esteems Heinrich as her spiritual teacher and director, Heinrich looks up to her with respect and admiration and regards her person as a mediator between himself and God. Cherishing her as a mystic endowed with grace who was closer to God as a result of her inner experiences, he sought to confirm and encourage her along this path, although he had no personal experience of such graces and hence felt poor and helpless. He writes to her:

> And for that reason the fear of God again comes upon me and makes
> me quite disheartened and I, a blind man, show one who is seeing

the way, that I, a mute, preach to the mouth that offers praise and utters truth, that I, a lame man, walk in front of one who is running fast toward eternal life and leaping high, in short, that I wish to teach one whom God Himself, as I trust, filled as I am with desire, with my own heart and also in accordance with the hearts of those who have fully assured me of this about you, has taught and wishes to initiate even more deeply into His hidden wonders.[16]

This is not, as has repeatedly been maintained in a dismissive way, an unclear and extravagant expression of Heinrich's own rapturous feelings; he does not rely solely on his own impressions, on his own heart, but also calls upon the judgment of others. Only then does he recognize that compared to the knowledge bestowed on Margaretha through God's grace he is blind, mute, and lame. He thus indicates his own weaknesses on various spiritual levels and indirectly praises Margaretha's grace-given lightness, which results from the gift of inner insight, of verbal expression and of ecstatic states. Margaretha was, from Heinrich's perspective, incomparably advanced on the mystic way to union with God. Indeed, as he writes to her in a letter, she became an unattainable model for him. "Your faithful heart and your pure soul and your burning spirit and your chaste love and your humble demeanor and your gentle countenance and the inward longing that you constantly have for God . . . these provide me with a holy model, a clear mirror, a well-prepared way to all divine truth if only I could follow you properly."[17]

In his view, she alone possessed true love of God; in her example he saw the true imitation of Christ. In his meetings with her and in her writings, he recognized God and God's working in human beings. Her pure soul became for him "a God-shaped image relected [from God] and lighting the way [into God] so that it would hover above him in burning flames of high-flying love," which he knows to be constantly behind him "as a faithful, motherly protection all his life."[18] These and similar expressions of admiration in his letters show how much Margaretha took on a spiritually nurturing role for Heinrich. Other passages, on the other hand, throw light on his role as her spiritual director. And although he refers to himself when writing to Margaretha as inwardly inexperienced, "rough and ready," "arid" and "an unpracticed laborer in the service of the service of the Lord,"[19] it is remarkable how accurately he uses lengthy quotations from Mechthild's *Flowing Light of the Godhead* throughout his letters in order to show his understanding, to support Margaretha, and to strengthen her in a situa-

tion characterized by inner experiences she did not always immediately understand. Without naming the source he quotes from Mechthild, Book I, chapter 22, and presents an antithetical description of the paradoxical nature of mystic ecstasy. He introduces the quote with the words: "Now take further note: it is said and described to us by the Friends of God [i.e., Mechthild of Magdeburg] that the bride becomes intoxicated at the sight of the noble countenance."[20] He then quotes:

> In the greatest strength she is lost to herself.
> In the most beautiful light she is blind in herself,
> In the greatest blindness she sees most clearly,
> In the greatest clarity she is both dead and living.
> The longer she is dead, the more blissfully she lives.
> The less she becomes, the more she learns.
> The more she is afraid, [the more flows to her].
> The richer she becomes, the more indigent she becomes.
> The more deeply she lives (in God), the more receptive she is,
> [The more she desires,] the more she demands.
> The deeper her wounds, the more violently she rages.
> The tenderer God is toward her, the deeper she is enraptured.
> The more beautifully she shines from the sight of God, the closer
> she comes to him.
> The more effort she makes, the more gently she rests.
> [The more she receives,] the more she understands.
> The more silent she remains, the louder she cries.
> [The weaker she becomes,] the greater are the miracles she works
> according to her strength with his power.
> The more his desire grows, the lovelier their wedding will be.
> The narrower the bed of love, the tighter the embrace,
> The sweeter the mouth kissing, the more loving the contemplation.
> The more painful the parting, the more generous his gifts.
> The more she consumes, the more she has.
> The more humbly she bids farewell, the faster he returns;
> The hotter she remains, the quicker sparks fly from her,
> The more she burns, the more beautifully she glows.
> The more the praise of God is spread, the greater her desire
> becomes.

Following Mechthild's style and content, Heinrich of Nördlingen explains Margaretha's singular grace of "bound silence" antithetically: "The

fuller, the more silent."[21] His purpose is to show understanding for the occasional silence imposed on her, which he interprets as a sign of the imitation of Christ "as his Father's captive according to his will" and a way "to give birth in you to the divine image without this being impeded by any created being."[22] In his letters, he characterizes these antitheses as a form of being totally possessed by God.

In these antitheses and paradoxes, Heinrich recognizes the meaning of the ecstasy of love as a revelation of God's glory, an insight that he wished to pass on by way of confirmation to Margaretha. He also understood that the transient ecstasies of love merely lead to an even greater desire, so that the heightening or vision of God's love can never quench human longing on earth because the very state of inwardness lies in a permanent movement toward God. For any life lived in love of God there is no absolute negation or destruction; the refuge afforded by the love of God is instead the blissful paradox inherent in the ever-increasing desire. When describing this idea of ecstasy elsewhere, Mechthild uses extraordinarily striking paradoxes based on the image of the Holy Trinity:

My Bride, I hunger for the heavenly Father,
forgetting all sorrow in him.
And I thirst for his Son,
who deadens all earthly lust.
And I have from the Spirit of the two of them such pangs of love
beyond the Father's wisdom, which I cannot grasp,
and beyond the Son's suffering, which I cannot bear,
and beyond the consolation of the Holy Spirit, which I cannot
 receive.
Whoever is ensnared in these pangs remains forever enmeshed and
 immersed in God's bliss.[23]

The paradoxical nature of the theory of climbing to ever-increasing heights was already elaborated by Gregory of Nyssa in his commentary on the Song of Songs, in which he took as his starting point the ascent of Moses on Mt. Sinai. "But he held by an insatiable thirst for more and begs to see God's countenance. . . . The vision of his countenance is the never-faltering pursuit of it, which can only progress if we follow in the footsteps of the WORD [i.e., Christ]."[24]

As for Gregory of Nyssa, for Mechthild and, following her, for Heinrich, too, the yearning and longing alone are in themselves bliss because

a human being can never go beyond longing in this life; this means that longing is both an essential element of human love of God and a driving force behind ecstasy. This insight is expressed by Mechthild in the vivid request: "Lord, cover me with the mantle of great desire."[25]

Reading Margaretha's written record of her *Revelations* and her letters, Heinrich understands intellectually that, as far as earthly life is concerned, the high form of love of God is ever-increasing desire because the fulfillment of love is reserved for the next life. Margaretha, however, realizes that it is one thing to know something in theory and another to know something from experience. She understands, in other words, that the experience of God's love possesses a special, a higher cognitive value. Thus she wants her "inexperienced" teacher and friend to receive the inner gifts she and those who have tasted God's sweetness have been granted. She writes in the only letter of hers that has survived:

> Now I yearn that in your profound modesty you shall be lifted up from crawling to soar in the high, eagle-like flight of my dear Saint John, upward to the heart of my beloved Lord Jesus Christ, that you may truly rest on His breast and be tenderly steeped in His grace and permeated by His inner sweetness so that you lose your unfamiliarity with feeling the grace of God and that you shall be given that feeling of God's inward delight which I and all those have felt who, blessed with God's grace, have sought in you and which those whom the grace of Our Lord has enlightened more than me have felt more deeply than I have.[26]

Restraining herself, but full of trust and longing for her friend, she continues in the same letter, "My Lord, you know well that I have always recognized myself as too unworthy and small for the perfect light that has shone for me in you. . . ; may the true sun honor you in itself and lighten all your clouded senses I will wait for you because I always like to have your advice and teaching before carrying out my wishes."[27] These lines from her letter bespeak the deep friendship and trust between two high-minded souls that developed from a chance meeting.

The prospects of a possible visit to Medingen were thwarted again and again. Heinrich writes: "If it happened that the Bavarian left the country, it could come about, if God so wills, that I shall see you."[28] "But I trust in the Lord: may He allow me to see you again, the true consolation of my heart."[29] "I wanted to come, but then the discord prevented me. Yet

I long for your presence so that I must come as soon as I can."[30] Emperor
Louis the Bavarian's order, however, against compliance with Pope John
XXII's interdict remained in place and was more strictly enforced so that
Heinrich, as a loyal supporter of the pope, had to keep out of the country.
In emphasizing his own weakness, Heinrich tries to make her waiting more
tolerable on both religious and human grounds, saying that she would al-
ways find him in God. "I, too, am very weak. I fear also that I would not
be safe in the country with you; I would have to be there secretly unless
I were advised differently. Hence I ask God to use all the riches of His
generous gift, with which He can satisfy all your longing, in order to take
my place for you and to replace my presence with His own blessed counte-
nance; may this countenance smile on you so tenderly that you need neither
me nor any other created being."[31]

When he finally did return to his native country on business, there
was not enough time for the visit to Medingen they both longed for so
dearly; instead he wrote a lovingly consoling letter to Margaretha. "My
dearest consolation and the salvation of my soul and the great joy of my
heart, you blessed child of our dear Lord Jesus Christ, O Margaretha, I,
your unworthy friend, have . . . God and your trusty help to thank that
I have entered the country again safely and completed my errand success-
fully . . . I would have liked to visit you first, but I travelled from Speyer
and Schwäbisch Gmünd. Forgive me! For my heart's thoughts are, as far
as my weakness allows, always lovingly with you in particularly sweet
delight. God be with you, as He truly is. I am filled with longing."[32]

Their correspondence replaces, as it were, the personal conversation
that has now become so infrequent and thus captures all the magic of hu-
man longing: "You, my most faithful friend and the safe refuge of my soul,
I do not know what to say, for my heart was filled with a quite strange
longing when I read your letter."[33] He continually makes use of the imag-
ery of the Song of Songs, in which spiritual and human eros are inter-
mingled. "I was bereft of speech and bearing as a result of the holy scent
and divine taste that penetrated me from your glowing words, and an
amicable war broke out in me between great fear and great desire. Rever-
ence commanded me to remain silent, but desire commanded me to speak
and was so victorious that my heart and mouth are opened wide to con-
verse with you, my dear, in God. If I only knew now what I should say
in order not to cause pain to you and your beloved Christ. But with God's
permission, I take this opportunity to speak with you."[34]

An occasion for such an exchange was offered, for example, by the

imposition on Margaretha of a "bound silence," about which he wanted
to know more, combining his inquiry with an interpretation of this state.
"My most faithful, loyal friend, I greatly desire to know how your heart
is renewed in your peace, which rests in God, and in your holy silence
in this silent child. For I imagine that it is very necessary for you to have
relinquished outward speech for the sake of the silent child in order to
elevate your eloquently speaking soul, your loudly singing spirit and the
lofty strivings of your heart with the Eternal Word and through the power
of the Spirit in such a way that no outsider can gain admittance."[35]

Despite all the human warmth and intimacy displayed in their rela-
tionship, both Heinrich and Margaretha understood that no matter how
great the harmony between them, it could not plumb the depths of their
individual spiritual experiences and affect the ultimate independence each
retained, a region to the threshold of which human love can lead but can-
not cross. They knew that the respect and awe felt for what belongs to
God, which includes the whole of creation, is wary of too much human
personal intimacy. The recognition of the limits of all human love and
friendship served to prevent Heinrich's and Margaretha's spiritual calling
from being undermined and destroyed. This is the same attitude expressed
by Saint Bernard in his sermons on the Song of Songs and by Mechthild
when she refused to answer all too inquisitive questions.

Heinrich was fully aware of this need to balance personal and spiri-
tual aspects of their relationship. In view of his own weakness and her
great inner richness and spiritual power, he wrote: "I place the heavier part
of my burden of sufferings on you, for in the same measure as you have
more love than I do, you can bear more than I can."[36] Margaretha is de-
picted as superior and stronger. Nevertheless, despite her great love of truth,
her relationship with Heinrich is characterized by the marked sense of tact
and the profound love of peace that are also basic features of her mystical
life. It was apparently this basic characteristic that moved Heinrich to
display trust and intimacy toward her and led him to encourage her re-
peatedly to continue to write to him about her experiences of God's grace.
In 1344, Heinrich suggested to Margaretha that she should write down
her inner experiences in chronological order. While he was in Strassbourg,
he received the first part of these written records; he answers in a raptur-
ous letter.

> What should I reply to you? Your God-speaking mouth renders me
> speechless. Thus, instead of speaking myself, I thank God for His own

sake for the heavenly treasure that He has opened up through you
and will, I trust, in His goodness open up even more. And so I ask
God . . . that you will write to me assiduously and collect to the end
what God gave to you to say and what you have previously forgotten
or not yet written down; and I shall keep everything as secret as you
have up to now. Nor do I dare to add or omit anything, be it in Latin
or German, until I have read it through with you and understood its
newly revealed truth from your mouth and your heart. I am especially
delighted that Eternal Truth has given you a special witness for this
work in your inmost heart. You are thus a debtor so that you lend it
your heart and mouth for this work, namely for its written record.[37]

Quite in keeping with *The Flowing Light of the Godhead*, Heinrich
urges Margaretha to understand her writings on the divine grace she has
experienced as a kind of preaching. He assigns the task of teaching to her
according to the model of Mechthild of Magdeburg. Mechthild received
a divine call to teach during ecstatic states. She called upon Moses as one
of her chief witnesses concerning the ecstatic state because he, too, expe-
rienced "intimacy" with God on the mountain and brought back "his splen-
did miraculous signs and his sweet teaching" on his descent. The "sweet
teaching" is the message of God's union with the human soul, the sole
message that Mechthild, considering it the most important, selects from
among Moses' signs. A similar vein is taken in the twin manuscript of *The
Flowing Light* (Einsiedeln MS 278), which comes from the same scriptorium
in Basle and contains Rudolph of Biberach's handbook on mysticism *Die
sieben strassen zu got (The Seven Roads to God)*: twice, namely in the
Prologue and in Book 7, the following passage occurs, which takes up the
teaching of Richard of Saint Victor and Saint Gregory the Great.

> When the human spirit which was, as it were, separated from body
> and soul, returns to the soul and the body from the land of inner light,
> it should report what riches it has received, what words it has heard
> and what delight it has tasted if it is capable of expressing this in words,
> for St. Gregory says: "It often happens that it is unable to clothe what
> is sees and experiences in words." If it is not able to put it in words,
> it should act like a second Moses when it returns to its body and soul
> from God's company and bring back some sign or testimony that it
> has been in the land of light.[38]

Mechthild knew, then, of the discussion about Moses' vision of God
and of the obligation imposed by the resultant teaching that the grace of

inwardly experiencing God is not a private matter but associated with the task of preaching. Heinrich of Nördlingen passes on to Margaretha Ebner this view derived from Mechthild's work and from Rudolph of Biberach's *Die sieben strassen zu got*, which was translated at approximately the same time from Latin into High Alemannic. He puts her in the same tradition as Moses and Saint Paul, who was taken up into the third heaven and did not know whether it was in the body or out of the body,[39] figures whom Mechthild called upon as her chief witnesses alongside the prophet Daniel in support of her ecstasies. Thus Heinrich conceives of Margaretha as a closer link in the chain of recipients of the "greeting of divine grace" that at all times issues forth from the "flowing God" (Mechthild).

It was the peace and security of her religious life that attracted Heinrich to Margaretha. He, himself, felt unbalanced in the "inconstancy of his heart" and "foolishly childlike in his senses."[40] He looked up to her in admiration and longed for her during the years of their separation. Nonetheless, Heinrich plays the role of a guiding *spiritus rector* for Margaretha. Occasionally, he is dismayed at the great respect she displays toward him and thinks that he must cut her loving view of him down to a realistic size. In a text typical of this attitude, he writes to her in an extremely gentle, yet also self-critical tone. "You have written one thing to me that I have to contest, namely that you cannot complain of my failures in your innermost heart. Dearest, faithful love of my heart in God, when will your beloved, Jesus, forgive me for them if you cannot beseech Him fervently to do so? I beg you to set my house in order before Him. This is what I commend to Him and you."[41] He counters her yearning for his personal closeness with Christ's word, "It is good that I depart from you" so that her life will be purged by the pain of separation and gain in spiritual strength.

This relationship changes, however, in the course of time.[42] Margaretha becomes a prophet and teacher for him. He feels himself to be poor compared to her. He seeks strength, instruction, and consolation from her as the repeated letters of thanks and the emphatic assertion that he can open his heart to her confirm: "To whom on earth could I utter my laments better than to you?"[43] He calls her the "faithful co-bearer of my suffering"[44] when writing to her from his approximately ten-year exile in Basle, where he has to put up with "envy and hatred" as well as "many poisonous attacks" precisely on the part of the professionally pious as a result of jealous reactions to the success of his sermons.[45]

The great variety of forms of address betrays the spiritual elevation he receives from Margaretha: "You chosen joy of my heart, sacred consolation of my soul, safe refuge of my life and all my hope";[46] "the faithful rule of my life and the sweet secret of my soul, in which my thoughts find nourishment and divine teaching and grace."[47]

The spiritual nourishment and teaching that Heinrich wishes to partake of through Margaretha is the intoxication that God requested in the language of the Song of Songs. He addresses Margaretha as "Beloved, *dilecta mea,* in Christ," who numbers among the "chosen hearts" for whom God "Himself planted the vineyard" so that he, "poor and thirsty" as he is, can likewise drink of "the Cyprus wine which is Christ Himself."[48] He sees his love for Margaretha as an indirect source of grace and integration on the way to love of God, regarding the friendship not as a mere instrument, but as a gift of mutual joy in mutual loyalty and responsibility that cannot be cherished highly enough. He praises this gift and thanks her for it in the most unreserved manner. "Dearest sister, bride of God and reverend mistress of my heart, I thank you [Euch] with a silent mouth and a heart that cries out for all the good that God in His faithfulness and exceeding mercy has given me through you. I can write no more about this. I commend it to Him who works it in you and grants it in His grace to me, poor and indigent as I am, through you."[49] And elsewhere: "To you, the most heartfelt treasure that I possess here on earth after God and through His grace. . . . You sweet fruit of the Holy Spirit."[50]

Margaretha for her part is convinced that Heinrich can do great things for the glory of God and grow close to Him. In one of her visions that recalls the language of Mechthild of Magdeburg, God praises Heinrich. "He is a true delight of my holy divinity and a sure follower of my holy humanity; he will taste me with the cherubim and see me with the seraphim and I will draw him into the wilderness of my holy divinity and sink him into the mirror of my holy divinity, where he will see my glory quite clearly."[51] Looking back in joy and gratitude to his first meeting with Margaretha, Heinrich recognizes her suprapersonal value for the whole church. He admits in all frankness to her, "I, your poor friend, stand in the midst of your caring radiance (free translation of, "Ich, Dein armer Freund, stehe in der Mitte Deiner fürsorglichen Ausstrahlung"). He is not only aware that he is personally carried onward by her spiritual powers and, as if cloaked in a protective mantle, protected against the vicissitudes of life but also convinced that her inner spiritual powers can become a

source of insight and a pointer to the way for all people. Looking back, he comes to the conclusion, "My dear, when I wanted to write to you, I had to beg so much for you. I was forced to do so by the grace with which God first gave you to me. I trust in Him . . . that He will wish to give me and the whole Church a special treasure through you and from you."[52]

Heinrich's relationship with Margaretha was based on his belief that Margaretha had a calling. He sees her not only as offering "sure access to God"[53] but also ascribes a prophetic task to her. He transports the personal gift of friendship beyond all subjectivity so that the timeless values experienced in it, the indwelling and working of God in humans may be proclaimed. Thus it is not "unmanly" when, conscious of his own inner, mystical inexperience, he refers to himself as "lowly" and "unworthy." He makes use of biblical imagery to express their mutual relationship. What, he writes, should an "arid heart" say to one that has drunk from the dew of heaven?[54] "What do you still need me for?"[55] he asks. He confesses to being lacking and admits that human talents and earthly ability cannot of themselves gain access to certain areas of experience. Spiritual experiences open up dimensions and set free powers that can give direction and provide constructive assistance to the individual as well as to the community at large as regards the orientation and shaping of their lives. Heinrich thus writes to her, again using the symbolic language of *The Flowing Light*, which is itself strongly influenced by the imagery of the Song of Songs. "I and all created presence must retreat before you; how gladly we would go with you! We are not allowed in [. . .] when you and your kingly beloved, Jesus Christ, enter the wine cell in which your chaste breasts are to be filled to abundance so that they shall suckle not only me, but rather the whole Church with good nourishment."[56] Here various images from different places in *The Flowing Light* are combined with each other in a new way. The image of the wine cell from the Song of Songs symbolizes intoxication in God, while the bridal relationship of the soul to God is the strongest image of the bond with God. Alongside this image as an expression of her individual, personal relationship with God, Heinrich sees Margaretha as the suckler of all souls, whose office toward souls is to nourish all Christians with the "overflowing milk of teaching," the faith or the mysteries of the faith. In Mechthild, this image is applied to the Virgin Mary and the church, which fuse into one. Mary as the church already nourished the teachers and prophets of the Old Testament as well as the apostles and martyrs with "her pure, immaculate milk," that is, intact faith:

"If you no longer wanted to suckle, the milk would cause you great pain."[57] This image symbolizes the "sweet necessity of the suckling breasts" from which salvation flows; in Mechthild of Magdeburg, it flows from Mary and the church, whereas Heinrich ascribes this lofty office to Margaretha as a God-filled proclaimer of His grace.

In her extraordinary power of love, Margaretha is for Heinrich the outstanding guide who leads humans to God. He names her the "faithful bearer of the sins of the world,"[58] a name otherwise applied to the Mother of God, since her love flows from "the eternal fount of love into us and all men" until "it flows back into its own origin."[59] He cries out to her as his spiritual mother, "Open up the soil of your heart and bring forth for yourself and us the Saviour."[60] As Mary bore Christ, the Son of God, in the body, so the power of the heart enlightened by the divine word brings about a rebirth of humanity. In order to elevate the figure of Margaretha even higher, Heinrich addresses her as "Mary's blessed follower from earthly to heavenly things, from the transient to the eternal."[61] He is convinced that what Margaretha says and writes is inspired since "St. John the Evangelist, God's secretary, is also her secretary."[62] These words recall the life of Hildegard of Bingen written shortly after her death: in order to strengthen her authority the authors, two monks called Gottfried and Theoderic, placed her at the side of Saint John the Evangelist.[63]

Margaretha was blessed with a rich range of above-average inner experiences. However strong her feelings were, she retained a remarkable love of truth. She emphasizes that Heinrich was given her by God "in the light of truth."[64] Her great experience of God in Minne's (Divine Love's) grip on her heart, symbolizing an exchange of hearts between Christ and herself, grants her as a first gift "the light of the truth of divine understanding."[65] With respect to this gift of understanding, Heinrich asks her in one letter whether "that inner eye is open to which alone God reveals himself."[66] Knowing of the enlightening powers of truth, Margaretha does not give in too quickly to her feelings and visions but makes distinctions to the best of her ability. A reassuring dream that Heinrich was given over to her faithful charge belongs to this search for certainty. A few hundred years later, a similar case is attested to when the sixty-year-old Saint Teresa of Avila received confirmation in a vision of the last great friendship God gave her, namely that with Father Jeronimo Grácian.[67]

The correspondence between Heinrich and Margaretha has its place in the chain of models of saintly friendships, such as those between Saint

Hildegard of Bingen and the monk who was her secretary, friend, and adviser, Volmar, whose death she "could never weep over enough";[68] between Jordan of Saxony and Diana; between Peter of Dacia and Christine of Stommeln; or between Mechthild of Magdeburg and the Dominican Heinrich of Halle. What is surprising in each case is the certainty with which two people believe, even over long periods of separation, that they exist for each other in a God-willed way. And to what purpose do they belong to each other? In order to allow their personal longing to flow into a greater yearning for God so that their personal exchange of what moves their hearts and spirits should end, filled with gratitude, in individual dialogue with God. Heinrich's letters show that the main emphasis of his correspondence between 1332 and 1351 lay in the exclusive purpose of drawing more closely to God. What is of primary importance in this connection is the soul's personal relationship with God; every other relationship, for example, that between man and woman, is developed on the basis of this relationship, which is one cultivated from above and not usurped from below. The incomparable inner experience urges an exchange with a friend in all purity and sincerity *ad maiorem Dei gloriam.* The value of a friendship does not rest in some consensus of social opinion but seeks its origins in a divine spark that cultivates the heart and the spirit as opposed to all superficial striving for pleasure, all immoderate relativism and pessimism, and rests on nobility of the heart, the prerequisite for living together in an ordered and peaceful way. What counts is the mature and formed individual, who alone is creative and capable of acting freely and responsibly, but not the anonymous, impersonal mass of society. It is individuals who constitute communities, which means that anthropology, the science of an individual and one's culture, precedes any kind of sociology and social studies.

The high value of friendship teaches us that individuals move people with their spiritual power and create relationships spanning time and space. When Heinrich enters the scene in Medingen — in the documents he is referred to as a *"magnae discretionis vir"* and *"honestus vir"* — [69] his friends become Margaretha's friends, too. Through Heinrich, Margaretha comes into contact with Queen Agnes of Hungary in Königsfelden in the Aargau in Switzerland, to whom Eckhart dedicated his *Book of Divine Consolation.*[70] She requests by letter financial support for construction work she plans for the convent, a request which is granted by the Queen.[71] As a result of Heinrich's stay in Basle she comes into contact also with Suso,

Tauler, and his circle of friends, one member of which is the well-known Beguine Margaretha of the Golden Ring, who is repeatedly mentioned in Heinrich's letters as sending Margaretha her regards. The extent to which Heinrich valued his friendship with Margaretha as a way to God is shown in a letter from Basle in 1346 or 1347, in which he lists some of his friends by name, for example, the Countess von Falkenstein in the Dominican Convent of Klingenthal in Basle, a knight in Pfaffenhofen by the name of Heinrich von Rheinfelden, and a knight in Landsperg together with his wife, a woman inspired by God, and concludes his list with the comment: "I cannot name them all to you." He sets great store by the cultivation of his friendship with Margaretha because he is convinced that his friends and she, too, will in this way achieve a more intimate relationship with God, as he makes clear to her in the same letter. "When I commend us and the friends God gives us to you, do not cease to open your heart and accept them as you would wish God to accept you and then carry them, with a new loving sincerity in your heart, into the heart of Jesus Christ so that they may enter His heart through yours. There they will no longer be an impediment to you but rather promote you before God so that you will be given as many new dwellings in God as you have ever been granted dwelling in Him."[72]

The principle of such piety feeds on the winged power of the mystic heart, which does not allow people to dry out or to become crippled. Even in the emotional sphere of affection, love, and friendship, it augments human understanding, leading to a mutual exchange of love of God and one's fellow persons. This proves to be a self-regenerating source of energy: in a God-created world, the web of human relationships assumes a mirror quality and acts as a symbol.

The correspondence shows how Heinrich's friendship with Margaretha was the motive for linking the geographically distant towns of Magdeburg and Helfta in Saxony via mystical writings with areas stretching from Basle, the Alsace, Cologne, and Aix-la-Chapelle to Medingen in Upper Swabia to bind them together as a circle of friends with Margaretha Ebner at their centre. These writings show further that the symbolic language of bride and bridegroom persists, albeit with variations, over space and time. It expresses the age-old desire existing between God and humans, the wine symbolism of the Song of Songs indicating the motif of bliss and intoxication by God. Even though Margaretha's *Revelations* are not distinguished by the rich forms of Mechthild's brilliant language, the correspondence

nevertheless conveys a picture of a pure, highly sensitive personality endowed with great spiritual power to whom not only Heinrich, but also numerous other people looked up. It communicates a trust that is attested to in the letter to Margaretha written by an unknown Friend of God and by the five letters addressed to her by Abbot Ulrich of Kaisheim.[73] The friendship between Heinrich and Margaretha was so fruitful for both of them in giving and taking that others, too, benefited from it. But it was only able to prosper, as Heinrich wrote, on the basis of a heart filled with grace: "One has first to be nourished before one can nourish others."[74]

In 1350, Heinrich, coming from the Alsace, at last returned home. He saw Margaretha once more before she died on 20 June 1351, at the age of sixty. Because she was regarded as a saint, a monument was erected to her in the chapter room of her convent soon after her death and later rebuilt as the Margaretha Ebner Chapel so as to allow her veneration. What became of Heinrich of Nördlingen is lost in the mists of history: the last that is heard of him is in the writings of Christine Ebner, who records that the seventy-four-year-old Dominican nun gave him shelter at the Convent at Engelthal near Nürnberg on 9 November 1351. After that no more is heard. The century-long veneration of Margaretha Ebner, however, remained unbroken, and on 24 February 1979, she was officially beatified.

7

IN SEARCH OF MEDIEVAL WOMEN'S FRIENDSHIPS

Hildegard of Bingen's Letters to Her Female Contemporaries

ULRIKE WIETHAUS

THE PROBLEM: DEFINING (MEDIEVAL) WOMEN'S FRIENDSHIPS

UNTIL VERY RECENTLY, the theme of medieval religious women's friendships with other women has elicited little attention. The search for women's same-sex relationships has emerged most clearly among historians interested in the history of medieval homosexuality.[1] Although research of this kind focuses on a specific group of women, the work done in this field is relevant to the lives of all medieval women. With the definition of feminist women as "woman-identified women," a term coined by Adrienne Rich, we can search for areas of exclusively female experiences in the larger field of patriarchal culture, in which women could create, no matter how precariously, relationships among themselves.[2] Such a search can generate a historical perspective in which women are not "the Other" of an androcentric cosmos but are defined in and through themselves.

We possess only a few contemporary theoretical models that describe explicitly the nature of women's friendships.[3] For medieval women, contemporaneous theoretical resources are as yet virtually nonexistent; one noteworthy exception is Christine de Pizan's (1365–ca. 1430) *Le Livre de la Cité des Dames.*[4] She wrote in detail about the relations among women at court and developed a theory on women's solidarity as a means to survive in a harsh, misogynist climate. The only same-sex relationship fairly well documented in medieval religious literature is male friendship, in particular during the relatively short period of early Cistercian culture. It found

93

its fullest expression among those Cistercians who were Hildegard's con-
temporaries, Saint Bernard of Clairvaux (1090–1153) and Aelred of Rie-
vaulx (ca. 1110–1167). In the works of these two writers, friendship among
men is celebrated with sensitivity and psychological insight. As Brian
McGuire points out, the revival of friendship among Cistercian monks was
rooted not only in a familiarity with classical and patristic sources. The
patterns of feudal life with their emphasis on kinship bonds, which were
familiar to the adult Cistercian novices, as well as a new sensibility of the
dynamics of personal experience count as equally if not more important
reasons.[5] Through the celebration of male friendship, a new generation
of adult male converts was able to express a religious identity. The notion
of friendship eased the transition from the secular to the sacred by trans-
ferring already known patterns of relationships into a monastic setting.

Why didn't medieval women, like men, leave us philosophical, spiri-
tual, or theological reflections on *their* relationships? One possible socio-
logical explanation can be constructed with the help of Michelle Zimbalist
Rosaldo's theory on women, social identity, and culture.[6] If she is correct,
we should not be surprised by the absence of medieval theories on female
friendship. Rosaldo noted that to become a man in patriarchal society is
usually understood as an achievement (that is, as a publicly acknowl-
edged performance), whereas "womanhood, by contrast, is more of a given
for the female."[7] As a result, "we find relatively few ways of expressing
the differences among women."[8] All women, owing to patriarchy's bio-
logical definition of femininity, "are" their feminine identity, they do not
"become" or "make" it. Because men are the ideological shapers of culture,
men's development of identity, based on the development of skills, has so-
licited infinitely more attention and reflection. Thus Cistercian discussions
of male friendship functioned at least in part to determine the monk's new
status as achievement and defined his aptitude for contributing to the emerg-
ing Cistercian system. Aelred's philosophy appears to support such a read-
ing. He emphasizes that friendship among monks is only justified if it is
geared toward a goal. The cultivation of friendship should serve as a means
to reach greater spiritual perfection.[9] This achievement could only be mea-
sured by comparison with other men and within a public context.

Rosaldo and Lamphere argue that because women in patriarchy
generally experience themselves less in terms of public performance, state-
ments and reflections regarding their status differences are rare or almost
nonexistent.[10] If this theory is correct, we might generally expect women's

reflections on their friendships with other women only in settings that are less patriarchally determined, that is, in those cases where women have access to public roles and activities. The monastery as an institution has historically provided a space in which women could develop hierarchies and status differences based on public performance with relatively little interference by men. From this perspective, McGuire's positive description of male monastic life and its opportunities for self-representation reflects the experiences of medieval religious women as well. He writes, "Friendship is a commonplace of monastic life. What more congenial environment could be found for the formation and cultivation of friendships than the protective recesses of monastic cloisters? Here existed the time, charity, and mutual concern so painfully absent in the outside world. In the cloister men could get to know each other and to experience each other in the fellowship of Christ."[11]

On the basis of McGuire's analysis of Cistercian male friendships, we need first to ask whether the reasons he cited for the formation of male monastic friendships can also be used as categories for an analysis of Hildegard's and other religious women's same-sex friendships. Certainly his assertion that the atmosphere of cloistered life and intimate day-to-day encounters fostered friendships will hold true. But was the depth-dynamics the same for women as for men? The most obvious difference is certainly that all medieval women, unlike medieval men, experienced their friendships against the background of patriarchal structures. In Hildegard's correspondence, I found also that at least in one case, her friendship appears to have been colored by the primal relation between mother and daughter. As contemporary psychoanalytic theory suggests, the rewards and challenges of identity and separation in such a relationship are fundamentally different from those in a relationship between mother and son.[12]

McGuire's second point, that a familiarity with an already existing tradition of writings on male friendship fostered a Cistercian endorsement of male friendships, is more difficult to translate into a female context. In his overview of friendship in Western monasticism, McGuire presents numerous examples of cross-sex friendships, in which educated women made use of rhetorical formulae derived from classical literature, but no female same-sex reflections on friendship are presented.[13] Although engaged in diverse and intense relationships with other well-educated women, Hildegard too does not seem to reflect on them by referring to a tradition of male writings on friendship.

McGuire's third observation, that already existing feudal kinship ties were translated into male-to-male friendships in a monastery, also needs to be reevaluated for an exclusively female context. Hildegard's feudal relationships to her women correspondents and her fellow nuns at the Rupertsberg did not necessarily translate into firm friendships. As I will show in the example of her correspondence with the countess Gertrud, who belonged to the highest circle of the German nobility, such relationships could foster stable ties. In the case of Richardis of Stade, however, friendship could be severed for the sake of closer family connections. Of interest in this context is a letter by the abbess Tengswich, in which she criticized Hildegard for yielding too much to feudal structures beyond the threshold of the convent.

McGuire's fourth argument for a renewed interest in friendship is the Cistercian recognition of the significance of personal experiences for spiritual growth. This perspective in Cistercian friendship theories is characterized by a sensitivity to psychological dynamics, and draws its emotional fervor from the Song of Songs. It is not by accident that Saint Bernard, who wrote the great series of sermons on the Songs of Songs, also left us letters in which he discussed his feelings of loving friendship for other men, such as William of Saint Thierry or Peter the Venerable. Dependent upon gender, however, same-sex friendships contribute differently to the growth of an individual. Within the context of a female same-sex friendship, patriarchal gender stereotypes can quickly lose their importance because the visible reference for all stereotyped behavior — men — is absent. Authenticity of conduct and freedom of self-expression can emerge more easily. About fifty-five years ago, the psychologist M. Esther Harding claimed that female friendships pose a challenge to the structures and foundations of andro-centric culture. Although she wrote about female friendships at the beginning of our century, her insights can be related to other patriarchal periods in history. She describes the alternatives that women's friendships offer to women as follows. "[W]omen, through their mutual relationships, are beginning to evolve a new consciousness . . . they seek in their friendships for a new kind of relationship — for a truth in human situations which has a significance beyond personal likes or expediency." A woman's search for female friends manifests a "need of a certain independence from men during a period in which woman is finding a new aspect of herself."[14] Harding's definition of women's friendships is without doubt idealistic. In her book *Women's Friendship in Literature*, Janet Todd

analyzes women's friendships with greater realism.[15] She suggests five types of friendship. These types may overlap; they are not intended to represent the full spectrum of female friendship; one or all of them may be played out in one particular relationship. The author distinguishes between sentimental, erotic, manipulative, political, and social friendships. Todd differs from Harding in the claim that it is only in political and social friendships that a critique of patriarchal structures is either explicitly or implicitly expressed. Only here can women perform socially significant "rituals of authority" and develop a personhood differentiated by achievement. Their self is created in public rather than private images. Because the public self has been built through relations with other women, its character is not necessarily determined by patriarchal stereotypes as are most male public performances.

Todd's five categories are defined as follows. Sentimental friendships are based on a "close, effusive tie, revelling in rapture and rhetoric. Unlike the sentimental romance which so often ruins, it aids and saves, providing close emotional support in a patriarchal world. If heterosexual love has proved violent or painful, it may even threaten and replace this love."[16] Erotic friendships are based simply on experiences of physical love, either as transient episodes or as a persisting element of a friendship. In manipulative friendships, one woman controls and uses another woman, and enjoys the power she has. Political friendship, as mentioned, comes closest to the revolutionary function of friendship M. Esther Harding suggested. Janet Todd, however, stresses more the public nature of such a friendship than does M. Esther Harding. Therefore, political friendship "requires some action against the social system, its institutions or conventions."[17] Social friendship, finally, "is a nurturing tie, not pitting women against society but rather smoothing their passage within it. . . . Here the support and acceptance of other women is essential, since through their teaching of female lore . . . women aid and sustain each other."[18]

MEDIEVAL EVIDENCE FOR FEMALE FRIENDSHIPS

Janet Todd developed her typology through an analysis of nineteenth-century literature. Although her search has not yet been repeated for the medieval period, a number of avenues to medieval women's lives suggest themselves. Eventually, an exploration of these and other sources can fill

the lacunae of theoretical texts on friendship by medieval women writers. Elizabeth Petroff, in her book *Consolation of the Blessed*, mentions the intense friendships Italian women saints enjoy with other women.[19] She writes about thirteenth-century female saints, "Almost every saint's life tells of a profound relationship with a woman friend: Benvenuta had her sister Maria, with whom she shared her bedroom, her secular friend 'the devout widow Jacobina', and in the convent which she visited almost daily there was her beloved Margarita."[20] Given the fact that so many women in the Middle Ages were drawn to a religious life-style, friendships of any type must have formed a new subculture of relationships in the growing number of lay religious life-styles, in which women experimented with new forms of communal living.

Women's friendships were frequently recorded iconographically in images and symbols and expressed metaphorically in relations to spiritual beings. For example, a description of female companionship is found in Mechthild of Magdeburg's (ca. 1212–1282) vision of an exclusively female heaven, with virgins populating the highest heavens, followed by widows and married women.[21] Herrad of Landsberg, an earlier artist and nun, left us illustrations of women fighting together and against each other in the allegorical battle of virtues and vices. Her text was intended for the instruction of fellow nuns (Herrad of Landsberg, *Hortus Deliciarum*).[22] The canoness Hrotsvit of Gandersheim (tenth century) wrote protofeminist plays in which pious women banded together in protecting themselves against hostile men.[23] A positive spiritual paradigm for women's friendship were women saints who acted explicitly as protectors of women. Writing about the Blessed Benevenuta of Friuli, Petroff observes, "The female saints in heaven are continually acting in collusion with the would-be saint on earth, giving her advice, pointing out new directions, consoling her, bringing her healing and confidence in her vocation."[24]

Finally, we also know about ritualized activities open only to women which as such affirmed their coherence and visibility as a group within society at large. The process of giving birth, for example, took place among an exclusive group of women; in the medieval community at Montaillou, women as a group took exclusive care of the dead. As Le Roi Ladurie writes poignantly, "between deathbed and burial, people became the property of the women, as they had been, when alive, during their infancy."[25]

Hildegard's letters thus are only one signpost among many others that point to the as yet uncharted territory of women's same-sex relation-

ships in the Middle Ages. To study these relationships signifies an important corrective to andro-centric views on medieval women.

HILDEGARD'S LETTERS

Although Hildegard enjoyed great fame during her lifetime, her position in a patriarchal world was not without conflicts. She had to fight to establish her new, independent convent on the Rupertsberg; it took a serious illness to push her to take the decisive step of publicizing her prophecies at the age of forty (something hard to imagine for a male writer of comparable social background and standing), and as an old woman, Hildegard had to stand up against the hierarchy of her diocese. She was threatened with excommunication. Do her letters to other women reflect these struggles? What were the relations Hildegard entertained with her female correspondents? By looking at her same-sex correspondence, the immediate impression is one of astonishing diversity. Although the letter collections stress an asymmetry in which Hildegard is the older counsellor who advises younger women or women of lesser spiritual status, a closer look reveals often touching variations on this theme. In some cases, Hildegard breaks through the role expectation of spiritual adviser and shows herself as capable of passion and despair, love and self-doubt. And although it is dangerous to generalize, one might say that Hildegard's same-sex correspondence generally impresses as being more direct, frank, and emotional. The letters express more of Hildegard's individuality than those composed for men (with the exception of those to men who were dear to her, such as Wibert of Gembloux). Status differences, formulated poignantly in the greeting, do not generally lead to the stilted style so frequently found in the correspondence with male recipients. Only rarely does Hildegard downplay her own status by pointing to herself as weak *femina forma*. In the following section, I interpret a few of her letter cycles as examples of the complexity of her friendships. In my reading, I rely heavily on Todd's categories.

Gertrud of Stahleck: A Social Friendship

Gertrud was a woman born into the highest circles of the German nobility; she was the sister of King Konrad III and an aunt of King Bar-

barossa.[26] Together with her husband, she made rich endowments to Hilde-
gard's convent on the Rupertsberg. After the death of her husband in 1156
and because she had no children, Gertrud decided to take the veil and re-
tire to the Cistercian convent in Wechterswinkel. She does not appear to
have been happy with her life in this convent; after a very short period
of time, in 1157, Gertrud moved to Bamberg, where Archbishop Eberhard
founded a convent for her and her fellow nuns. Hildegard obviously played
an important part in finding this new place for Gertrud: using her author-
ity, she wrote a letter to Eberhard and asked successfully for his support
of Gertrud. In the following year, 1158, Gertrud renewed and reaffirmed
the endowments to the Rupertsberg convent made earlier by her and her
husband. At this crucial period of change for Gertrud, who must have
been about forty, Hildegard was in her sixties and at the height of her
powers. Gertrud's move to Bamberg might have reminded her of her own
fight to move to the Rupertsberg and to found her own convent, which
had happened just a decade earlier (between 1147 and 1150).

The interests and needs each woman brought to the relationship ap-
pear to be balanced. The dependencies seem mutual — Hildegard was obliged
to Gertrud financially; Gertrud needed the advice of the older woman and
perhaps also her network of connections. Using Janet Todd's scheme, we
thus might speak of a social friendship, whose function is "a nurturing tie,
not pitting women against society, but rather smoothing their passage
within it."[27] As Todd writes, the teaching of "female lore" is crucial.[28] Both
women support each other with the resources they have in plenty: in one
case money, in the other, advice ("female lore") and connections.

How is this relationship expressed in the few extant letters? When
Gertrud entered the Cistercian monastery in Wechterswinkel, Hildegard
prepared her for the shock this change of life would create. "Don't let your
heart be confused," she admonished. The new and more austere way of
life would give birth to Gertrud's true spiritual identity, which had been
repressed by her rich and proud secular life-style. To give up comfort would
be painful, but, as she consoled Gertrud, God loves those who are chas-
tized. Unlike in the secular world, where Gertrud needed to be indepen-
dent, trusting only herself, the novice could now relax: God held her fully
in His hands, knowing her deeply, being at her side continuously.

The same psychological sensitivity to Gertrud's state of mind can be
found in a second letter, in which Hildegard answered Gertrud's inquiry
whether the older woman can see into the future and tell where the new

home for Gertrud and her fellow nuns will be. Hildegard opened the letter
by characterizing Gertrud's personality: "O daughter of God, deep inside,
you are always worried about the state of souls."[29] In the next sentence,
her judgment of the younger Gertrud is even sharper: "O beloved child
of God, in your soul you are always worried!"[30] And without any delay,
she immediately addressed Gertrud's concern. The woman who has been
praised as a public figure of great charisma now shows her practical side
and shares "female lore."[31] No, she has had no vision, she answered Ger-
trud, but she knows how to find a new place, as she has heard in the form
of words in the light.[32] Gertrud should use her own intelligence and skills
during the search, get the advice of experts, and look for a place that
responds to the needs of Gertrud's small community. Gertrud should not
compromise. Such a practical approach is quite holy, Hildegard hastens
to add, because human beings are created in the image of God, and this
creation includes the use of common sense. And in a very motherly way,
Hildegard closes this no-nonsense letter in full circle, responding again to
Gertrud's lack of confidence: "Now be happy again and stick to your enter-
prise, in the name of God."[33] Hildegard's responses in the two letters show
her to be a realistic counselor who eases her friend's entrance into a new
social context. The behavior prescriptions are far from stereotyped: Ger-
trud should be receptive and relaxed when necessary, but active, deter-
mined, and steadfast as well if the situation calls for it. Hildegard seemed
to have been well aware, however, of the force of gendered behavior stereo-
types. In the supportive letter to Archbishop Eberhard in Bamberg, Hilde-
gard uses masculine or gender-neutral images rather than feminine ones
to describe Gertrud's situation. This shift in imagery underlines Gertrud's
initiative and desire for change rather than emphasizing a stereotypically
female passivity, which Hildegard was willing to endorse in her own case
when it was politically opportune. Gertrud is made to appear as a second
Abraham, who left his country because of God. She resembles the man
who, early in the morning, worked in his vineyard. But because of her
unhappiness in Wechterswinkel, she is pressed like the grapes in the kelter,
an image reminiscent of Christ. "Therefore help her," Hildegard writes,
"so that her vineyard might not be destroyed."[34]

Hildegard's final letter of this cycle is directed to the new community
in Bamberg. It marks a new stage in this social friendship. Unlike Hilde-
gard's first and second letter to Gertrud, this letter lacks warmth and in-
timacy. The old abbess stresses the responsibility involved in setting up

a new community. The women may forget about God and the spiritual life. Bad habits, pride, and vanity can easily flourish in a convent. Despite previous admonitions to be active, Hildegard now stresses that it was ultimately not a personal victory to have gained a new place, but God's preconceived plan that came to fruition. The crisis is over, Gertrud is established as abbess; she needs to roll up her sleeves and get to work. The umbilical cord is cut, the "beloved daughter of God" is weaned, the transition is over: authority and commitment have replaced confusion and discouragement. Gertrud will respond to this appeal to her new status by sharing *her* resources — money — in turn: needs are mutually, if differently, identified and satisfied.

Elisabeth of Schönau: A Professional and Political Friendship

The letters exchanged between Elisabeth of Schönau and Hildegard are very well known and have frequently been discussed as examples of the great diversity in visionary experience and mission among medieval women mystics. Therefore, I will concentrate only on a few observations that highlight the women's emotional relationship rather than their particular form of visionary mysticism.

The letters — three by Elisabeth, two by Hildegard — begin roughly at the time of Hildegard's letters to Gertrud (before 1157); and with an interruption of about six years, reappear shortly before Elisabeth's death at the age of thirty-six (1165).[35] Although Elisabeth and Hildegard were temperamentally different, they shared a unique quality: that of intense contact with supernatural reality. Other encounters between religious medieval women weave a background to these letters and, by contrast, make these letters all the more touching: Joan of Arc's (ca. 1412–1431) meeting with Catherine de la Rochelle with whom she spent two nights to test the validity of Catherine's nocturnal visions, only to reject them at the end.[36] Equally uneven was the encounter between a struggling Margery Kempe (ca. 1373 until after 1438) and a serene and wise Julian of Norwich. We know very little about the emotional relationship between the Helfta mystics, Gertrud and Mechthild of Hackeborn (both thirteenth century). Another relationship, that between the visionary abbess Benedetta Carlini (d. 1661) and her lover, the much younger nun Bartolomea (d. 1660), was probably one of exploitation and dependency.[37]

Given the unusal sharing of visionary experience between Hildegard

and Elisabeth, a new category needs to be introduced that I would like to call a professional friendship. Both women exchanged thoughts about their public "work," their calling, their literal profession as visionaries. In Todd's scheme, it seems that they also entertained to a certain extent a "political friendship." This type of relationship is defined as requiring "some action against the social system, its institutions or conventions."[38] Hildegard acknowledged in the letters that she and Elisabeth worked against the corruption of contemporary society, and that they were carrying out a divine mission. Finally, their relationship also exhibited elements of a social friendship, in that Hildegard (and here we find less mutuality than in the relationship to Gertrud) helped Elisabeth to cope with the pressures of her environment.

The professional and political aspects of their relationship create a shared public space for the two women. As such, their sense of personhood as evidenced in their correspondence comes close to a masculine definition of personality based on publicly acknowledged achievement. Their mutual empowerment and affirmation parallel masculine public rituals of authority. Visionary and publicly recognized authority, however, is fraught with anxiety for both women. More unusual among men, it is the tension between private self-definition and public image about which Elisabeth and Hildegard write and which they try to resolve through their relationship.

As Michelle Zimbalist Rosaldo noted, entering the public arena is anxiety-provoking for women, because it constitutes a challenge to a male prerogative. "[Women's] position is raised when they can challenge those claims to authority, either by taking on men's roles or by establishing social ties, by creating a sense of rank, order and value in a world in which women prevail. One possibility for women, then, is to enter the men's world or to create a public world of their own."[39] As fragmentary and limited as these letters are, they nonetheless describe both routes. Hildegard and Elisabeth reflect on their unusual public role and make an attempt at establishing a sense of rank, order, and value in their own visionary "world." The first letter Elisabeth writes to Hildegard has been written while Elisabeth was still a simple nun (before 1157). Through a mutual acquaintance, Hildegard had previously sent greetings and words of comfort to the younger woman. Elisabeth had met with much opposition among the laity and the clergy who questioned the truth of her visions. She wanted to explain the rumors to Hildegard and asks for Hildegard's judgment on her

behavior. Certainly, Elisabeth did not do anything that was wrong? Elisabeth wanted the older and well-established visionary to pronounce her innocence and thus be reconfirmed in her vocation. Who else but Hildegard could better verify Elisabeth's experiences? Here we have a rarely documented case in which the professional expertise of one woman is used to strengthen the public image of another woman against a critical public audience. Hildegard's response is surprising. Rather than speaking from a position of human authority, Hildegard began by exchanging her title "magistra" with the self-deprecating formula that she uses so often in her letters to men to depict herself as visionary, calling herself a "miserable form" and a "fragile vessel." The point of reference is divine and implicitly critiques human power structures. What matters is not that Hildegard is older and has more experience, but that the divine chooses some human beings over others to become visionaries. It is God, Hildegard seems to say, who affirms Elisabeth; human opinion and ranking do not matter in this context. Nonetheless, Hildegard, at least in part, claims the authority of a mother over her daughter by using titles of address common in monastic discourse among women. Three times in this letter, Elisabeth is addressed and admonished as daughter — she should listen to Hildegard, and follow her advice to see herself as a "trumpet of God," trying to live an impeccable life. In her seemingly contradictory two epistolary postures toward Elisabeth, Hildegard thus balances aspects of her complex vocational persona: that of Mother Superior, that of divinely chosen visionary, and that of publicly visible prophet. Perhaps because of the similarity of their experiences as openly scrutinized visionaries, Hildegard discloses some personal information that validates Elisabeth's feelings of anxiety. At the end of the letter, Hildegard describes movingly her own feelings of inadequacy and the fear she sometimes feels pronouncing God's will. Elisabeth responds to Hildegard with fervent admiration and gratefulness: "Your words have kindled me as if a flame would have touched my heart."[40]

After this crisis, Elisabeth projects a more self-confident persona; a later letter can be interpreted as a formal epistolary "ritual of authority" that further consolidated both women's visionary calling. Written around 1163–1164, at a time when Elisabeth, now a magistra herself, has found greater public acclaim, its content focuses exclusively on a church-political issue, the rise of the heretical sect of the Cathars.

Here, Elisabeth paints a glowing picture of Hildegard as a leader of the church. Any request for a prayer or advice, so frequent in other letters

addressed to Hildegard, is missing, and there is only praise and admiration for the older woman. The letter celebrates the center of their mission: to reform the church and to do the will of God. The early phase of insecurity seems to have been overcome for now.

Toward the end of Elisabeth's life, however, the relationship takes yet another turn that is demarcated in one final letter by Hildegard. The abbess obviously had heard of Elisabeth's life-threatening measures of ascetic exercises. Given her somewhat unstable and vulnerable psychological makeup, Elisabeth's self-mortification might have functioned as a means to constrain recurring self-doubt and insecurity. Hildegard now stresses the authority she previously received in full measure from the younger woman: "O daughter of God, who calls me, a miserable form, 'mother', learn constraint!"[41] Hildegard obviously cares about Elisabeth; unlike letters of advice sent frequently to other religious and lay people, this letter is rather long. Psychologically sensitive, Hildegard does not attack Elisabeth. She merely unveils the self-destructive dynamic behind all-too-fervent fasting and other practices of self-immolation. Subliminally suggested by the devil, Hildegard writes, it is a sign of denying God's intention in having created both body and mind. Elisabeth's fasting and self-mortification are interpreted as a rejection of her physical nature. The letter closes with tender, supportive words: "Oh happy soul, who quickly and in great courage ran to the living God — like the stag to the well — consider these words so that the strong king may keep you in this courage and lead you to eternal joy in happiness."[42] What began as a professional exchange has turned into a caring friendship between an older and a younger woman who share in an exceptional gift.

Richardis of Stade: A Sentimental Friendship?

The letters and biographical fragments which tell about the friendship between Hildegard and Richardis equal in tragic passion and depth the letters between Héloïse and Abelard. The texts reveal an aspect of Hildegard invisible in her famous visions, yet not disconnected with their tone. The intensity of images and dramatic involvement we sense in the visions is the same we detect in Hildegard's feelings for Richardis. Walt Whitman's words "when I give myself, I give myself fully"[43] could have been written for Hildegard.

The relationship to Richardis is unusual, because Hildegard's feel-

ings were deeper than in other friendships. They made Hildegard more vulnerable and pushed her to actions that did not find the approval of people around her. The intensity with which Hildegard lived her attachment to Richardis challenged her and presented a potential for growth and new insight unlike any other friendship we know of in her life. In Hildegard's biography, retrospectively, Richardis is introduced as yet another test God sent her, and a proof of a karmic, saturnine pattern Hildegard perceives in her life. In referring to Richardis, Hildegard writes, "God did not want me to remain steadily in complete security: this he had shown me since infancy in all my concerns, sending me no carefree joy as regards this life, through which my mind could become overbearing."[44] The connections between Hildegard and Richardis's family, the von Spanheim and Stade, were complex and probably added an additional element of tension to the dynamics of the friendship.[45] Richardis von Spanheim-Lavanttal, the mother of Richardis the younger, supported the Rupertsberg convent with generous endowments, thus obliging Hildegard to her family. A niece of Richardis the younger also became a nun at the Rupertsberg and, together with Richardis, finally left the convent to become an abbess elsewhere. What seems to be an even more significant circumstance is that Hildegard's teacher, Jutta, the founder of the hermitage at Disibodenberg, where Hildegard was brought as a child, was a cousin of Richardis von Spanheim-Lavanttal. Richardis the younger became to Hildegard what Hildegard had been to her aunt: a gifted, intelligent, eager young student.

Of all possible figures from the Bible, Hildegard chooses the relation between Paul and Timothy, older teacher and younger devoted student, as a symbol of her relation to Richardis.[46] Richardis did more, however, than simply study with her abbess. As Hildegard points out, she greatly supported Hildegard during her work on *Scivias:* "She had bound herself to me in loving friendship in every way, and showed compassion for my illnesses, till I had finished my book."[47] Given the great physical difficulties that accompanied Hildegard's creative processes, Richardis became an indispensable source of comfort and reassurance.

In return, Hildegard loved Richardis with an extraordinary intensity, even in the eyes of her community. Hildegard writes to Richardis: "I loved the nobility of your conduct, your wisdom and chastity, your soul and the whole of your life so much that many said: What are you doing?"[48] Richardis's attentiveness, showered on Hildegard in a time of great stress, led Hildegard to project on Richardis a feeling of trust she might have felt

earlier only for Jutta. It was Jutta, as Hildegard writes in her autobiography, who launched Hildegard's career because she was the first who discovered her visionary gift: "Because of the fear I had of other people, I did not tell anyone how I saw. But a certain high-born woman, to whom I had been entrusted for education, noted this and disclosed it to a monk whom she knew."[49]

It is puzzling to note that Hildegard saw herself paradoxically both as mother and as dependent daughter in her relationship to the younger Richardis. When Richardis decided to leave Hildegard's convent, she writes, mourning her departure, "woe is me, your mother, woe is me, your daughter—why have you abandoned me like an orphan?"[50] The great traumatic experience—Richardis leaves her in order to become abbess in a convent close to her brother—is perceived as a breach in trust and a deprivation of nurturing care: "Pain rises up within me. Pain kills the great trust and the solace that I found in a human being."[51] This relationship, which is only preserved through Hildegard's letters, touched on two aspects of Hildegard's personality that isolated her from early childhood on—her sickly constitution and her visionary gift.

Hildegard's unusual visionary experiences started at the age of three. She sensed that others would not believe her, and concealed her visions. Her frequent illnesses added additional barriers. She writes in her biography, "I was ignorant of much of the outer world, because of the frequent illness that I suffered, from the time of my mother's milk right up to now."[52] Given Hildegard's shyness and the burden of her visionary calling, Richardis's support in writing Scivias, her first book of visions, must have been precious. It seems to me that the depth of this relationship is connected to Hildegard's most vulnerable traits that reach back to her childhood experiences: an overwhelming feeling of loneliness and an equally overwhelming visionary gift. Richardis obviously was able to break through Hildegard's feeling of isolation at a crucial creative period and affirmed Hildegard both emotionally and intellectually. Mother-and-daughter imagery take on a special meaning in this case. It appears that at least from Hildegard's perspective, the relationship is one of maternal nurture and intimate emotional closeness. This reading perhaps explains why Richardis's leaving the convent was such a traumatic experience for Hildegard and why she struggled desperately to keep Richardis there. As Peter Dronke comments, "Hildegard, unwilling to accept this, in her doting attachment, made an exhibition of herself in a way she never did [though she had feared

to] in her early visions."[53] Hildegard appealed to an astonishing circle of influential people to gain Richardis back: Richardis's mother and brother, the abbot of the nearby monastery Disibodenberg, the archbishop of Mainz, and even the pope. Being unsuccessful, Hildegard "felt that there was a conspiracy against her."[54] She resorted to a last means and used her authority as visionary for what appears to be only personal gain. As Dronke writes, composing the petitions, "she is never less than certain that she knows the will of God; doing God's will and doing her will are seen as identical. There is a frightening hint of megalomania here."[55] It might have been the desperation of the abandoned child in Hildegard rather than megalomania.

How is this enormous crisis of lost trust and love resolved? In a letter to Richardis's brother, Hildegard responded all too humanly: the younger woman is blamed for wanting independence. "If one of restless mind seeks preferment, longing to be master, striving lustfully for power rather than looking to the will of God, such one is a marauding wolf in person."[56] How different is this judgment of separation from the separation she described to her nuns at the Rupertsberg! Referring to their fate after her death, she promised, "Now my daughters glow in their hearts in the mourning they feel for their mother . . . But later, they will shine in bright, shimmering light by the grace of God and will be strong warriors in the house of God."[57] The contrast between a young woman who *seeks* independence and is cast in the role of a "marauding wolf" and a group of other women *forced* into independence by Hildegard's death interpreted as God's glorious Amazons could not be greater. Despite her inconsistency, however, it must be noted that in both cases, the women are depicted as forceful and active.

After a period of anger and frustration, Hildegard finally composed a reflective letter to Richardis, who now lived in the new convent. As Peter Dronke points out, this letter testifies to Hildegard's learning process and a more mature acceptance of what had happened. The experience is interpreted from a spiritual perspective, yet earlier interpersonal experiences seem to seep into her resigned view. The separation taught Hildegard not to put trust in humans, but only in God. She does not deny herself the sadness she feels: "Now let all who have a sorrow like my sorrow mourn with me — all who have ever, in the love of God, had such high love in heart and mind for a human being as I for you — for one snatched away from them in a single moment, as you were from me."[58] Hildegard is, however, not fully reconciled. In the account given in her biography, she adds that

other young women, certainly less important to her than Richardis, subsequently left the convent as well (which happened not infrequently at other places, too). She interprets these departures indiscriminately as a punishment, and comments, "But I and those who loved me wondered why such great persecution came upon me, and why God did not bring me comfort, since I did not wish to persevere in sins but longed to perfect good works with His help."[59]

This story of once satisfied, then frustrated desire came to a sudden end. Richardis died of an illness within a year of their separation. Hildegard's ambiguous response is, "God did not wish to give his beloved to a rival lover, that is, to the world."[60] Did God act on what Hildegard wished? How else should Hildegard's uncanny last words in her letter to Richardis be understood? "[B]ut may the angel of God precede you, and the son of God protect you, and his mother guard you. Be mindful of your poor mother Hildegard, that your happiness may not fail."[61] Note that the last sentence reads like a plea and a threat. How could Hildegard destroy or at least wish to destroy Richardis's happiness if she neglected the older woman? Hildegard's strategies, proven to be so efficient in the case of Gertrud, turned out to be ineffective when it came to keep Richardis in her convent. Even the pope declined to interfere. The feudal ties among the family of the von Stade proved to be stronger than the ties of love Hildegard claimed to exist between Richardis and herself. Can we blame her to move the fight to the plane of mysterious threats and wishful thinking?

Of all three relationships discussed in this essay, this is the most difficult to name. None of Todd's five categories seem to fit smoothly. Hildegard and Richardis enjoyed not only emotional but also mutual intellectual and spiritual enrichment. Certainly, it is not a social friendship in the strict sense. Although Richardis seems to play the crucial role of midwife when Hildegard works on *Scivias*, Hildegard denies Richardis the right to move into a larger social context and to become a leader herself. It seems to me that even the category of sentimental friendship does not work sufficiently because the relationship, passionate as it seemed to have been, goes beyond "emotional support in a patriarchal world."[62] Another alternative suggests itself: the dynamics of a woman's primal relationship to another woman — the mother-daughter relationship. Todd touches the issue briefly. She observes that "where the mother-daughter relationship has been loving, close, and reasonably extended, the heroine is prepared for friendship . . . where the tie was rudely severed by real repulsion, the daughter

will tend to seek a woman over a male lover, not to enjoy friendship, but to relive history."[63]

As other letter cycles indicate, Hildegard was able to entertain long-lasting friendships with women. As a Benedictine oblate, however, Hildegard did not enjoy a "reasonably extended" tie to her mother because she was given to Jutta at a very young age. McGuire cites as one of the reasons for the Cistercian development of the friendship motif the converts' rich experience of family life, a childhood and adolescence not lived apart, but within the family. Hildegard and many other nuns brought up like her experienced as family fellow nuns and oblates and very likely projected onto older nuns the needs and affections children have toward their parents. Great tenderness for other women was often openly expressed in other letters to and by Hildegard. Admittedly, the depth dynamics of the relationship to Richardis can only be discussed speculatively. But it seems accurate to state that Richardis touched Hildegard in the depth of her being and challenged her like no other woman. The primal dyad of mother and child is at least one interpretative possibility, especially because monastic culture encourages nuns to perceive the relationship between abbess and nun in terms of parental relations. The Benedictine praxis of offering oblates provides additional support for stressing the projection of parental images onto authority figures. What should perhaps surprise us is the *absence* of such imagery in monastic relations (such as in the case of Gertrud and Elisabeth), rather than its presence. What renders the relationship between Richardis and Hildegard so fascinating, however, is the reversal of roles: the older woman opens herself to the younger woman, and through her attachment, is made powerless. The story of Hildegard's struggle is also a poignant commentary on the influence of feudal relationships on women's personal friendships. Hildegard's emotional needs were canceled out by the family interests of Richardis's mother and her brother Hartwig, who wanted Richardis to live closer and manage some of their property as an abbess. If we can believe Hartwig's letter, Richardis herself was divided between her attachment to Hildegard and the drive for publicly acknowledged authority as abbess. Winner in this conflict are the representatives of objective feudal power; loser is the personally involved Hildegard.

In the beginning of this essay, I quoted McGuire as saying that friendship is a commonplace of monastic life because it offers the most con-

genial environment for the cultivation and formation of friendships. I hope to have shown that monastic friendship in the twelfth century was not the prerogative of Cistercians and not limited to men or cross-sex friendships. In the exemplary world of Hildegard's correspondence we perceive aspects of women's friendships that are intriguing in their complexity. Looking at women among themselves in a relationship of their own, Hildegard and her correspondents emerge as intensely alive — intellectually and spiritually as well as emotionally.

8

REALITY AS IMITATION

The Role of Religious Imagery
Among the Beguines of the Low Countries

JOANNA E. ZIEGLER

IN THIS ESSAY I wish to explore—by concentrating on the Low Country Beguines—the radical shift in the character of women's spirituality and its imagery that took place in the first half of the fourteenth century.[1] Ecstatic female mysticism was transformed in this period into mother-oriented spirituality. Ecstasy, rapture, and revelation, so central to the lives of exceptional holy women in the thirteenth century, were increasingly replaced by spiritual experiences that focused on practical compassion for the suffering Christ, such as nursing and placing Him in bed, and a more directly personalized relationship with His Mother, who became for the Beguines an approachable model of motherhood and chastity. This shift marks a turning point in the history of women's spirituality when mysticism, once practiced only by an elite few religious specialists, became accessible, because of alternate practices, to many women.

There are two manifestations of this shift: first, the established rules for formal Beguine membership and second, the imagery and function of Beguine art. Beguine rules codified female sanctity so that all women could adapt themselves to it. The rules were based on the principle of imitation: women must "appear" saintly in dress, walk, and action. The types of art favored by the Beguines evoked similar mimetic responses that reinforced the outward signs of imitation. The three sculptural themes that we explore in this essay center on gentle caring and nurturing feelings, rather than on the extravagances of the preceding period with its imagery and experience of mystical marriage and bridehood. The statues of the *Pietà* and the *Virgin and Child* evoked clearly defined feelings of compassion

112

and encouraged women to model themselves very practically on the ac-
tions as well as the virtues they represented. Beguine rules and imagery
played, as we shall see, a vital role in shaping the new and very precise
contours of the increasingly accessible spirituality of the fourteenth cen-
tury. The essential characteristics of Beguine spirituality were social and
psychological in nature, and they emerged from the clergy's desire to
tighten control over what had become women's excessive and extravagant
spiritual behavior. Beguine life as an institution and Beguine imagery, as
I describe them in the following pages, illuminate this situation with ex-
traordinary clarity.

BEGUINE SCULPTURE IN THE CONTEXT OF BEGUINE LIFE:
HERMENEUTICAL PRINCIPLES

Our discussion of Beguine art is limited to three sculptural themes — the
Standing *Virgin and Child*, the *Pietà*, and the *Christuskindje*. As a work-
ing hypothesis I suggest that these religious objects — seen by every, any,
and all medieval persons — were transformed by the Beguines into carriers
of specific messages. The most common and popular carved works of art
were thus made to elaborate themes that only *Beguines* could fully under-
stand: their own desires, joys, hopes, fears, and beliefs. But however per-
sonal visual imagery was to these encloistered women, it played out an
authoritarian role. For the clergy and secular authorities, visual imagery
was a safe means of controlling women's religious responses: it could be
counted on to channel and direct women's responses that by the fourteenth
century had proven, for a number of reasons, to be especially troubling.

The clergy could rely on this effect because visual imagery functioned
as an inspiration and confirmation of the complex character of institution-
alized Beguine life. For these encloistered women, intimate association with
particular images was a source of reward and a means of continual renewal
for having chosen their particular life-style. Visual imagery, especially the
Christuskindje, *Pietà*, and *Virgin and Child*, provided a routine and direct
way to "have and hold" the body of Christ in a motherly fashion. In the
Beguine context, a particular kind of imagery was, therefore, an emotion-
ally and spiritually dynamic shell, the core of which was the Beguines'
personal life and public function. The clergy had perhaps introduced the
imagery; clearly, they approved of it. But regardless of the origins of the
commissioning patrons, the Beguines used a consistent body of religious

imagery to secure their identities, to soothe troubles that were particular to them, and to gratify their hunger for physical union with the body of Christ. This approach is a radical redefinition of the role of visual imagery because it opens, to masses of women, the possibility for direct contact with Christ to take place in less physically extravagant ways than in the preceding period. Fixed, yet appropriately stimulating imagery, then, is one of the means by which stress in women's spiritual experience was shifted from random, private ecstasy to routine devotion.

To reveal the dynamic quality of Beguine art and to develop some of the specific aspects of its meaning, I will begin by exploring the general nature of the Beguines' life-style — how they lived, acted, and prayed, basing my exploration on what can be extracted from the rules for membership as a Beguine. The rules are, as yet, an untapped historical resource both in regard to Beguine ideology (things seen and shaped by clerical and secular authority) *and* in regard to Beguine mentality (things experienced by Beguines as predictable and routine). Both ideology and mentality were based, as I shall propose, in the elaborated principle of imitation. For clerical and secular authorities, imitation was a means of behavioral control. Requiring Beguines to imitate nuns and holy women, to "appear" chaste and devout, was a perfect way to monitor their behavior and make their conformity visible publicly. For the women themselves, imitation, as set forth in the rules, ensured prideful confirmation of the holiness of life as a Beguine. Imitation, manifested via physical appearances in dress, action, and prayer, was the overt communalizing element. It bonded all of them together as more than women; it bonded them together as *Beguines.*

Nowhere was the principle of imitation specified more precisely than in the rules for membership required of the Beguines. Our goal, then, is to link these rules with the visual imagery reinforcing them. With the ideology of imitation firmly in place, the clergy was, it seems, able to introduce visual imagery to direct women away from ecstasy — a tendency which, as Jo Ann McNamara has shown in her essay, was threatening to the clergy and threatened women's survival — and toward more orthodox forms of religious affirmation and more acceptable spiritual experiences.

BEGUINES AND BEGUINAGES

The term *Beguine* refers generically to women who lived, either alone or with their parents, or in groups, a chaste life of charity.[2] Beguines were

holy women who practiced as celibates a form of active charity, nursing, tending lepers, thereby contributing to the society around them. Large, stable communities of Beguines were able to commission and house numerous, often valuable, works of religious art. It was during the middle decades of the thirteenth century in the southern Low Countries that these communities and their large precincts, called *beguinages*, were first founded and endowed.

The formal institution, as we call the beguinage, was firmly tied to the church and to the towns. The spiritual activities of its members were watched over by a pastor employed especially to perform that job. He was assisted in his role by the rules, where the routine practice of a particular pattern of religious life was spelled out. With the organization of the quasi-cloistered beguinage, the clergy was assured that Beguines were not exposed to heretical views of the laity or even of the local town clergy.[3]

The rules proved fundamentally important to the stability of the beguinages. Accepted religious life for women had traditionally operated under the assumption that women take permanent vows and renounce their private property; acceptable religious life for women had been fully cloistered.[4] The cloister kept women from making contact with the secular world, thereby establishing the perfect site for guaranteeing the clergy a high degree of control. Beguinages, however, were not absolute cloisters, but forms of encloisterment. Women passed in and out of the beguinage to visit family and to do business. What made the institution of the beguinage so acceptable to its ecclesiastical supporters was that it substituted, in the place of permanent vows and complete claustration, a set of rules that *all* Beguines were required to follow. These rules guaranteed that women desiring to become Beguines adopt modes of action, appearance, and spiritual practice deemed appropriate by the supervising clergy and secular authorities as well. The rules, and a governmental structure to maintain them in the office of Head Mistress, should be counted first among the reasons why the church condoned a mode of religious life that in other contexts was deemed suspect.[5]

Generally speaking, the later thirteenth century was not a particularly propitious time for laypeople, especially women, to lead a group religious life.[6] In this regard, the beguinages in the towns of the southern Low Countries, and their members, are both rare and fortunate phenomena because they survived and even flourished in the face of the fourteenth century's increasingly repressive church policies. They survived precisely

because their institutional prerogatives were written down and approved
of by the clergy—because the behavior and actions of individuals could
be predictably subsumed under those of the approved and carefully super-
vised collective. The rules, therefore, are the key element for understand-
ing any aspect of the Beguines, including their art, and it is to them we
must now turn our attention.

BEGUINAGE RULES: CODIFIED CUSTOMS

All Low Country beguinages formulated an independent or self-sufficient
set of regulations known as the rules.[7] These were drawn up by founders
and clergy and modified at various points between 1234 and 1800. We are
interested here in the examples that appeared between 1234 and 1400.
Scholars have emphasized, however, that the Beguines' rules are indepen-
dent of monastic rules, which are more uniform and derive from evolving
precedents. Yet despite their structural departure from conventional reli-
gious practice, the similarities among the various Beguine rules are so strik-
ing that certain generalizations may be drawn from them. Rules for
beguinages in Flanders and Limburg reveal recurrent themes that address
governance, spirituality (as expressed through prayer, discipline, medita-
tion, the sacraments, and silence), chastity, work, clothing and household
goods, and charity.

A primary theme is governance. Written by Bishop Robert in 1246,
the statutes for the Beguines in the entire diocese of Liège explain, for ex-
ample, that a mistress shall govern the beguinage, and they state how she
shall be elected. The hierarchy, disciplinary structure, and election pro-
cess in Liège are typical. Directives are given for taking communion (how
many times a year and on which feast days) and for going to confession
(how often and to whom, the pastor or the Beguine chapter as a whole).
There are supplementary stipulations regarding which prayers the Beguines
shall say, how they shall act on feast days and Sundays, and with whom
they may or may not speak during holy times. The rules invoke silence
and quietude as the manner that best readies the Beguines for closeness
to God.[8]

In addition to governance and routine religious activities, the largest
portions of the rules are occupied with chastity. Bishop Robert's statutes
of 1246 clarify, as do other beguinages' rules, that the "most serious of-

fence" (in addition to being recalcitrant to the priest or head mistress) is if a Beguine "goes out at night without the permission of the pastor or head mistress, if she let in a man during the night; if she had been caught in unchastity with a man or if she has lost her good name; similarly, if she has been a procuress to another Beguine and caused her to sin again chastity."[9] Another constant theme concerns work. In 1328, the delegates of the bishop of Tournai recorded this about the Beguines from the beguinage of Saint Elisabeth's in Ghent:

> In those houses many of them (the Beguines) live together in community and they are so poor that they possess nothing apart from their clothes, a bed and a wooden box. Nevertheless they are no burden to anybody, for they do manual work and by cleaning wool and washing clothes, that are sent to them from the town, their daily earnings are such that they can support themselves modestly, pay the fees due to the church, and distribute from their modest income modest alms. And in each convent there is a so-called work mistress, who has to attend to the works and the women workers in order that everything may be faithfully executed according to God's will.[10]

Bruges' beguinage dedicates an entire chapter of the rules especially to "how they will behave in their work." The rules further address clothing and household goods. Charity is covered, too. How shall the Beguines care for their sisters? The rules for Bruges say that, "They will have a pitying heart and will give generously in the name of God, each according to her means and with joy. They will raise up and put to bed those who are sick and will give them soft beds and will make their food properly and will wash their feet as if she wants it done for herself; they will console those who are tempted and melancholy."[11]

Obedience, chastity, and charity address conduct, to which are added spiritual pursuits, working regulations, and dress codes.

The rules guaranteed the beguinages' survival and success. They were framed in practical terms that individuals from different backgrounds could easily follow. All rules provided prescriptive details by means of which women could model themselves on the virtues expected by church and society, and which could be imitated easily. The rules are responsible, then, for establishing a clear, practical step toward accessible spiritual practices.

SAINTLY LIFE-STYLES OF THE FEW MADE PALATABLE TO THE MANY

The patterns of the rules were founded on precedents rooted in broadly understood and accepted patterns of female sanctity established in the decades immediately preceding the founding of the beguinages. Scholars know much about the historical framework and activities of individual holy women in the late twelfth and early thirteenth centuries, women who were not yet living as a group in the enclosed precincts of the beguinages. Those great holy women were fascinating figures to contemporary male clergy for their demonstrated commitment to the Eucharist and the humanity of Christ as well as for their startling expressions of ecstasy and rapture. The latter wrote admiring biographies of the former. The best-known example, the biography of Marie d'Oignies (1177–1213), who lived in the diocese of Liège, was written by her confessor, the great preacher who eventually became bishop of Acre, James of Vitry.[12]

Biographical accounts of exceptional holy women, of which James's was in many ways the prototype, established the formulae for women's behavior and actions that could and would be codified in the rules of the beguinages. One comparison will suffice to illustrate the point. Here is James's description of Marie,[13] which is contrasted to a passage from the rules of the beguinage in Bruges:

> The external behavior of her outward parts showed the manner of the inward formation of her mind. The serenity of her expression could not hide the joy of her heart, but with a wondrous moderation she tempered the mirth of her heart with a serious expression and hid the merriment of her mind a little with the simplicity of a modest face. And since the apostles said, "women shall pray with their head veiled (1 Cor. 11:6)," the white veil which covered her head hung before her eyes. She walked humbly and with a slow and mature gait with her head bent and her face looking to the ground.

> Her language will be brief and as expedient as possible . . . without laughing loudly but always modestly, the face joyful, serious and collected . . . In walking their gait should be dignified, their eyes fixed, the face slightly inclined, the head covered by a veil.[14]

The rules, as this comparison provocatively suggests, appear to have derived their formulae for the "good" Beguine from those formulae pre-established by the *vitae* of exceptional holy women drafted in the im-

mediately preceding period. Many scholars have already argued that Marie
was herself the "first" or "model" Beguine because she was the "ideal" Beguine.
I suggest that the "modeling" operation happened because what was re-
corded about Marie and other holy women provided a recipe for actions,
behavior, and attitudes that the organizers and participants of the later
women's religious movement could easily follow.

The model of female sanctity as narrated in the *vitae* of individual
holy women manifested certain clear contours, and the rules of the be-
guinages shaped those contours in such a way that *all* women, whether
they were of humble or noble birth, could adapt themselves to them. At
the heart of the rules was imitation: one must appear "saintly" in dress,
walk, and action. The sanctity of the few took on the *appearance* of saint-
liness in the many.

Nearly everything regulating Beguine life seems to have revolved
around the principles of imitation and appearance. The ideals of chastity,
poverty, and humility would have been perceived by thirteenth-century
persons as *inner* states, states that exceptional women were blessed with
almost innately. Such inner states were necessarily difficult to expect of
and impose upon vast numbers of "ordinary" women from many stations
and from various backgrounds and of varying individual character. Yet
the Beguine rules managed to enforce and make ever present the inner state
of holy women in remarkably creative, efficient, and appropriate outer
ways. They did so by phrasing those states as patterns and formulae that
were imitable by *all* women—patterns of walk, dress, and action. Chas-
tity was covered, for example, by dress code and by public action; poverty
was expressed by the appearance of simplicity in the fabric of one's dress
and the arrangement of one's living quarters; and that greatest of saintly
virtues, humility, the Beguines could achieve by walking with heads and
eyes cast down, by being neither vain nor showy, and by speaking with
a soft voice.[15] An *inner* state could be announced by *outer* appearance.

I am not the first to posit a link between female saints and their, shall
we say, ordinary women followers. Historian Richard Kieckhefer already
proposed this possibility in his illuminating book on fourteenth-century
sanctity, *Unquiet Souls*, where he located the four major elements of
fourteenth-century sanctity as residing in patience, devotion to the pas-
sion, penitence, *and* rapture and revelation.[16] We will discover that these
four elements appear clearly in the rules of the beguinages in the southern
Low Countries. Patience (related, Kieckhefer argues, to humility, submis-

siveness, and conformity to God's will) was phrased by the rules in terms
that any Beguine could comprehend because it was phrased as obedience.
Devotion to the Passion, Kieckhefer's second element, poses interesting,
if complex, issues that can only be touched upon in this essay. The rules
do not specify meditational practices on the themes of the Passion; yet
they regulate the times when the Beguines should and could receive the
Eucharist, the sacrament linked most closely with the Passion. Moreover,
the very kernel of Beguine life as depicted in the rules is embedded in com-
passion and imitation, two reactions that Kieckhefer stated would be evoked
by meditation on the Passion. Beguines were expected to show compas-
sion by giving alms, servicing others, tending the sick, indigent, poor, and
dying.

Kieckhefer's third element of fourteenth-century sanctity, penitence,
is highly elaborated in the rules. There was confession, which took two
forms (confession to the pastor and to the chapter of Beguines) and the
routine practice of penitence, which ranged from self-flagellation to fast-
ing on hard bread and water, to repeated supplications on bare floors, and
finally to permanent expulsion from the beguinage.[17]

There is a remarkable concurrence in the rules between the direc-
tives to the Beguines and the fundamental elements of female sanctity as
defined by Kieckhefer. Penitence was institutionalized by governance and
obedience. Penitence is the fundamental manner of behavior that ensures
the Beguine a secure place within the beguinage. Devotion to the Passion
was addressed in spirituality and spiritual practices, compassion, and imi-
tation. These formulae, upon which the Beguine was to model herself,
constitute — and I would stress the point — the fundamental character of
the institutional ideology of Beguine life. I say fundamental because these
formulae ensured that secular and ecclesiastical authorities could control
and monitor women's lives and because they gave women explicit behav-
ioral patterns to adopt and follow. The rules provided, then, both control
and definition. Their roots and productive reality lay in the ideology of
imitation, an ideology enacted externally through women's physical ap-
pearance and actions.

RAPTURE, REVELATION, AND IMAGERY

Let us now turn to the fourth and most telling element of sanctity — rapture
and revelation — and the issues posed by art and having to do with explicit

imagery. Kieckhefer, as well as Caroline Bynum, has illuminated with extraordinary clarity that rapture and revelation characterized exceptional holy women from the thirteenth and fourteenth centuries. Indeed, from their biographies we know that rapture and revelation were routine spiritual experiences. Women fasted, scourged themselves, rolled their bodies in nails, bled profusely, and wept oceans of tears. After Saint Francis, it was a woman, Elisabeth of Spalbeek (d. ca. 1300) who bore the stigmata for the second time, bleeding profusely every Friday from her eyes and from the five wounds of Christ.[18]

But as far as can be determined, rapture and revelation were not a routine part of life for most Beguines living in their beguinages. There are exceptions, such as Gertrude van Oosten and Ludwina of Schiedam. But for most Beguines, those two elements of sanctity are nowhere to be found. This needs to be questioned more closely.[19] Why, of the four elements of sanctity, are rapture and revelation altogether missing from the prescriptives for living a holy life as a good and "saintly" Beguine? If rapture and revelation were so central to the lives of great holy women, why are there no comments on these experiences in the rules? We ought therefore to ask, as Jo Ann McNamara does in her essay, whether rapture and revelation had simply been absent from Beguines' spiritual activities or whether other forms of channeling were present to "normalize" such excesses by giving them more acceptable form?

I wish to propose here that encoded visual imagery, like the rules, controlled women's actions; it made behavior predictable and spiritually rewarding. It replaced, or at least directed into more legitimate form, the tendency of women toward rapture and revelation. Affective imagery constituted a safe means of controlling, while still encouraging, devotion to the Passion and the body of Christ. It would be strange indeed if religious imagery for the Beguines contradicted the institution's ideology. It is far more reasonable for us to presume that it secured that ideology and acted in harmony with it by supplementing, not abrading, it. I would argue that it did, and it did so by providing women with a means to externalize rather than internalize their spiritual experiences.

BEGUINE ART AND IMAGERY

Let us now return to the three sculptural themes introduced at the beginning of this essay — the Standing *Virgin and Child*,[20] the *Pietà*, and the

Christuskindje.[21] I propose to adopt three categories to help explain the Beguines' reception of this collection of imagery: first, reward; second, prescription and definition; and third, transference. Let us begin with reward.

Images performed miracles. This was no less true as a belief for the Beguines than for other laypersons in the thirteenth through fifteenth centuries. No image type was more miraculous than the Standing *Virgin and Child.* Our earliest evidence for miraculous expectations is revealing, for it records that two great holy women made pilgrimages to a "miraculous" image of the *Virgin and Child.*[22] The Beguine, Lutgard of Aywières, and the founder of the *Feast of Corpus Christi*, Juliana of Cornillon, made a special visit to the city of Tongeren (in present day Limburg, Belgium) to venerate its miraculous *Virgin and Child.* According to the written sources, Juliana went there because she was struggling to overcome opposition to the *Feast of Corpus Christi*, which she was then trying to find in her diocese of Liège.[23] She journeyed to Cologne to visit the churches of the apostles and to seek the intercession of Saint Ursula and her eleven thousand virgin martyrs. From Cologne Juliana proceeded to the Church of Our Lady in Tongeren, sometime between 1240 and 1250, to ask help before a statue of the *Virgin and Child.* These two examples illustrate that from the early days of the women's religious movement in the north, women sought the miraculous, practical intercession of the Virgin by praying to statues.

For thirteenth-century people, statues could and did perform miracles.[24] The Beguines in Bruges, for example, owned a miraculous virgin. Their prized possession, the Standing *Virgin and Child* of Spermalie, was a gift from a nearby community of Cistercian nuns.[25] In 1257, the pope accorded this sculpture an indulgence to all those who visited it. The beguinages in Courtrai, Diest, and Aarschot also owned statues of the *Virgin and Child.* In 1394, the Beguines Christine and Marguerite from Sint-Truiden endowed lamps, with a yearly rent, to burn before the image of Our Lady placed in a chapel in the Church of Our Lady in their town.[26] And their beguinage owned one of the finest examples of any *Virgin and Child*, which dates from ca. 1300. In 1488, the Beguines in Diest paid two stivers for a metal crown for their Virgin; in 1494–1495, these same Beguines paid ten stivers to buy a cloth cape for her.[27] This Virgin most likely dated from the thirteenth century, for, in the fifteenth and sixteenth centuries, it was common practice in the southern Low Countries to "refashion" such sculptures with jewels and clothes.

The Standing *Virgin and Child* type was the standard miracle bearer in the Low Countries. It cured the lame, healed the sores of lepers, and brought stillborn children back to life.[28] Surely the statues of the Virgin that graced the naves of Beguine churches and stood aloft the gables of their streets said special things to the women who habitually passed them by. To learn what these things were, we must turn to our second category of use, prescription and definition. What other group stood to gain more in the way of genuine applicable inspiration from the virtues of the heavenly mother than women in the religious orders and communities? Consider what is represented by the *Virgin and Child* type — the Queen of Heaven, chaste and blessed by the presence of the virgin birth. To the Beguines, required every day to say the Hail Mary — "blessed art thou, Mary, full of grace" — her physical presence in the image served, it seems likely, to remind them of why they did so. The image served to represent and thus remind them that the highest reward for the chaste and holy woman would be to embrace the presence of the living Christ. For a Beguine to behold the image of the *Virgin and Child* must have been an especially reassuring activity.

The statues of the Virgin that graced the churches and homes of the Beguines were necessarily perceived through the Beguines' special lens. Mary herself was not a nun; Mary herself was a holy laywoman; Mary herself, had she so desired, could have known the pleasures of the conjugal bed. Her chastity and goodness, like those of the good Beguines themselves, were rewarded by the presence of God in the form of Christ. The meanings of the image were, therefore, personalized, for they resonated specifically with the character of the particular viewers' lives as Beguines.

SOME DOCUMENTATION OF USE

In 1362, a document records a citizen of Douai, then in the county Flanders, who was involved in the thirteenth century foundation of the Beguine convent there.[29] It recalls how Bernard Pilate had bought two houses in the city for ten poor women Beguines of good name, graced and renowned beyond reproach. He instructed them on his deathbed, presumably before the foundation date of 1282, to pray daily for his soul by saying five Our Fathers and fifteen Hail Marys before a statue of the Virgin Mary in the hospital. A candle was to be lighted on each Saturday, on the vigils of

the five feasts of the Virgin, the night before Christmas, Whitsun, Easter, and All Saints Day. This list details the veneration of the Virgin that must have been very common in Beguine houses at the time. It also suggests that the secular community recognized the Beguines' special access to the favors of the Virgin, who, we should note, took the form of sculpture. From what scholars and folklorists have documented about popular usage of religious sculpture in the Low Countries, we can deduce that statues of the *Virgin and Child* had a miraculous and rewarding function in the beguinages, yet one that was specifically directed in its message, and in the utility of its message, to the Beguines.

Beguines themselves also owned numerous images of the *Pietà*. The beguinage in Diest owned a *Pietà*, dating from the first decade of the fifteenth century.[30] On 29 August 1379, a will endowed the church of the beguinage in Tongeren with an altar in honor of the Passion, known as and consecrated to the *Pietà* (in Flemish, *Nood Gods*).[31] In the first half of the fourteenth century, a *Pietà* became the centerpiece of a fresco cycle in the chapel commemorating the stigmatized Beguine Elisabeth of Spalbeek.[32] The main altar of the beguinage church in Bilzen was dedicated to the *Virgin of the Seven Sorrows*, a theme that incorporates the *Pietà* and adds swords to the Virgin to symbolize her sorrows.[33] The Beguines in Tongeren placed a statue of the *Virgin of the Seven Sorrows* in a gable over a Beguine's house.[34]

Let us not forget that the veneration of the *Pietà* (and its successor, the *Virgin of the Seven Sorrows*) was extremely intense, fervent, and widespread. *Pietàs* were sometimes the locus of long-lived pilgrimages.[35] So we must ask, as we did for the *Virgin and Child* type, also popular outside the beguinages, how the *Pietà* may have functioned specifically inside the beguinages. This is where the issue of imitation raised in our discussion of the rules becomes important. For women who were themselves without husband and child, the Virgin of the *Pietà* can be seen to have provided a practically and spiritually prime example with which to identify. Mary in the *Pietà* nurses and tends the dead or dying Christ. Beguines, who were actively engaged in servicing the sick and dying, were probably more predisposed than any other laypeople to avail themselves of the profits offered by that action. Beguines, moreover, would have been keenly sensitive to the *Pietà*'s discourse on the particular meaning of "woman" and on the paradigmatic virtues for mature women of chastity and compassion.

The theme of the *Pietà* was seen, I would argue, and received for

its exemplary or prescriptive character: be like Mary, act like Mary, dress like Mary. In many *Pietàs* the Virgin is even represented as clothed in the habits and veils of widows and Beguines. The *Pietà* Mary was therefore didactic. Though only an image, she was there to help Beguines understand their roles as virgins and to inspire them time and again to persevere in seeking the rewards of that state. There are two ways in which the *Pietà* Mary may have done this: first, by making compassion visible, and second, by featuring the Virgin's reception of the corporeality (the body and blood) of Christ. There is a "reception" metaphor in the *Pietà*, which Beguines probably understood as a supplementary directive to the rules. In the latter they were instructed to receive the Eucharist, and the image of the *Pietà* likely reminded them to do so. There is another possibility here, that the Beguines were physically stimulated by the Virgin's example of touching the body of Christ. As Jo Ann McNamara has suggested in her essay, Eucharistic activities of the mystics led to a "dynamic concept of reception which became dissociated from the formal liturgy and opened a path to God directly without intermediaries."[36] There is good reason to interpret the *Pietà* and its physical address as one such path.

The *Pietà* Mary was likely both prescription and definition. Knowing what we now do about the beguinages' institutional ideology from our introduction to the rules, we may presume that the *Pietà* Mary was exemplary. Such a visual "reading" would have come naturally to women who were accustomed to modeling themselves in dress, talk, and action on one another, as well as on ideal holy women. Surely, comprehensive imitative behavior must have conditioned women to encode a particular message when beholding the Virgin of the *Pietà*, the exemplar among exemplars.

We now turn to our last category of function, physical transference, by examining the little freestanding sculptures of the Chirst child, sometimes accompanied by a crib or cradle, the *Christuskindje*, or *Infant Jesus*. Documents from the first decade of the fifteenth century point to the sculpture's great popularity among women, especially among the Beguines in Louvain and Mechelen, who were particularly active collectors.[37] Why was the *Infant Jesus* type so well liked by such prominent Beguines?

We can document that the Beguines believed that they slept with Christ. The statutes for Bruges say, for example, that after their evening prayers, they "shall go to bed and sleep with God." Moreover, the Beguines made the cloth, sewed the ornaments, and designed the bedclothes for the cradle into which was laid the small figurine of the *Infant Jesus*. What

motivated these activities? There is the strong possibility that a species of powerful physical transference routinely developed between beholder and "human-like" object. The small, naked *Infant Jesus* would have been an acceptable outlet for women needing to reenact a physical relationship with the body of Christ. In the doll-like figurine of the *Infant Jesus* was an object for women to touch, hold, and rock as though it were their own beloved son of God. They clothed him, put him in the crib, covered him with precious blankets, and laid him to rest in cradles ornamented with the most expensive and precious handmade (often by the Beguines themselves) details.

The popularity among Beguines of the *Infant Jesus* type raises the central theme of this essay—the role of imitation and physical appearance within the ideology of the institutionalized Beguines. Works of art, the most revealing example of which, at this point, may be the *Infant Jesus*, played a central part in enabling institutional ideology to be physically, as well as intellectually comprehensible, especially when it came to echoing women's "natural" tendency toward rapture and revelation. Women, as we have heard so often from scholars, generally took much farther than men the prevalent desire to live in imitation of Christ. They did so by manifesting extreme bodily reactions—stigmata, excreting bodily fluids, other forms of bleeding, paralysis, and the like.

The tendency for women to imitate the humanity of Christ, already present, as Jo Ann McNamara explains, before the founding of the beguinages, became the footing and expectation upon which the rules of the beguinages could rest. The rules took as a given that women were able and, in the eyes of supervisors and founders, naturally inclined to imitate in their bodies and physical actions the humanity of Christ. Those individuals in charge understood this tendency and used it as a way to regulate and control the behavior of women. At the same time they used *imitatio* as the fundamental character and guarantee of institutional (Beguine) definition. In the institutional ideology of the beguinages, physical imitation, as codified in the rules, was powerfully reinforced, but in an alternative cognitive form in the guise and preferred types of religious imagery. By permitting women to house, own, and behold, as other laypersons did, popular images of the Virgin and Christ *imitatio* was comprehensively normalized.

TEXT AND CONTEXT IN
HILDEGARD OF BINGEN'S *ORDO VIRTUTUM*

PATRICIA A. KAZAROW

ILDEGARD OF BINGEN's *Ordo Virtu-tum* is an extraordinary work because it can be experienced on multidimensional levels.[1] Its text is bound to the themes, characters, and visions of one of her major theological works, *Scivias*.[2] Its music is monophonic chant, which, because of its inspired innovations, significantly contributes to and expands the compositional process of the tonal art of Hildegard's era. This music drama, produced for her nunnery on the Rupertsberg, is also impressive as the first extant liturgical morality play. But more than this, *Ordo Virtutum* stands as a work of transformational music, and as such, through its unique exploration of the power of melody, sound, and word, it can evoke a change of consciousness and thereby enable an experience of the spiritual, for its performers and audience alike.

This essay will focus attention on *Ordo Virtutum* in its musical, theological, and drama-historical contexts. Divided into three parts, it will first describe the play and its staging, music, and text; second, place *Ordo* in the dramatic milieu of its day; and third, discuss the relationship between Hildegard's music and theology.

STAGING, MUSIC, AND TEXT

Ordo Virtutum (The Play [Rite] of the Virtues), composed ca. 1151, forms the last vision of the third part of Hildegard's first theological work, *Scivias (Know the Ways of the Lord)*. It is written in Latin dramatic verse

and contains eighty-two melodies. The plot of the play presents the battle between allegorized Virtues and the Devil (*Diabolus*) for the Soul (*Anima*), chronicling her temptation, fall, and eventual redemption. The *Dramatis Personae* are: the Patriarchs and Prophets; the Virtues: Knowledge of God, Charity, Hope, Chastity, Heavenly Love, Discretion, Faith, Contempt of the World, Discipline, Patience, Modesty, Fear of God, Obedience, Innocence, Mercy, and Victory; a chorus of embodied Souls; the Soul; the Devil; and Humility, the Queen of the Virtues.

Psychologically speaking, all of the protagonists are personified forces who present us with the struggle between the power of love and the deep-running forces of evil that transpires within the human psyche. Thus the Patriarchs and Prophets are the revealers of the mystery of the Word; the Virtues are numinous emanations and the helpers of humans; and the Soul is everyman/everywoman. The Devil, the antagonist, who tempted Christ in His lifetime and was defeated, suffers this same fate in the play. He is also the only character who does not sing.

While *Ordo Virtutum* is specifically about the struggle and the eventual salvation of one Soul placed in the flesh, it can be read more generally as Christianity in microcosm and macrocosm. From the preexistent Creator to the final Redemption, Hildegard presents us with a great drama in which God gathers all of fallen creation into His Son, restoring it with humankind's cooperation to its original state.[3]

The manuscript of the play is not divided into acts; however, modern editions make a six-part division into a prologue, four scenes and a finale.[4] With regard to staging, we can deduce from the play's internal evidence that the Virtues would have been elevated in some way with Humility in the most prominent position. The Chorus of embodied Souls was on the main playing space with the Devil on a yet lower level.

Men and boys from the choir usually played any of the women's roles, for example, the three Marys in *Visitatio Sepulchri*, in medieval church music dramas when presented in abbeys, chapels, and cathedrals. Thus the presence of the large number of women's roles here indicates that *Ordo Virtutum* was composed and first performed at Hildegard's nunnery, the setting for which was most likely the new cloister church on the Rupertsberg near Bingen.[5] Perhaps her longtime friend and secretary, Volmar, played the Devil. It is also likely that monks from the neighboring monastery of Saint Disibod sang the roles of the Patriarchs and Prophets.

As playwright, Hildegard would have functioned as choirmistress, training her nonprofessional singers-actors to perform her work. As director-

producer, she would have overseen the staging and acting. She also would
have prepared (or supervised) the preparation of the script and musical
score.[6]

If the description from *Scivias* for each Virtue was used in the cos-
tume design for the production, the effect must have been stunning. For
example, Charity is dressed in an azure gown with a golden stole reaching
down to her feet; Faith is robed in scarlet, symbolic of martyrdom; Obe-
dience wears a lavender color with silver fetters on her throat, hands, and
feet; Fear of God has a dark mauve dress on which are painted many silver
closed eyes, as if all her attempts to see God have been thwarted by the
excess of His light.[7]

The play's music and text will now be explored in some detail. Hilde-
gard's music is highly individual and unorthodox in spite of her depen-
dence on Gregorian chant models. Some of the characteristics that make
it uniquely her own include markedly extensive melismas; the use of short
motivic formulae as a means of melodic construction; and the musical fig-
ure of the rising fifth expanding to the octave.

There are three major styles of chant: (1) syllabic, in which there
is one note per syllable; (2) neumatic, in which there are two or three notes
(represented by a single neume or note group) per syllable; and (3) melis-
matic, in which there are more than three notes per syllable. Extended
melismas, with ten to thirty or more notes, are found not only at the begin-
ning and end but also in the middle of musical phrases. While they some-
times emphasize a particular word, they are more frequently a musical
adornment—an outburst of unrestrained vocality.[8]

The longest melisma of *Ordo* occurs on its last word, "porrigat"
("reach"):

> that he may reach you his hand.
> ut vobis manum suam porrigat.[9]

Musical example 1:[10]

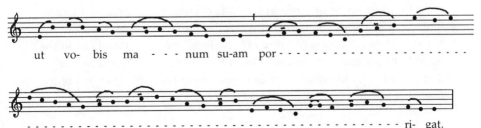

ut vo- bis ma - - - num su-am por - ri- gat.

Hildegard often began[11] and/or ended[12] her compositions with lengthy melismas that also function as structural boundaries for them, forming in effect preludes and postludes for the works they introduce, conclude, and/or enclose. While there is no consistent rule for the placement of Hildegard's melismas that also appear in the middle of her musical phrases, her setting of "porrigat" here appears to be textually linked—a symbolic response in sound to the text's form and meaning. As such, it is an example of Hildegard's conscious tone-painting.[13]

Hildegard used short motivic formulae or patterns in her melodic construction. They are quite unlike the centonate chant formulae of her day represented by the work of Adam of Saint Victor (ca. 1110–1180) or especially by Gregorian Tracts and Graduals.[14] In these, the melodic elements are standard phrases that are variously selected and combined in the manner of a patchwork quilt. In contrast, Hildegard's formulae are frameworks on which she weaves her melodies that occur in numerous variations.

There are two issues that must be taken into account when considering Hildegard's innovative compositional process. The first is that we must believe her when she says that she heard the melodies that she subsequently wrote down in the "living Light." This approach is not unlike the compositional process that many later composers also describe. The second, more technical issue is that there existed for Hildegard a functional, rather precise notational system. Centonate chant relied on standard phrases that were retained in singers' memories. As Isidore of Seville (ca. 560–636) wrote, "Unless sounds are remembered by man, they perish, for they cannot be written down."[15] However, with Guido d'Arezzo's (ca. 990–ca. 1050) notational system that was specifically designed to aid singers in the learning of new chants or assist masters in the writing down of an as yet unwritten melody, there came into existence the possibility for composers to express themselves freely and to have their resulting compositions be "exactly" repeatable.

In the prologue of *Ordo*, Hildegard's compositional process is clearly illustrated in the dialogue between the Patriarchs and Prophets and the Virtues. Here the first seven notes of the Patriarchs and Prophets on the word "qui" are recast in the response of the Virtues on "O antiqui sancti." The notes for "quid admiramini in nobis" are in turn an expansion of the first phrase.

Musical example 2:[16]

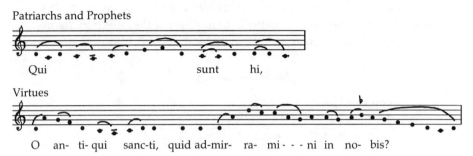

Patriarchs and Prophets

Qui sunt hi,

Virtues

O an- ti- qui sanc-ti, quid ad-mir- ra- mi - - - ni in no- bis?

The third illustration of Hildegard's unique compositional style is her musical figure of the rising fifth expanding to the octave, contained in the second and third phrases of this same example. While the leap of the fifth upward in the D mode is characteristically Gregorian, these leaps always return in the direction of their origin, for example, the Gradual "Ecce quam bonum."[17]

Musical example 3:[18]

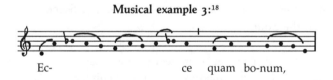

Ec- ce quam bo-num,

Therefore, the further leap upward to the octave by means of the perfect fourth is strikingly unusual. This figure's significance as it relates to music and mathematics, cosmology and the theses of Boethius (ca. 480–524/526) and Pythagoras (ca. 582–ca. 500 B.C.E.) is discussed below as is its symbolic and theological use.

Musical example 4:[19]

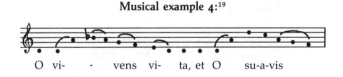

O vi- - vens vi- ta, et O su-a-vis

Many of Hildegard's musical motives, however, are still tradition-ally Gregorian. The opening words of Scene I "O nos peregrine sumus"

("O we are pilgrims") are set in a low-ranging, stepwise melody. This line paraphrases the Improperia for Good Friday: "Popule meus, quid feci tibi?" Musically, these melodies are in the same mode, have the same pitch framework, and display similar melodic outlines.

Musical example 5:[20]

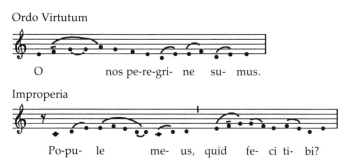

Ordo Virtutum

O　　　nos pe-re-gri- ne　su- mus.

Improperia

Po-pu- le　　me- us, quid　fe- ci ti- bi?

The Improperia is also an important textual source for the Devil, as he paraphrases a line from it at the beginning of Scene IV. In his dialogue with the Soul, he shouts:

> Tu amplexata es me, et ego foras eduxi te.
> Sed nunc in reversione tua confundis me —
>
> You were in my embrace, I led you out.
> Yet now you are going back, defying me — [21]

The Improperia text reads:

> Quia eduxi te de terra Aegypti:
> Parasti crucem Salvatori tu.
>
> Because I led you out of the land of Egypt:
> you have prepared a cross for your savior.[22]

The words of the Devil throughout the play are not allowed to be sung because, according to Hildegard, only men and angels may sing praises to God.[23] In an interesting parallel, the lost people, the sinners, in Dante's (1265–1321) *Inferno* also have no music.[24]

It is not only *Ordo*'s music that is compelling, creative, and diverse but also its text that is filled with rich, vivid imagery rooted in Scripture and "greened" by Hildegard. In the brief Prologue, the Patriarchs and Prophets sing:

> Who are these, who are like clouds?
> Qui sunt hi, qui ut nubes?[25]

The Virtues answer:

> You holy ones of old, why do you marvel at us?
> The Word of God grows bright in the shape of man,
> and thus we shine with him,
> building up the limbs of his beautiful body.
>
> O antiqui sancti, quid admiramini in nobis?
> Verbum dei clarescit in forma hominis,
> et ideo fulgemus cum illo,
> edificantes membra sui pulcri corporis.[26]

The Patriarchs and Prophets acknowledge:

> We are the roots, and you, the boughs,
> fruits of the living eye,
> and we grew up in its shadow.
>
> Nos sumus radices et vos rami,
> fructus viventis oculi,
> et nos umbra in illo fuimus.[27]

Thus Hildegard opens her play by presenting her audience with two powerful images, that of light (i.e., the divine Source) and that of a cosmic tree (i.e., the body of Adam-Christ), the tree of virtue that can strengthen the body of the virtuous human.[28] She then unites them by identifying the Patriarchs and Prophets as the roots of the tree having grown up in the shadow of the divine light and the Virtues as the fruits of the cosmic tree having been ripened by the full divine sunlight.[29]

In the long second scene, Chastity sings in praise of maidenhood:

Maidenhood, you remain within the royal chamber.
How sweetly you burn in the King's embraces,
when the Sun blazes through you
and still your noble flower never falls.
Gentle maiden, you will never know the shadow over the falling
 flower.

O Virginitas, in regali thalamo stas.
O quam dulciter ardes in amplexibus regis,
cum te sol perfulget
ita quod nobilis flos tuus numquam cadet.
O virgo nobilis, te numquam inveniet umbra in cadente flore!

The Virtues respond:

The flower in the meadow falls in the wind, the rain splashes it.
But you, Maidenhood, remain in the music of heavenly habitants:
you are the tender flower that never grows dry.

Flos campi cadit vento, pluvia spargit eum.
O Virginitas, tu permanes in symphoniis supernorum civium:
unde es suavis flos qui numquam aresces.[30]

The language contained in this passage is reminiscent of that of the
Song of Songs and offers us insight as to Hildegard's vision of Virginity.
For her, every nun was a figure of the virgin bride. As brides of Christ,
"Virgins are wedded in the Holy Spirit to holiness and the dawn of virgin-
ity; therefore, it befits them to come to the High Priest as a whole burnt
offering consecrated to God."[31] The opening words of Chastity's speech
were revealed to Hildegard in a vision in which she saw Richardis von
Stade, her favorite nun, confidante, and secretary, and heard a voice say-
ing, "Maidenhood, you remain within the royal chamber." It is possible
that the role of Chastity was first played by or at least intended for Rich-
ardis; however, the dating of the vision, Richardis's untimely death (mak-
ing perhaps the text of the role an epitaph), and the actual draft of the
script for the first performance make this impossible to determine.[32]

At times, the verses are direct quotations from Scripture. In the pro-
logue, for example, the question posed by the Patriarchs and Prophets forms
the first part of a phrase from Isaiah 60:8:

Who are these who fly as clouds and as doves to their windows?

Qui sunt hi, qui tu nubes volant et quasi columbae ad fenestra suas?

The Virtues' response alludes to the words of John 8:12 ("I am the light of the world") and the second entrance of the Patriarchs and Prophets recalls John 15:5 ("I am the vine and you the branches.") Later, in the first scene, the Virtues tell the Soul "multum amas" ("you love much") which repeats the words of Christ to the sinful woman of Luke 7:47, traditionally identified as Mary Magdalene, "Wherefore I say to thee, her many sins are forgiven, because she hath loved much."

Following the second scene, the "lost sheep," the Soul, returns to the foot of the steps to invoke the pity and help of the Virtues. This forms the main action of Scene III.

Scene IV opens with the Devil claiming the Soul as his. For the first time in the play, she declares that she will fight against him and calls to Humility for aid. The Queen of the Virtues sends Victory and some of her companions to bind the Devil, which they do by using his own chains. Bound but not silenced, Chastity refutes his final charges that she has transgressed God's command to nature through her avoidance of "pleasant intercourse" ("suavi copula") by saying:

> I did bring forth a man, who gathers up mankind
> to himself, against you, through his nativity.
>
> Unum virum protuli, qui genus humanum
> ad se congregat, contra te, per nativitatem suam.[33]

The brief finale is sung by all of the Virtues and the Chorus of embodied Souls from among whom the Soul first came. It celebrates the communal meaning of the Redemption as the attainment of the fullness of creation.

> In the beginning all creation was verdant,
> flowers blossomed in the midst of it;
> later, greenness sank away.
> And the champion saw this and said:
> "I know it, but the golden number is not yet full.
> You then, behold me, mirror of your fatherhood:

in my body, I am suffering exhaustion,
even my little ones faint.
Now remember that the fullness which was made in the beginning
need not have grown dry,
and that then you resolved
that your eye would never fail
until you saw my body full of jewels.
For it wearies me that all my limbs are exposed to mockery:
Father, behold, I am showing you my wounds."

In principio omnes creature viruerunt,
in medio flores floruerunt;
postea viriditas descendit.
Et istud vir preliator vidit et dixit:
Hoc scio, sed aureus numerus nondum est plenus.
Tu ergo, paternum speculum aspice:
in corpore meo fatigationem sustineo,
parvuli etiam mei deficiunt.
Nunc memor esto, quod plenitudo que in primo facta est
arescere non debuit,
et tunc in te habuisti
quod oculus tuus numquam cederet
usque dum corpus meum videres plenum gemmarum.
Nam me fatigat quod omnia membra mea in irrisionem vadunt.
Pater, vide, vulnera mea tibi ostendo.[34]

The passage and the play conclude with an admonition for the au-
dience or congregation:

So now, all you people,
bend your knees to the Father,
that he may reach you his hand.

Ergo nunc, omnes homines,
genua vestra ad patrem vestrum flectite,
ut vobis manum suam porrigat.[35]

DRAMATIC MILIEU

We turn now to the dramatic milieu of the middle of the twelfth century.
As stated at the beginning of this essay, Hildegard's play is a liturgical

morality play — the first extant example of its genre. At the time of *Ordo's* writing, three major types of church drama were flourishing: (1) The scriptural liturgical drama, in which the words and characters of the play were taken directly from the Scriptures and its action based on liturgical ceremonies. The most famous examples of this type are the numerous *Visitatio Sepulchri*, which most likely arose through the independent development of the "Quem quaeritis" trope before the Introit of Easter mass and its accompanying ceremonial action. (2) The scriptural drama, in which the story of the play has a scriptual basis, but the action apparently does not form part of a liturgical ceremony. An example of this type is the famous *Play of Daniel*. And (3) the miracle play, based on a saint's life. This genre is best represented by the many Saint Nicholas plays.[36]

In contrast to these major dramatic forms, Hildegard's *Ordo Virtutum* provides dramatic tension and sudden reversals of expectation for the audience. Furthermore, there is an interest in the motives of the characters, in the sources of emotion, and in the workings of a particular human mind.[37]

Thus *Ordo* belongs to the apparently later genre of the morality play that, according to Arnold Williams, "had no long history of development" but "as a dramatic form . . . springs into existence, pretty much completely developed in the fourteenth century."[38] The definition of the morality play given by O. B. Hardison states that this type is

> of necessity psychological drama. The characters do not act in such and such a way because history says they did but because a sacramental psychology requires them to do so. Since the characters are personified motives, the form is also psychological in a literal sense: it takes place within the mind of the central character, who appears in the action as a personification of the soul or what would now be called the ego. The "full scope" morality play begins with a period of innocence, terminating in a fall, reaches its climax at a reversal whereby the central character is saved or reborn and ends with reconciliation and hope.[39]

Given this definition, Hildegard's *Ordo Virtutum* is clearly a morality play. As such, its existence renders Williams's statement inaccurate by nearly two centuries!

The question then arises about whether this genre "sprang into existence completely developed." In light of recent scholarship concerning

the great diversity in the earliest drama of medieval Europe, it would appear that this thesis also needs to be reconsidered. Thus Axton argues that the traditions of secular drama, as well as sources in the apocryphal literature, constantly enriched the sacred drama of the church; as such, these may have contributed to a gradual evolution of the morality play.[40]

Two such influences for Hildegard's *Ordo* may have been (1) the "Harrowing of Hell," the earliest of all liturgical plays; and (2) the secular dancing-game play. Whether Hildegard was aware of these plays or whether they actually influenced her is not yet conclusive; however, they offer convincing evidence, provide possible source materials, and at the very least serve as contexts for her play to the contemporary reader—perhaps even shedding light on the effect that *Ordo* might have had on its twelfth-century audience.

"HARROWING OF HELL"

The first extant liturgical drama dating from the eighth century recounts the "Harrowing of Hell," as told in the apocryphal *Gospel of Nicodemus*.[41] It exists as a fragmentary "oratorio" for two soloists, Adam and Eve, and a chorus of all of the just ("omnes antiqui iusti"). According to mainstream theology as well as the apocryphal account, they were all chained captive in hell after the Fall of humanity. It portrays the powerful meeting of Christ and Satan. "The light shining before the imprisoned patriarchs in darkness precedes the advent of Christ as a warrior, the Lord 'mighty and strong in battle' who hurls a triple challenge at the gates of hell."[42]

> And again there was a cry without: Lift up, ye princes, your gates, and be ye lifted up, ye everlasting doors, and the King of glory shall come in. And again at that clear voice Hell and Satan inquired saying, Who is this King of Glory? and it was said unto them by that marvelous voice: The Lord of hosts, he is the King of glory.
>
> And lo, suddenly Hell did quake, and the gates of death and the locks were broken small, and the bars of iron broken, and fell to the ground, and all things were laid open. And Satan remained in the midst and stood put to confusion and cast down, and bound with a fetter about his feet. And behold, the Lord Jesus Christ coming in the glory of the light . . .

Then the Lord Jesus the Saviour of all men, pitiful and most gracious, greeted Adam with great kindness, saying unto him: Peace be unto thee, Adam . . . Then all the saints adoring him cried out, saying: Blessed is he that cometh in the name of the Lord.[43]

Although this story contains the material from which great church dramas might well be inspired, its apocryphal status and its consequential exclusion from the liturgy explains why "Harrowing" plays are scarce and why the ones that do exist lack clearly realized action. The "Harrowing of Hell" account does, however, form the basis of the ancient rule of cleansing and consecration of a church, which until the bishop's ceremonial entry is regarded as a house of Satan.[44] A ninth century *Ordo Dedicationis Ecclesiae (Order for Dedication of a Church)* used by the bishop of Metz is summarized by Young as follows:

According to this *ordo* the bishop begins the purifying of the building by sprinkling the exterior of the walls. The procession of clerics marches round the exterior of the church three times, halting each time at the west door, and performing there a special ceremonial. The bishop strikes the door thrice with his staff, saying "Tollite portas" ("Lift up, ye gates"), and receives the response "Quis est iste rex gloriae?" ("Who is this king of glory?") from a cleric concealed within the church. After the third recital of this dialogue, the bishop declares himself in the words "Dominus virtutum, ipse est rex gloriae" ("The Lord of hosts, he is the king of glory"), the doors are flung open, and the procession enters the building. Meanwhile the cleric who has been concealed behind the closed doors slips out and, resuming his vestments, joins the procession as the bishop proceeds with sprinkling the interior of the church.[45]

Given the date of its creation (ca. 1151), Hildegard's *Ordo Virtutum* may have first been performed for the dedication of the cloister church on the Rupertsberg, located approximately one hundred kilometers east of Metz. The celebrant for this occasion in 1152 was the archbishop of Mainz. That she prepared music for such a ritual is supported by four antiphons for the "Dedication of a Church" contained in her *Symphonia armonie celestium revelationum (Symphony of the Harmony of Celestial Revelations).*[46] These are "O virgo Ecclesia," "Nunc gaudeant," "O orzchis Ecclesia," and "O choruscans lux stellarum." Furthermore, she entitled her work *Ordo*

(Rite) as opposed to *Ludus* (Play). Therefore, I suggest that the "Harrowing" material could have served as an important context for Hildegard.

SECULAR DANCING GAME

The long, lyrical second scene of *Ordo* is one in which the Virtues dance. Each Virtue, in turn, presents herself, offers a description of her nature or what she does or both and calls the other Virtues to come to her. The Virtues respond to each soloist. Humility begins:

> I, Humility, queen of the Virtues, say:
> come to me, you Virtues, and I'll give you the
> skill to seek and find the drachma that is
> lost and to crown her who perseveres
> blissfully.

> Ego, Humilitas, regina Virtutum, dico:
> venite ad me, Virtutes, et enutriam vos ad
> requirendam perditam dragmam et ad
> coronandum in perseverantia felicem.[47]

The Virtues sing in response:

> Oh glorious queen, gentlest mediatrix,
> gladly we come.

> O gloriosa regina, et O suavissima
> mediatrix, libenter venimus.[48]

Charity follows:

> I am Charity, the flower of love — come to
> me, Virtues, and I'll lead you into the
> radiant light of the flowering branch.

> Ego Caritas, flos amabilis — venite ad me,
> Virtutes, et perducam vos in candidam lucem
> floris virge.[49]

The Virtues answer:

> Dearest flower, with ardent longing we run
> to you.
>
> O dilectissime flos, ardenti desiderio
> currimus ad te.[50]

Meanwhile the Devil continues his derisive taunts, appearing now wolflike in his desire to steal one of the "sheep" from this pastoral scene. Innocence warns the Virtues:

> My flock, flee from the Devil's taints:
> Fugite, oves, spurcicias Diaboli![51]

The Virtues cry:

> We shall flee them, if you give us aid.
> Has te succurrente fugiemus.[52]

At the close of the dance and scene, Humility answers the challenges of the Devil:

> Daughters of Israel, God raised you from beneath
> the tree, so now remember how it was planted.
> Therefore rejoice, daughters of Jerusalem!
>
> O filie Israhel, sub arbore suscitavit vos deus;
> unde in hoc tempore recordamini plantationis sue.
> Gaudete ergo, filie Syon![53]

The Virtues are heirs to the Patriarchs and Prophets, sprung from the same root. Despite the Devil's efforts, the divinely planted cosmic tree is still growing and this circumstance is a cause for joy.[54]

The action of this scene may be viewed as a transformation of the secular dancing-game play, in which there is a chorus of maidens who sing of love and an enemy who tries to abduct one of them. Although there is great variety among them, certain patterns of action are recurrent: there is usually a sacred place that protects the lovers, for example, the sacred

circle itself; then there are the hostile forces who wish to steal away the "bride" from her guard.[55]

The roots for Hildegard's dance motif go deeper, however. Her second scene also re-creates an ancient gnostic sacred dance found in the apocryphal *Acts of John*. Christ's call and the disciples' response voice the oneness of those initiated into the Christian mysteries:[56]

> Before I am delivered up unto them let us sing an hymn to the Father, and so go forth to that which lieth before us. He bade us therefore make as it were a ring, holding one another's hands, and himself standing in the midst he said: Answer Amen unto me. He began, then, to sing an hymn and to say:
>
> Glory be to thee, Father. And we, going about in a ring, answered him: Amen. Glory be to thee, Word: Glory be to thee, Grace. Amen. Glory be to thee, Spirit: Glory be to thee, Holy One: Glory be to thy Glory. Amen. . . . I would pipe; dance ye all. Amen. . . . The number Twelve danceth on high. Amen. The Whole on high hath part in our dancing. Amen.
>
> . . . Thou that dancest, perceive what I do, for thine is this passion of the manhood, which I am about to suffer. For thou couldest not at all have understood what thou sufferest if I had not been sent unto thee, as the word of the Father.[57]

These two sources of dance scenarios, in which there is call and response from one who is inside the circle to those outside of it and an enemy who is trying to effect ruin, provide source materials that may also have had an impact on Hildegard's creative process. Regardless of the influences, however, the fact remains that Hildegard is the playwright of the first extant liturgical morality music drama, and she deserves to be recognized as such.

MUSIC AND THEOLOGY

In Thomas Mann's (1875–1955) *Doktor Faustus*, the statement "Music—a highly theological concern" appears in a dialogue between the Devil and composer Adrian Leverkühn.[58] Hildegard concurred with him eight centuries earlier when she wrote concerning *Ordo Virtutum* that "the words symbolize the body, and the jubilant music indicates the spirit; and the

celestial harmony shows the Divinity, and the words the Humanity of the Son of God."[59] Such a view, according to Söhngen, asserts that music has "theological content and belongs in the comprehensive system of theology."[60] From this perspective, I believe that *Ordo Virtutum* can be shown to form a tonal expression of Hildegard's theological views on the Incarnation of the Word of God by interpreting the text of the play using the four levels of medieval biblical exegesis and by analyzing the music of the play in accordance with these same four levels.

Medieval biblical exegesis occurred on: (1) the literal or historical level (i.e., the elucidation of Scripture as a description of actual historical events); (2) the moral or tropological level (i.e., a prescription for moral action); (3) the allegorical or symbolic level (e.g., the Temple as Christ's body— "Destroy this Temple, and in three days, I will raise it up";[61] and (4) the anagogical or mystical level (from *anagoge*, to spiritualize). Using this typology, the story of the Exodus, for example, can be viewed as a historical event of the departure of the Israelites from Egypt under Moses' leadership on the first level; as the movement from slavery to freedom on the second level; as Redemption through Christ on the third level; and as the passage of a Soul to union with God on the fourth level.

Turning now to *Ordo*, one is confronted with Hildegard's theological position regarding the Incarnation of the Word of God. For her, "the Word, the Logos, was part of the Father from eternity, became with creation a proceeding or outgoing Word, and as Jesus the Christ took on flesh. He is the key to both the cosmos and history, He broke the silence of God and revealed what was hidden."[62]

Textually, the play can be interpreted on the four levels mentioned above:

1. the literal or historical level — the Fall of Adam, the coming of the new Adam in the person of Jesus Christ, the redemptive act of the Crucifixion, the glorious return in the apocalypse as exemplified in the finale quoted above.

2. the tropological or moral level — the Restoration of humankind to grace from sin by means of free will. This Redemption is demonstrated in the following texts sung by the Soul, Humility, and the Soul respectively.

> I am the sinner who fled from life:
> riddled with sores I'll come to you —
> you can offer me redemption's shield.
> All of you, warriors of Queen Humility,

her white lilies and her crimson roses,
turn to me, who exiled myself from you like a stranger,
and help me, that in the blood of the Son of God I may arise.

Ego peccator qui fugi vitam:
plenus ulceribus veniam ad vos,
ut prebeatis michi scutum redemptionis.
O tu omnis milicia regine,
et o vos, candida lilia ipsius, cum rosea purpura,
inclinate vos ad me, quia peregrina a vobis exulavi,
et adiuvate me, ut in sanguine filii dei possim surgere.[63]

All you Virtues, lift up this mournful sinner,
with all her scars, for the sake of Christ's wounds,
and bring her to me.
O omnes Virtutes, suscipite lugentem peccatorem,
in suis cicatricibus, propter vulnera Christi,
et perducite eum ad me.[64]

I recognized that all my ways were wicked, so I fled you.
But now, you trickster, I'll fight you face to face.
Queen Humility, come with your medicine, give me aid!

Ego omnes vias meas malas esse cognovi, et ideo fugi a te.
Modo autem, o illusor, pugno contra te.
Inde tu, o regina Humilitas, tuo medicamine adiuva me![65]

3. The allegorical or symbolic level — Redemption made possible through the Word, the healer, the physician. All of the characters in the play function either symbolically, that is, the Devil as evil personified; Chastity as a figure of Mary, who brought "forth a man, who gathers up mankind to Himself"; or archetypically, the Soul.

4. the anagogical or mystical level — the journey of the Soul to union with God.

I suggest that the use of this same fourfold typology can serve us well as we turn now to an analysis of the music that "exegetes" the meaning, complexity, and multidimensionality of that medium that bears and expresses the play's text.

On the first level, Hildegard's music is heard in space and time. She wrote that she received her compositions in illuminations of the "living Light," and that she had never learned how to read neumes or how to sing.[66]

Nevertheless, we experience a composition that engages our attention and also delights us.

On the second level, a musical performance according to Hildegard "tells of the glory and honor of the citizens of Heaven, and lifts on high what the word has shown."[67] It also "softens hard hearts, and draws from them the tears of compunction, and invokes the Holy Spirit."[68] "And as the power of God is everywhere and encompasses all things, and no obstacle can stand against it, so too the human intellect has great power to resound in living voices, and arouse sluggish souls to vigilance by the song."[69]

Before the third level can be discussed, the correlation of music and mathematics, cosmology and the theories of Boethius and Pythagoras must be considered. The treatise *De institutione musica* by Boethius exerted tremendous influence on almost the entire medieval era.[70] One of his primary theses was that music consists of audible numbers. For his rationale, he relies on the legend that Pythagoras walked past the forge of a blacksmith and heard beautiful harmonies in the sounds of four anvils at work. Having reasoned that the sounds were produced by the hammerheads, he determined that their weights represented the relationships of twelve, nine, eight, and six. Relating the hammerheads to each other, he derived the ratios of: first, 2:1 (the twelve to the six; in music, the octave); second, 3:2 (the twelve to the eight or the nine to the six; in music, the perfect fifth); third, 4:3 (the eight to the six or the twelve to the nine; in music, the perfect fourth); and fourth, 9:8 (the nine to the eight; in music, the whole tone). These ratios made the anvil sounds harmonious; he proposed that the more simple the ratio, the more beautiful the sound. Applying his thesis to the cosmos, Boethius determined that all things, not just music, were beautiful because of their dependence on numbers. God is the most beautiful being whose reflection is the world; its reflection in turn is the human. Thus music can depict the beauty and proportion of God, the world, and the human. In philosophic terms, a microcosm (human) in the macrocosm (world) can be duplicated by number.[71]

With Pythagoras in mind, then, on this third level, the musical figure of the rising fifth expanding to the octave followed in most cases by a descending whole tone, can be viewed as a symbol of the Incarnation because of the particular combination of intervals

As stated above, Hildegard's theology is Christ-centered. The intervals formed in this figure of the octave, the fifth, and the fourth are perfect. These are then followed by imperfect intervals, that of the whole tone or, in one case, by a major third. There are twenty-two places in the play where Hildegard uses this musical figure or a slight variation thereof.[72] In each instance, the underlying text relates directly to the Incarnation, the Word of God, the "perfect" and "imperfect" (in musical terms), that is, the divine and human manifested in Jesus Christ.

There are three variations of this figure. Other occurrences of the figure in which repeated notes appear are not considered as such because the intervals formed are still those of the octave, fifth, fourth, and major second.[73] The variations are:

1. the entrance of the Soul, where the imperfect descending interval of the figure is a major third:

Musical example 6:[74]

O sua-vis vi-ta,

The text is:

> Oh sweet divinity, oh gentle life,
> in which I shall wear a radiant robe,
> receiving that which I lost in my first manifestation —
> I sigh for you, and invoke all the Virtues.

> O dulcis divinitas, et o suavis vita,
> in qua perferam vestem preclaram,
> illud accipiens quod perdidi in prima apparitione,
> ad te suspiro, et omnes Virtutes invoco.[75]

2. the two entrances of the Virtues, where the D is embellished by an E upper neighbor tone:

Musical example 7:[76]

O De- us, hoc ma- gnum

The text is:

> Who are you, God, who held
> such great counsel in yourself,
> a counsel that destroyed the draught of hell
> in publicans and sinners,
> who now shine in paradisal goodness!

> O deus, quis es tu, qui in temetipso
> hoc magnum consilium habuisti,
> quod destruxit infernalem haustum
> in publicanis et peccatoribus,
> qui nunc lucent in superna bonitate![77]

In the Soul's case, perhaps the major third indicates to Hildegard more humanness, that is, more imperfection that does the whole step because she sets the text, which focuses attention on the "fall," with a less "simple" (i.e., "beautiful") interval. In the Virtues' case, perhaps the embellishment of the D and its subsequent consecutive perfect fifths is more symbolic to Hildegard of the divine relationship of the Father to His Son, who has now triumphed in the defeat of the Devil.

It must be noted here that it is not only in *Ordo Virtutum* and related passages in *Scivias* that Hildegard relates music symbolically to the Incarnation. In her song cycle *Symphony of the Harmony of Celestial Revelations*, for example, we find in a hymn to Mary the following:

> Your womb held joy when all heaven's
> harmony rang from you,
> for virgin, you bore the Son of God
> when in God your chastity blazed.
>
> Let the whole Church flush with rapture
> and resound with song
> for the sake of sweet Mary,
> the maiden all-praised,
> the Mother of God.[78]

> Venter enim tuus gaudium habuit,
> cum omnis caelestis symphonia
> de te sonuit,
> quia, Virgo, Filium Dei portasti,

ubi castitas tua in Deo claruit.

.

Nunc omnis Ecclesia in gaudio rutilet
ac in symphonia sonet
propter dulcissimam Virginem
et laudabilem mariam, Dei Genitricem.[79]

"So the Incarnation is the embodiment of music itself: Mary bears
not only the Word but the Song of God in her flesh."[80] It is worth noting
that the same musical figure identified above as symbolic of the Incarna-
tion is present in this composition as well. While Ritscher, Stevens, and
others have argued that it is unwise to project text painting, symbolism,
numerology, and so forth, onto Hildegard's compositional technique given
the milieu of medieval music, it is nevertheless also possible that she was
once again several hundred years ahead of her time.

Finally, with regard to the fourth level, the sound of Hildegard's mu-
sic itself opens deeper windows of perception and allows the other three
levels to be more deeply experienced and integrated, thereby creating a
resonating *Gestalt*. Newman notes, "Music, like fragrance, is immaterial
substance; arising on earth it ascends to heaven, filling the air with its
presence and luring the soul to praise."[81] Bernard of Clairvaux (1091–1153),
in Sermon I of *On the Song of Songs*, offers the following instruction to
his monks regarding the power of music:

> Again I think that your own experience reveals to you the meaning
> of those psalms, which are called not Songs of Songs but Songs of
> the Steps, in that each one, at whatever stage of growth he be, in ac-
> cord with the upward movements of his heart may choose one of these
> songs to praise and give glory to him who empowers you to advance
> . . . And still more that beautiful and salutary exhortation of the
> Apostle: "With psalms and hymns and spiritual canticles, singing and
> chanting to the Lord in your hearts."[82]

Having depicted the ladder that music may form for the spiritual
ascent, Bernard later describes the ultimate encounter of union with the
Beloved:

> But there is that other song which, by its unique dignity and sweet-
> ness, excels all those I have mentioned and any others there might be;

hence by every right do I acclaim it as the Song of Songs. It stands at a point where all the others culminate. Only the touch of the Spirit can inspire a song like this, and only personal experience can unfold its meaning. Let those who are versed in the mystery revel in it; let all others burn with desire rather to attain to this experience than merely to learn about it. For it is not a melody that resounds abroad but the very music of the heart, not a trilling on the lips but an inward pulsing of delight, a harmony not of voices but of wills. It is a tune you will not hear in the streets, these notes do not sound where crowds assemble; only the singer hears it and the one to whom he sings — the lover and the beloved. It is preeminently a marriage song telling of chaste souls in loving embrace, of their wills in sweet concord, of the mutual exchange of the heart's affections.[83]

In similar fashion, Hildegard's *Ordo Virtutum* may have functioned as a means of personal transformation for her own medieval community and its audience through the multidimensional totality of the power of her tonal art. Stevens has argued that the experience of spiritual truth and joy and the experience of music are so closely linked in Hildegard's imagination as to be indistinguishable.[84] My own experience in directing productions of the play would indicate that *Ordo Virtutum* continues to function as a means of personal transformation both for contemporary performers and for members of audiences who allow themselves to be open to it. For the power of music can only evoke a state of expanded awareness; it remains for the individual to respond in and to that state. Jungian psychologist James A. Hall, in a discussion of personal transformation through initiation rituals, affirms this when he writes:

> I now consider the actual purpose of a ritual act to be the inner transformation of the psyche, particularly the dominant-ego of the person undergoing initiation. Much of the outer ritual is merely an attempt to make this inner transformation more likely, to increase the probability of real psychic transformation. The outer ritual itself cannot produce the desired inner change, which depends on subtle, inner forces of the psyche, forces that can be invited but cannot be coerced by the outer process of initiation. The outer ritual is necessary but not sufficient cause of inner transformation.[85]

In considering this fourth level, one must also recall the historical relationship between music and its power to refine the soul and to lift it

into ecstasy in the Western tradition. This has its roots in biblical texts, in Greek legend, and in literary and philosophical writings. The Old Testament records several episodes that show the relationship between music and prophetic ecstasy. Elisha, for example, having determined that he would come to the aid of the three kings of Judah, Israel, and Edom, says "'Now bring me someone who can play the lyre'. And as the musician played, the hand of Yahweh was laid on him."[86] Yahweh then revealed what course of action was necessary for their army to be spared. Saul has a similar experience in that he goes into an ecstasy with a group of prophets coming down from the high place headed by harp, tambourine, flute, and lyre.[87]

According to Greek legend, Orpheus, through his music, was able to heal the sick, attract and tame animals, animate lifeless objects, promote religious fervor at temple rites, and resurrect Eurydice. In the writings of Clement of Alexandria (150–215), Orpheus was replaced by Christ the musician as the symbol of the Resurrection, playing music to lead the blessed souls and to join the dance in heaven. Dante in the final Canto of *Paradise* describes the scene of all the blessed singing and dancing in the Empyrean as well as his own beatific vision at which point he is only able to write that his will and desire were in accord with "l'amour che muove il sol e l'altre stelle"—the love that moves the sun and the other stars."[88]

Iamblichus (ca. 250–ca. 325) and Porphyry (ca. 234–ca. 305) expanded the thesis of Pythagoras. Because audible music is similar to that harmony by which all things are governed, music can lead to the Divine. The soul of the human is naturally sympathetic to music and can be put in tune by it.[89]

A contemporary of Boethius, Cassiodorus (ca. 485–ca. 575), summarizes the tradition that he has inherited and applies it to Christianity. He describes a progression that leads up from the merely physical qualities of sound, that is, from sensation to proportion and then to numbers. The Christian ascends still higher, proceeding from numbers to Unity; for her or him, the experience of this musical mystery flowers into mystical ecstasy. Through the contemplative enjoyment of these, one can transcend one's ego and in so doing is provided the means to perfect happiness.[90] Barbara Grant echoes these thoughts of Cassiodorus, having recently stated that the "rich aesthetic fare of Benedictine liturgy . . . provided a 'way in' to deep contemplation and probably to altered states of consciousness."[91]

In her play, Hildegard gave musical form to the divine mysteries she saw and heard in unique and creative ways in addition to her reliance on

the dramatic and musical traditions with which she was familiar. In so doing she presents a mystical marriage of music and theology that communicates to her listeners as much today as in her own era, a "sense of wholeness and completeness which is ideally the entelechy of creative effort."[92]

In conclusion, *Ordo Virtutum* is a historical, psychological, allegorical, theological, and mystical music drama—a creative projection of Hildegard's unique inner vision. Because it demanded a richer means of expression than the ecclesiastical dramatic traditions of her day, she transformed all of the available sources in her experience into a new genre—the liturgical morality play. In this work, Hildegard's actors are functional; they are figures in a cosmic pattern and explainers of the sacred mystery into which everyman/everywoman can be initiated as into the dance of everlasting life.[93]

NOTES

BIBLIOGRAPHY

INDEX

NOTES

1. INTRODUCTION

1. This issue has most recently been stressed in "Working Together in the Middle Ages: Perspectives on Women's Communities," ed. Judith M. Bennett, Elizabeth A. Clark, and Sarah Westphal-Wihl, *Signs* 14, no. 2 (Winter 1989): 255-61.

2. Michel DeCerteau, *The Practice of Everyday Life*, Steven F. Randall, trans. (Berkeley: Univ. of California Press, 1986), 82.

3. For the United States, see Susan Mosher Stuard, ed., *Women in Medieval Society* (Philadelphia: Univ. of Pennsylvania Press, 1976) on social history; John A. Nichols and Lillian Thomas Shank, eds., *Medieval Religious Women* 1, *Distant Echoes* on monastic history, and 2, *Peace Weavers* (Kalamazoo: Cistercian, 1984 and 1987) on exceptional religious women; Katharina M. Wilson, ed., *Medieval Women Writers* (Athens: Univ. of Georgia Press, 1984) on individual women writers; Elizabeth Alvilda Petroff, ed., *Medieval Women's Visionary Literature* (New York: Oxford Univ. Press, 1986) on individual visionary women writers; Julius Kirshner and Suzanne F. Wemple, eds., *Women of the Medieval World: Essays in Honor of John H. Mundy* (New York: Blackwell, 1985) on social history cases and images of women in medieval texts.

For Great Britain, see Derek Baker, ed., *Medieval Women* (Oxford: Blackwell, 1978), historiographical studies.

In Germany, edited works currently emphasize theological issues. See Peter Dinzelbacher and Dieter R. Bauer, eds., *Frauenmystik im Mittelalter* (Ostfildern bei Stuttgart: Schwabenverlag, 1985), theology; Margot Schmidt and Dieter R. Bauer, eds., *"Eine Höhe, über die nichts geht." Spezielle Glaubenserfahrung in der Frauenmystik?* and *Grundfragen christlicher Mystik* (Stuttgart: Frommann-Holzboog, 1986 and 1987), theology; Johannes Thiele, ed., *Mein Herz schmilzt wie Eis am Feuer: Die religiöse Frauenbewegung des Mittelalters in Porträts* (Stuttgart: Kreuz, 1988), individual women mystics; Kurt Ruh, ed., *Abendländische Mystik im Mittelalter* (Stuttgart: Metzlersche Verlagshandlung, 1986).

4. See Genevieve Lloyd, *The Man of Reason: "Male" and "Female" in Western Philosophy* (Minneapolis: Univ. of Minnesota Press, 1984), 28-38; Julia O'Faolain and Lauro Martinez, eds., *Not in God's Image: Women in History from the Greeks to the Victorians* (New York: Harper & Row, 1973), 127-79; Vern Bullough, Brenda Shelton, and Sarah Slavin, *The Subordinated Sex: A History of Attitudes Toward Women* (Athens: Univ. of Georgia Press, 1988), 83-102; Susan Mosher Stuard, "The Dominion of Gender: Women's Fortunes

155

in the High Middle Ages," in *Becoming Visible: Women in European History*, 2d ed., ed. Renate Bridenthal, Claudia Koontz, and Susan Mosher Stuard (Boston: Houghton Mifflin, 1987), 153-75.

5. Jacques Le Goff, *The Birth of Purgatory* (Chicago: Univ. of Chicago Press, 1984), 289-334.

6. See Caroline Walker Bynum, *Holy Feast and Holy Fast: The Religious Significance of Food to Medieval Women* (Berkeley: Univ. of California Press, 1987). Richard Kieckhefer characterizes the spirituality of the fourteenth century as an exception to the rule because "to some extent there was a feminization of male piety, as men began to adopt the extreme fervor previously reserved for women. The fifteenth century saw a withdrawal from these trends, an abatement in the level of intensity," *Unquiet Souls: Fourteenth-Century Saints and Their Religious Milieu* (Chicago: Univ. of Chicago Press, 1984), 17.

7. Laurie A. Finke, "Mystical Bodies and the Dialogics of Vision," this volume, 29.

8. Bynum, *Holy Feast and Holy Fast*, n. 6.

9. E. Ann Matter, "Interior Maps of an Eternal External," this volume, 72.

10. Ibid.

11. Matter takes a similarly balanced course in her analysis of the Virgin Mary in "The Virgin Mary: A Goddess?" in *The Book of the Goddess: Past and Present*, ed. Carl Olson (New York: Crossroad, 1985), 80-97. For the arguments of reformers and revolutionaries in feminist religious studies, with bibliographical citations, see Mary Jo Weaver, "Who Is the Goddess and Where Does She Get Us?," *Journal of Feminist Studies in Religion* 5, no. 1 (Spring 1989): 49-65.

12. Rosemary Rader, *Breaking Boundaries: Male/Female Friendship in Early Christian Communities* (New York: Paulist, 1983); Penny Schine Gold, "Male/Female Cooperation: The Example of Fontevrault," in *Distant Echoes*, 151-67.

13. Janice G. Raymond, *A Passion for Friends: Toward a Philosophy of Female Affection* (Boston: Beacon, 1986), 113.

14. Matter, "My Sister, My Spouse: Woman-Identified Women in Medieval Christianity," in *Weaving the Visions: New Patterns in Feminist Spirituality*, ed. Judith Plaskow and Carol P. Christ (San Francisco: Harper & Row, 1989), 51-63.

15. See also Jeffrey Hamburger, "The Use of Images in the Pastoral Care of Nuns: The Case of Heinrich Suso and the Dominicans," *Art Bulletin* 71, no. 1 (Mar. 1989): 20-46.

16. See Carol Neel, "The Origins of the Beguines," *Signs* 14, no. 2 (Winter 1989): 321-42.

2. THE RHETORIC OF ORTHODOXY:
CLERICAL AUTHORITY AND FEMALE INNOVATION IN THE STRUGGLE WITH HERESY

1. For example, the record of the nuns at Faremoutiers in the early seventh century, inserted into Jonas of Bobbio, *Vita S. Columbani abbatis discipulorumque eius*, ed. B. Krusch, *Monumenta Germaniae Historica, Rerum Merovingicarum Scriptorum* 4 (1826): 119-43, is a worthy predecessor to the collective biographies of fourteenth-century nuns. Yet we have no comparable record of the mystical life of a convent until the thirteenth century. J. König, ed., "Die Chronik der Anna von Münzingen," *Freiburger Diözesan-Archiv* 13 (1880): 129-236, describes the organization of the women of Freiburg in 1236 by Countess Kunigunde

von Sulz, who later entrusted them to the Dominican order. The Chronicle of Unterlinden describes a similar adoption by the Dominicans of an established community, Jeanne Ancelet-Hustache, ed., "Les *Vitae sororum* d'Unterlinden: Édition critique du manuscrit 508 de la Bibliothèque de Colmar," *Archives d'histoire doctrinale et littéraire du moyen âge* 5 (1930): 317–509.

2. Herbert Grundmann, *Religiöse Bewegungen im Mittelalter: Untersuchungen über die geschichtlichen Zusammenhänge zwischen der Ketzerei, den Bettelorden und der religiösen Frauenbewegung im 12. und 13. Jahrhundert* (Berlin: Olms, 1935).

3. Henry Charles Lea, *A History of the Inquisition of the Middle Ages* (New York: Russell & Russell, 1958), 1:72.

4. Ernest W. McDonnell, *The Beguines and Beghards in Medieval Culture with Special Emphasis on the Belgian Scene* (New Brunswick, N.J.: Rutgers Univ. Press, 1954), 95–96.

5. Barbara J. Newman, *Sister of Wisdom: St. Hildegard's Theology of the Feminine* (Berkeley: Univ. of California Press, 1987), 6.

6. McDonnell, 343.

7. Robert E. Lerner, *The Heresy of the Free Spirit in the Later Middle Ages* (Berkeley: Univ. of California Press, 1972), 37.

8. Hugo of Floreffe, *De B. Yvetta vidua reclusa Hui in Belgio, c. 62, Acta Sanctorum* 13 (1868): 863–86.

9. Caroline Walker Bynum, "Women Mystics in the Thirteenth Century: The Case of the Nuns of Helfta," in *Jesus as Mother: Studies in the Spirituality of the High Middle Ages* (Berkeley: Univ. of California Press, 1982), 170–261.

10. *The Life of Blessed Juliana of Mont-Cornillon* 13, trans. Barbara J. Newman (Toronto: Peregrina, 1988).

11. Evelyn Underhill, *The Essentials of Mysticism* (New York: Dutton, 1960).

12. Brother Theodore, *Sanctae Hildegardis: Natales, Res Gestae, Scripta,* c. 4, in *Hildegardis . . . Opera Omnia,* 197, 92.

13. Hildegard of Bingen, *Epistola 29, PL* 197, 189–90, 5.

14. Thomas de Cantimpré, *Life of Lutgard of Aywières* I, 13, Martinus Cawley, ed. and trans. (Lafayette, Oreg.: Guadalupe Translations, 1987), 42.

15. Kathryn Kerby-Fulton and Dyan Elliott, "Self-Image and the Visionary Role in Two Letters from the Correspondence of Elizabeth of Schönau and Hildegard of Bingen," *Vox Benedictina* 2, no. 3 (1985): 204–23.

16. Lina Eckenstein, *Women under Monasticism, 500–1500* (Cambridge: Cambridge Univ. Press, 1896), 336.

17. Lea, 1:111.

18. Jacques de Vitry, *The Life of Marie d'Oignies,* Margot H. King, trans. (Saskatoon, Canada: Peregrina, 1986).

19. Lea, 1:250; McDonnell, 402.

20. Ulrike Wiethaus, "Cathar Influences in Hildegard of Bingen's Play 'Ordo Virtutum,'" *American Benedictine Review* 38, no. 2 (1987): 192–203; Jeffrey B. Russell, *Lucifer: The Devil in the Middle Ages* (Ithaca, N.Y.: Cornell Univ. Press, 1984), 161.

21. *Liber visionum* 3.4, *Die Visionen der Heiligen Elisabeth und die Schriften der Äbte Ekbert und Emecho von Schönau,* ed. F. W. E. Roth (Brünn: Studien aus dem Benedictiner- und Cistercienser-Orden, 1984), 60–62, 224.

22. Hugo of Floreffe, *Vita Yvettae*, in *Acta Sanctorum* 5 (1866): 71.

23. Jacques de Vitry, *The Life of Marie d'Oignies*, 82.

24. Hugo of Floreffe, *Vita Yvettae* 4:12.

25. Newman, *Sister of Wisdom*, 93.

26. Prudence Allen, "Hildegard of Bingen's Philosophy of Sex Identity," *Thought* 64 (1989): 231-41.

27. John Bugge, *Virginitas: An Essay in the History of a Medieval Ideal* (The Hague: Martinus Nijhoff, 1975).

28. Ancelet-Hustache, ed., "Les *Vitae sororum d'Unterlinden*," 317-509.

29. Ibid., 18.

30. Peter of Dacia, *De gratia naturam ditante sive de virtutibus Christinae Stumbelensis*, ed. Monika Askalos (Stockholm: Univ. of Stockholm Press, 1982).

31. Hugo of Floreffe, *Vita Yvettae*, 80.

32. Ibid., 11.

33. Luke Demaitre, "The Description and Diagnosis of Leprosy by Fourteenth-Century Physicians," *Bulletin of the History of Medicine* 59 (1985): 327-44; Stephen R. Ell, "Blood and Sexuality in Medieval Leprosy," *Janus: Revue internationale de l'histoire des sciences, de la médicine de la pharmacie et de la technique* 71 (1984): 156-63.

34. Jeanne Ancelet-Hustache, ed., *La vie mystique d'un monastère de dominicaines d'après la chronique de Töss* (Paris, 1928).

35. Die Nonne von Engelthal, *Büchlein von der Gnaden Überlast*, ed. Karl Schröder (Tübingen: Bibliothek des litterarischen Vereins, 1871), 322.

36. For example, Die Nonne von Engelthal, 294; A. Birlinger, ed., "Die Nonnen von St. Katharinental bei Dieszenhofen," *Alemannia* 15 (1887): 151-83.

37. Ancelet-Hustache, "Les *Vitae sororum d'Unterlinden*," 21:386.

38. Margery Kempe, *The Book of Margery Kempe*, 15, B. A. Windeatt, trans. (New York: Penguin, 1985).

39. Hugo of Floreffe, *De B. Yvetta*, 9, 25.

40. Ibid., 9, 26-27. Her attitude was vindicated years later when one of the sons so spared embraced an impure life and also became a usurer.

41. A. Huyskens, ed., *Der sogenannte Libellus de dictis quattuor ancillarum s. Elisabeth confectus* (Marburg: Elwert, 1911); Matthias Werner, "Die heilige Elisabeth und die Anfänge des deutschen Ordens in Marburg," in *Marburger Geschichte*, ed. E. Dettmering and R. Grenz, 121-64 (Marburg: Der Magistrat, 1980); André Vauchez, "La pauvreté volontaire au moyen âge," in *Religion et Société: Essais par André Vauchez* (Turin: Bottega d'Erasmo, 1980).

42. Jacques de Vitry, *The Life of Marie d'Oignies* 2:44. Marie indeed shows all the symptoms that Rudolph M. Bell (*Holy Anorexia* [Chicago: Chicago Univ. Press, 1985]) attributes to his holy anorexics.

43. Birgitta of Sweden, *Regula Sancti Salvatoris* 20, *Revelationes S. Brigittae Card. Turreremata*, ed. Consalvus Durantus (Rome: Stephanus Paulinus, 1606), 754-70.

44. Hildegard of Bingen, *Epistola* 47, PL 197, 232.

45. Bynum, *Holy Feast and Holy Fast*, 252.

46. Lea, 1:63.

47. Newman, *Sister of Wisdom*, 28.

48. Ancelet-Hustache, "Les *Vitae sororum* d'Unterlinden," c. 36.

49. S Canivez, ed., *Statua capitulorum generalium ordinis cisterciensis ab anno 1116 ad annum 1786* 1 (Louvain: Bureaux de la Revue d'histoire écclésiastique, 1933), 53–56.

50. Simone Roisin, *L'hagiographie cistercienne dans le diocèse le Liège au XIIIᵉ siècle* (Louvain: Bibliothèque de l'Université, 1947); Bynum, *Holy Feast and Holy Fast*, 229.

51. Hugo of Floreffe, *Vita Yvettae* 5:81–82.

52. Ibid., 96.

53. Kieckhefer, 44–45.

54. Lea, 1:258.

55. Heinrich Suso, *Life of Heinrich Suso*, c. 34, ed. N. Heller and trans. Sr. M. Ann Edward (Dubuque, Iowa: Priory, 1962), 97.

56. Peter of Dacia, appended account of John the Priest.

57. Ancelet-Hustache, "Les *Vitae sororum* d'Unterlinden," c. 19.

58. Ibid., 21.

59. Bynum, "Women Mystics," 237.

60. Jacques Le Goff, *The Birth of Purgatory* (Chicago: Univ. of Chicago Press, 1985), 331.

61. Marta Powell Harley, ed., *A Revelation of Purgatory by an Unknown Fifteenth-Century Visionary: Introduction, Critical Text and Translation* (Lewiston, N.Y.: Mellen, 1985).

62. Jo Ann McNamara, "The Need to Give: Economic Restrictions and Penitential Piety among Medical Nuns," in *Images of Sainthood in Medieval Europe*, ed. Renate Blumenfeld-Kosinski and Timea Szell, 199–221 (Ithaca, N.Y.: Cornell Univ. Press, 1991).

63. Elsbet Stagel, *Das Leben der Schwestern zu Töss*, ed. F. Vetter (Berlin: Weidmann, 1906).

64. Byrum, "Women Mystics," 232.

65. Jean Gerson, *De examinatione doctrinarum, Oeuvres Complètes* 9, ed. P. Glorieux (Paris: Declée, 1960–73): 19–20.

66. Harley, 17.

67. Thomas de Cantimpré, 2:7.

68. McDonnell, 241.

69. *Epistola* 212, *Bibliotheca Maxima Veterum Patrum* 25 (Lyon, 1677), 47.

70. Stephen E. Wessley, "The Thirteenth-Century Guglielmites: Salvation Through Women," in *Medieval Women*, ed. Baker, 289–303.

71. Die Nonne von Engelthal, 266.

72. Philipp Strauch, ed., *Margaretha Ebner und Heinrich von Nördlingen: Ein Beitrag zur Geschichte der Deutschen Mystik* (Freiburg-im-Breisgau: Mohr, 1882; reprint, Amsterdam: P. Schippers, 1966).

73. Grundmann, 401.

74. McDonnell, 529–31.

75. Lea, 2:369; Lerner.

76. John Moorman, *A History of the Franciscan Order from Its Origins to the Year 1517* (Oxford: Clarendon, 1968), 422.

77. Jo Ann McNamara, "De Quibusdam Mulieres: Reading Women's History from Hostile Sources," in *Women and the Sources of Medieval History*, ed. Joel Rosenthal (Athens: Univ. of Georgia Press, 1990).

78. Lerner, 87.

79. McDonnell, 355.

80. Ibid., 357.

81. Lerner, 112.

82. Ibid., 139.

83. Lea, 2:384.

84. Kieckhefer, 130.

85. Bell, 163.

86. Kieckhefer, 130.

87. Bynum, *Holy Feast and Holy Fast*, 22–23.

88. Lea, 2:409.

89. Ibid., 388.

90. Francis Rapp, *L'église et la vie religieuse en Occident a la fin du Moyen Âge* (Paris: Presses universitaires de France, 1971), 113; Gerson, *De examinatione doctrinarum, Oeuvres Complètes* 9:2.

91. Gerson, *De distinctione verarum visionum a falsis*, c. 50–51, *Oeuvres Complètes* 3; Louis B. Pascoe, *Jean Gerson: Principles of Church Reform* (Leiden: E. J. Brill, 1973), 28.

92. Gerson, *Tractatus contra sectam se flagellantium, Oeuvres Complètes* 10.

93. Pascoe, 118.

94. Ibid., 32 n. 67.

95. Paschal Boland, *The Concept of Discretio Spirituum in John Gerson's 'De probatione spirituum' and 'De distinctione verarum visionum a falsis'* (Washington: D.C.: Catholic Univ. of America Press, 1959).

96. Gerson, *De probatione spirituum*, c. 3, *Oeuvres Complètes* 9.

97. Ibid., c. 73.

98. Lea, 2:388.

99. Gerson, *Tractatus contra sectam, Oeuvres Complètes* 10.

100. Lea, 1:292.

101. McDonnell, 127.

102. Gerson, *De distinctione*, c. 75, *Oeuvres Complètes* 9.

103. Ibid., c. 81.

104. Boland, 36.

105. *Reflection* xi, c. 50, *Oeuvres Complètes*.

106. Gerson, *De probatione spirituum*, c. 3.

107. Rapp, 233.

108. Boland, 53.

109. Johannes Nider, *Formicarius* 3:2 (Auguste per Sorg: Proctor, 1696).

3. MYSTICAL BODIES AND THE DIALOGICS OF VISION

1. Michel Foucault, *Discipline and Punishment: the Birth of the Prison*, Alan Sheridan, trans. (New York: Vintage, 1979), 3–69, esp. 30. For an important discussion of the relationships between the body and the forms of divine power in the Hebraic Scriptures,

esp. Genesis, see Elaine Scarry, *The Body in Pain: The Making and Unmaking of the World* (New York: Oxford Univ. Press, 1985), esp. chap. 4, "The Structure of Belief and Its Modulation into Material Making," 181–243. For a discussion of early Christian commentaries on Genesis 1–3, see Elaine Pagels, *Adam, Eve, and the Serpent* (New York: Random House, 1988). I wish to thank Robert Markley, Valerie Lagorio, and Ulrike Wiethaus for their helpful comments on earlier drafts of this essay.

2. Bynum, *Jesus as Mother*, 172.

3. Gottfried Koch, *Frauenfrage und Ketzertum im Mittelalter*, 1962; quoted in Richard Abels and Ellen Harrison, "The Participation of Women in Languedocian Catharism," *Medieval Studies* 41 (1979): 215–51.

4. This term is a rough translation of Mikhail Bakhtin's term — *raznojazychie* — for the ideologically contested field of utterances.

5. In her notes to *The Book of Margery Kempe*, for example, Hope Emily Allen points out many instances of intertextuality between Margery's writing and that of several continental mystics (edited with Sanford Meech, London: Oxford Univ. Press, 1940). Kempe describes her visit to her contemporary, Julian of Norwich, with whom she enjoyed lengthy conversations.

6. M. M. Bakhtin, *The Dialogic Imagination*, Caryl Emerson and Michael Holquist, trans. (Austin: Univ. of Texas Press, 1981), 354.

7. Petroff, *Medieval Women's Visionary Literature*, 108.

8. Ibid., 108–9.

9. Ibid., 110. On the position of women in the early church see Jo Ann McNamara and Suzanne F. Wemple, "Sanctity and Power: The Dual Pursuit of Medieval Women," in *Becoming Visible*, 96–109.

10. Luce Irigaray, *Speculum of the Other Woman*, Gillian C. Gill, trans. (Ithaca, N.Y.: Cornell Univ. Press, 1985), 191. Irigaray's psychoanalytic reading of mysticism in "La Mystérique" regards the mystical experience as belonging in some essential way to women, or at least to the female; "the poorest in science and the most ignorant were the most eloquent, the richest in revelations. Historically, that is women. Or at least the female" (192). Irigaray's somewhat romanticized idealizations place the mystical experience outside language and representation, aligning it ahistorically, I would argue, with hysteria and madness. Irigaray's opposition of mystical discourse to the "dry desolation of reason" denies the historical complexity of women's participation in mysticism as a public, not solipsistic, discourse that thrived in a dialogic relationship with medieval culture.

11. To my knowledge, no one has made this argument specifically about the medieval mystics, although someone might. For the dangers in appropriating medieval women writers for feminism, see Sheila Delany, "Mothers to Think Back Through," in *Medieval Texts and Contemporary Readers*, ed. Laurie A. Finke and Martin Schichtman (Ithaca, N.Y.: Cornell Univ. Press, 1987), 177–97.

12. Petroff, *Medieval Women's Visionary Literature*, 6.

13. Although Marguerite was burned at the stake in 1310 and her book, *The Mirror of Simple Souls*, ordered burned by the Inquisition, the *Mirror* survived her death; its popularity is attested to by the number of translations made during the fourteenth century, including one in English. See Peter Dronke, *Women Writers of the Middle Ages: A Critical Study of Texts from Perpetua (203) to Marguerite Porète (1310)* (Cambridge: Cambridge

Univ. Press, 1984), 217. Margery Kempe during her religious life alternately suffered accusations of madness and heresy and enjoyed the patronage and support of powerful English ecclesiasts.

14. Hubert L. Dreyfus and Paul Rabinow, *Michel Foucault: Beyond Structuralism and Hermeneutics* (Chicago: Univ. of Chicago Press, 1982), 120–25.

15. See Bynum, *Jesus as Mother*, 196–209.

16. Cited ibid., 206.

17. Ibid., 207.

18. For a discussion of these changes in the twelfth-century church, see McNamara and Wemple, "Sanctity and Power," 110–16.

19. John Moorman, *A History of the Franciscan Order from Its Origins to the Year 1517* (Oxford: Clarendon, 1968), 35.

20. Petroff, *Medieval Women's Visionary Literature*, 6.

21. For an illuminating analysis of medieval misogyny as evidence of a "deep mistrust of the body and of the materiality of the sign," see Howard Bloch, "Medieval Misogyny," *Representations* 20 (1987): 14.

22. See M. M. Bakhtin, *Rabelais and His World*, H. Iswolsky, trans. (Cambridge, Mass.: MIT Press, 1968), 19; and Peter Stalleybrass and Allon White, *The Politics and Poetics of Transgression* (Ithaca, N.Y.: Cornell Univ. Press, 1986), 9–26.

23. On the affective nature of female piety in the fourteenth century, see Kieckhefer.

24. Cited in Petroff, *Medieval Women's Visionary Literature*, 259.

25. Ibid., 257.

26. Ibid., 7.

27. See Scarry on the cultural significance of wounding in the Judeo-Christian tradition, *The Body in Pain*, 181–243.

28. Cited in Petroff, *Medieval Women's Visionary Literature*, 186.

29. Bell, 107–8. Although I would want to distance myself from its conclusions, Bell's book, like Bynum's *Holy Feast and Holy Fast*, 209–11, provides numerous examples of this kind of self-torture.

30. Bell, 108.

31. Bynum writes that the drinking of pus was a common practice among female saints (*Holy Feast and Holy Fast*, 144–45). For another argument on the "hidden alliances" between mysticism and torture, see Michel DeCerteau, "Mystic Speech," in *Heterologies: Discourse on the Other*, Brian Massumi, trans. (Minneapolis: Univ. of Minnesota Press, 1986), 35–46.

32. Foucault, "Sexuality and Solitude," in *On Signs*, ed. Marshall Blonsky (Baltimore: Johns Hopkins Univ. Press, 1985), 43.

33. Ibid., 367.

34. DeCerteau, *Everyday Life*.

35. Foucault, *Discipline and Punishment*, 34.

36. Ibid., 45.

37. Ibid., 35.

38. Julian of Norwich, *Showings*, ed. Edmund Colledge and James Walsh (New York: Paulist, 1978), 187–88.

39. Dronke, *Women Writers of the Middle Ages*, 160.

4. "SHE WEPT AND CRIED RIGHT LOUD FOR SORROW AND FOR PAIN": SUFFERING,
THE SPIRITUAL JOURNEY, AND WOMEN'S EXPERIENCE IN LATE MEDIEVAL MYSTICISM

1. See Robin Lane Fox, *Pagans and Christians* (New York: Knopf, 1987), chap. 9,
esp. 438-39. For example, Perpetua (martyred A.D. 203) "was tossed [into the arena] first,
and fell on her loins. Sitting down she drew back her torn tunic from her side to cover her
thighs, more mindful of her modesty than her suffering. . . . Then she rose, and seeing that
Felicitas was bruised, approached, gave a hand to her, and lifted her up. And the two stood
side by side, and the cruelty of the people being now appeased, they were recalled to the
Gate of Life. There . . . being roused from what seemed like sleep, so completely had she
been in the Spirit and in ecstasy, [she] began to look around her, and said to the amazement
of all: 'When we are to be thrown to that heifer, I cannot tell'. When she heard what had
already taken place, she refused to believe it till she had observed certain marks of ill-usage
on her body and dress." ("The Passion of Ss. Perpetua and Felicitas," H. R. Musurillo, trans.,
in Petroff, *Medieval Women's Visionary Literature*, 76.)

2. W. Butler-Bowden, ed. and trans., *The Book of Margery Kempe* (New York: Devin-
Adair, 1944); Sanford B. Meech and Hope E. Allen, eds., *The Book of Margery Kempe* (New
York: Oxford Univ. Press, 1940). References henceforth cite book (1 or 2), chapter, and page
number in the Butler-Bowden translation, and page in the Meech and Allen critical edition:
Kempe, *Book* 1.80;174;191.

3. Donald R. Howard, *Writers and Pilgrims: Medieval Pilgrimage Narratives and
Their Posterity* (Berkeley: Univ. of California Press, 1980), 35.

4. Clarissa W. Atkinson, *Mystic and Pilgrim: The Book and World of Margery Kempe*
(Ithaca, N.Y.: Cornell Univ. Press, 1983); and see Kieckhefer.

5. On the association between liturgical drama and church architecture, see M. D.
Anderson, *Drama and Imagery in English Medieval Churches* (Cambridge: Cambridge Univ.
Press, 1963).

6. On the importance of visualization in medieval culture, see Margaret Miles, *Im-
age as Insight: Visual Understanding in Western Christianity and Secular Culture* (Boston:
Beacon, 1985).

7. Kieckhefer, 110-14. See also Jaroslav Pelikan, *Jesus Through the Centuries* (New
York: Harper & Row, 1985) and Gertrud Schiller, *Ikonographie der christlichen Kunst*, 4 vols.
(Gütersloh: Humphries, 1971-1972). For English examples of the transition see Tancred Borenius
and E. W. Tristam, *English Medieval Painting* (New York: Hacker, 1976).

8. Although without satisfactorily analyzing its theological meaning, a number of
medieval scholars, including Kieckhefer, and Bynum in her excellent *Holy Feast and Holy
Fast*, have recently pointed to the pervasiveness of suffering in medieval spirituality. Without
systematically developing it, Kieckhefer and Bynum do at least note what I consider critical
here. Kieckhefer remarks on the progression from comprehension of Christ's humanity to
understanding of his divinity but does not discuss the mechanism of the progression. Bynum
also notes the progressive tendency in the texts she considers. Although she gives an example
of how the progression might work in the case of the fourteenth-century Dominican Cather-
ine of Siena — where Catherine explains that the more we taste of God, the more we crave
of God, and thus are drawn along the path toward understanding the fullness of God —
Bynum does not explore how the process of suffering in *imitatio Christi* works. Although

they do not develop this point, scholars like Kieckhefer and Bynum have seen that for most late medieval authors spiritual growth does not end at the recognition of the humanity of Jesus.

9. Julian of Norwich, *Showings*, Colledge and Walsh, trans. (the Long Text). For the critical edition see Julian of Norwich, *A Book of Showings to the Anchoress Julian of Norwich*, ed. Colledge and Walsh (Toronto: Pontifical Institute of Medieval Studies, 1978). Hereafter all quotations cite the Long Text by chapter and page number in English translation followed by page number in the critical edition (e.g. 20:213;375).

10. See Janet Coleman, *Medieval Readers and Writers 1350–1400* (New York: Columbia Univ. Press, 1981).

11. Kempe, *Book*.

12. An enlightening comparison with the fourteenth- and fifteenth-century context discussed here can be found in Ulrike Wiethaus's article on the transformative nature of suffering in the thirteenth-century Mechthild of Magdeburg: Ulrike Wiethaus, "Suffering, Love, and Transformation in Mechthild of Magdeburg," *Listening* 22 (1987): 139–51.

13. Julian of Norwich, *Showings*, 20:213;375.

14. Augustine, *Sancti Augustini Opera* 1, 1, in *Corpus Christianorum, Series Latina* 27 (Turnhout: Brepols, 1962). English translation: Augustine, *Confessions*, R. S. Pine-Coffin, trans. (New York: Penguin, 1961).

15. Kempe, *Book*, 1.9:14;21–22.

16. Ibid., 76:328: "We cannot see the beauty of God unless we contemplate [humans' sins] with contrition with him [the sinner], with compassion on him, and with holy desires [or longing] to God for him."

17. Ibid., 1.14:23;31.

18. W. A. Pantin, *The English Church in the Fourteenth Century* (Buffalo: Univ. of Toronto Press, 1980), 191. For the pronouncement see J. D. Mansi, ed., *Sacrorum Conciliorum: Nova et Amplissima Collecto* (Venice: Zatta, 1925). On attitudes toward sin and confession in late medieval culture in general see Thomas N. Tentler, *Sin and Confession on the Eve of the Reformation* (Princeton: Princeton Univ. Press, 1977), and on the place of confession in medieval English literature see Mary J. Braswell, *The Medieval Sinner: Characterization and Confession in the Literature of the English Middle Ages* (Toronto: Associated Univ. Presses, 1983).

19. For sermons see G. R. Owst, *Preaching and Medieval England* (Cambridge: Cambridge Univ. Press, 1926) and G. R. Owst, *Literature and Pulpit in Medieval England*, 2d ed. (Oxford: Blackwell, 1961); Alan J. Fletcher, "The Sermon Booklets of Friar Nicholas Philip," *Medium Aevum* 55 (1986): 188–202; and Woodburn O. Ross, ed., *Middle English Sermons* (New York: Oxford Univ. Press, 1960).

20. Kieckhefer, 124–35; Tentler, 156–62.

21. Kieckhefer, 126.

22. Ibid., 126–28.

23. Julian of Norwich, 39:244;449–51.

24. Ibid., 78:332;697.

25. Ibid., 39:245;451–52.

26. Kempe, *Book*, 1.1:1: "She had a thing on her conscience which she had never shown before that time in all her life . . . for the dread she had of damnation on the one

side, and his [her confessor's] sharp reproving of her on the other side, the creature went out of her mind and was wondrously vexed and laboured with spirits for half a year, eight weeks and odd days."

27. Kempe, *Book*, 1.3:7;13.

28. Ibid., 1.14:23;31.

29. Julian of Norwich, 16:206–7;357–59.

30. Ibid., 18:210;366.

31. Ibid., 77:330;692.

32. Aelred of Rievaulx, *Aelredi Rievallensis Opera Omnia*, in *Corpus Christianorum, Continuatio Medievalis 1*, ed. A. Hoste and C. H. Talbot (Turnhout: Brepols, 1971), 662–73; John Hirsch, "Prayer and Meditation in Late Medieval England: MS Bodley 789," *Medium Aevum* 48 (1979): 55–66 [translation mine].

33. Julian of Norwich, 17:209;364.

34. Ibid.

35. Ibid., 18:210;367.

36. Ibid., 17:209;365.

37. Hirsch, 60 [translation mine]. The Passion of Christ, and particularly the Crucifixion, is the theme of vast numbers of medieval devotions and lyrics. See Rosemary Woolf, *The English Religious Lyric in the Middle Ages* (Oxford: Clarendon, 1968), esp. chaps. 2 and 6. See also Douglas Gray, *Themes and Images in the Medieval English Religious Lyrics* (Boston: Routledge & Kegan Paul, 1972), esp. chap. 7. As I am suggesting for the mystics considered here, Gray notes that the Passion is portrayed as the supreme expression of Christ's love and calls for a response of love from humanity. Many of the lyrics are "poems of meditation" designed to make the worshipper present at the events surrounding Christ's Crucifixion.

38. Julian of Norwich, 20:213;376.

39. Ibid., 28:227;411.

40. Ibid., 22:217;385.

41. "The love which made him suffer it surpasses all his sufferings, as much as heaven is above earth; for the suffering was a noble . . . deed, performed once in time by the operation of love. And love was without beginning, it is and shall be without end" (Ibid., 22:217;386–87). And "he showed to my understanding a part of his blessed divinity . . . strengthening my poor soul to understand what can be said" (Ibid., 24:220–21;395).

42. Ibid., 28:227. "I saw how Christ has compassion on us because of sin and just as I was filled full of pain and compassion on account of Christ's Passion, so now I was filled with compassion for my fellow Christians" (Ibid., 28:226).

43. Kempe, *Book*, 1.85:191;209.

44. Ibid.

45. Julian of Norwich, 28:226;408.

46. Kempe, *Book*, 1.26:51. Again, this is not without parallel in the lives of other religious figures. See, for example, the work of Heinrich Suso (Kieckhefer, 107).

47. Hirsch, 64 [translation mine].

48. Kempe, *Book*, 1.77:167;183.

49. Ibid., 1.14:23;31.

50. Julian of Norwich, 21:214–15;379.

51. Ibid., 31:230;418.

52. Ibid., 64:305;619–20.

53. Ibid., 72:320;662.

54. Kempe, *Book*, 1.14:23;31.

5. INTERIOR MAPS OF AN ETERNAL EXTERNAL:
THE SPIRITUAL RHETORIC OF MARIA DOMITILLA GALLUZZI D'ACQUI

1. Judith Brown, "Lesbian Sexuality in Renaissance Italy: The Case of Sister Bene-detta Carlini," *Signs* 9, no. 4 (1984): 751–58, and *Immodest Acts: The Life of a Lesbian Nun in Renaissance Italy* (New York: Oxford Univ. Press, 1986); Bell, 54–83.

2. Six copies of the *Vita* are in the Biblioteca Ambrosiana of Milan: MSS D.77 sussidio (which may be in Maria Domitilla's own hand), G.97 sussidio, H.47 sussidio, A.276 sussidio, I.41 sussidio, and H.91 sussidio. The *Passione,* containing much of the same material as Book 2 of the *Vita*, is extant in five manuscripts: Pavia, Biblioteca Universitaria MS Aldini 306 — *Passione*, and Aldini 145; Milan, Biblioteca Trivulziana MSS 268 and 490; and a copy in the private collection of Dott. Massimo Archetti-Maestri of Acqui Terme.

3. Gaetano Romano, "Suor Maria Domitilla d'Acqui: Cappuccina in Pavia," *Bollet-tino Storico Pavese* 1 (1893): 9–40, 119–50, 197–238. The codex of letters, Pavia, Biblioteca Universitaria MS Aldini 306 — *Carteggio*, contains testimony to Maria Domitilla's piety by religious and lay, rich and poor. The first letter, dated 1655, is from Anna Maria, archduchess of Austria and electrice of Bavaria, who thanks her for saving Pavia from the French; the last, dated 1665, is from a woman who claims Maria Domitilla's prayers made possible the birth of her first child.

4. E. Ann Matter, "Discourses of Desire: Sexuality and Christian Women's Visionary Narratives," *Journal of Homosexuality* 18 (1989): 119–31.

5. "Doppo la morte di mio padre mia zia mi misse in cura de Padri Barnabiti accio attendessi meglio a piacere a servire meglio il mio Signore. Piglio per suo e mio Confessore uno de detti Venerandi Padri il quale commincio ad alevarmi nel servitio del Signore come S. D. M. l'inspirava ma la mia simplicita o sia sempieta non intendeva quella santissima virtu e perfettione solo facevo ogni cosa pensando di far bene se bene l'amasso quanto potevo secondo la mia inclinatione e meschinita facendo tutto quello che quel Padre mi diceva per amore di S. D. M. e per darli gusto ero obediente e credevo simplicemente tutto quello che mi diceva onde dicendomi che nel giorno di S. Andrea mi voleva in una oscura camera della sua religione crucifigere sopra una grossa croce che gia egli haveva apparecchiata et che di cio ne chiedessi licenza a mia zia io pigliai questa licenza con tanta allegrezza che mia zia s'infervoro all'mar-tirio. Io non hebbi mai pensiero che questo Padre non mi dicesse la verita et ero cosi semplice che non pensavo che le figliole non potessero entrare ne Conventi de Fratri e quanto egli mi disse che non me voleva piu crocifigere perche non ero degna piansi amaramente." *Vita*, bk. 1, chap. 10, Milan, Biblioteca Ambrosiana MS G.97 sussidio f. 22r–v. I have transcribed these texts as they appear in the manuscripts, although it is clear that the idiosyncrasies and characteristic breathlessness of Maria Domitilla's narrative style sometimes violate the rules of formal Italian.

6. "In questo tempo cominciai a communicarmi tre volte la settimana e le Feste de Santi devoti di mia Zia quali erano moltissimi oltre le Domenice e feste commandate. Soleva

NOTES TO PAGES 62–65

mia Zia doppo haver meco la mattina avanti giorno finito di recitar le hore del divino officio e della Madona le lettanie de Santi e della Beatissima Vergine con molte altre Orationi vocali pigliarmi stretta fra le sue mani et braccia et offerirmi teneramente a piedi dell Crocifisso Amore et in tal affetto spesse volte ella lagrimava ed io ne sentivo tenerezza ed interna consolatione." Ibid., Milan, Biblioteca Ambrosiana MS G.97 sussidio, ff. 22v–23r.

7. "Mia madre temeva ch'io dovessi patir assai essendo da vedere figliolina di sei o sette anni ma andavo per li dodeci e tutti si stupivano che puotessi satisfare a cose cosi gravi massime." Ibid., f. 22v.

8. The amusing story of how Severetta and her Aunt Domitilla outwitted this "parachiano sacerdote vecchio e timorata di Dio" is told in bk. 1, chap. 11 of the *Vita*, in Ambrosiana MS G.97 ff. 25r–27r. Chap. 12 begins: "Doppo questo piacque al Signore per confessore concedermi il Signore Nicolo Lodolo Canonico del Domo Religioso buono allevato nelle cose dello Spirito da Padri Barnabitti," f. 27v.

9. Rodolfo Maiocchi, *Le Chiese di Pavia. Notizie* 2 (1903): 31–43; Maria Grazia Bianchi, "Una 'illuminata' del secolo XVII: Suor Maria Domitilla Galluzzi, Cappuccina a Pavia," *Bollettino della Societa Pavese di Storia Patria* n.s. 20–21 (1968–69): 6–7.

10. Bianchi, 11–16. The *Constitutions* of the Capuchin nuns of this house are preserved in a double manuscript, Pavia, Biblioteca Universitaria MS Aldini 502. The first part, dated 1610, is *Costitutione della Monache Capuccine di Santa Franca di Pavia*, the second, dated 1648, *Costitutioni delle Monache Capuccine della Prima Regola di Santa Chiara del Monastero del Santissimo Sacramento e Nativia della Beatissima Vergine di Pavia*. The last part of this title may reflect the name Santa Maria alle Pertiche. Maria Domitilla entered the community in 1616, and signed the *Constitution* of 1648 on the last folio of this manuscript.

11. Ibid., 32–35. Maria Domitilla's first treatise, *Vero lume del modo d'osservare l'antica regola di Santa Chiara*, is extant in three copies: Pavia, Biblioteca Universitaria, MS Aldini 306 — *Lume* (the third volume of a "fair copy" set including the *Passione* and the codex of letters to Maria Domitilla); Pavia, Biblioteca Civica MS 1, 11; and Milan, Biblioteca Trivulziana 491.

12. The second *Constitution* of the house specifies that two hours of "mental prayer" are to be done by each sister after compline in her cell, Cap. III "Nell'oratione Mentale," Pavia, Biblioteca Universitaria MS Aldini 502, pt. 2 f. 8. Maria Domitilla's *Vita* includes a chapter on mental prayer: "Come fa l'oratione mentale con l'affetto in che s'impiega con la raccommandatione del prossimo tutto a Sua Divina Maesta," bk. 1, chap. 23, Milan, Biblioteca Ambrosiana MS G.97 sussidio, ff. 123v–125v.

13. This may refer to Teresa of Avila, whose influence on Maria Domitilla is discussed by Bianchi, 43. Maria Domitilla describes a vision of Teresa of Avila at the end of bk. 3 of the *Vita*, Milan, Biblioteca Ambrosiana MS G.97 sussidio, f. 413r; H.75 sussidio f. 17r.

14. Her confessor, Giovanni Battista Capponi, to whom this account is addressed.

15. That is, that the apparition was not of the devil. Bell, 159–79, argues that after 1500 women's visionary experiences were increasingly suspected to be of diabolical origin.

16. "Essendo una volta nell'oratione della notte ritirata in cella nell'anno 1622. Vidi non so se con gli occhi della mente opure in uno di quelli sogni che mi vengano all'oratione, una serva di Dio la quale e molto lontana da questa citta et ha gran nome in virtu et santi costumi la quale in quelle hore notturne stava battendosi fortemente. Questa vista a me fu

tanto chiara e manifesta, che cominciai grandemente a sospirare e credo a piangere come quella che di cio hebbi grand invidia essendo che mi vede tanto priva delle vera virtu, per l'acquisto dell quali ho una continua fame di fare simili rigorose penitenze ma questa gratia da V.R. non mi e concessa, poiche egli et le mie R.M. Superiori conoscano la mia grande meschinita, percio esclamai al Signore: quasi con esso lamentandomi et esalando il mio desiderio con il maggior affetto che me fu concesse, dicendo O Signore Iddio mio come e possibile che mi sopportate cosi inutile nel numero di tante vostre serve le quali cosi da dovere si esercitano in opere di vera penitenza e come comportate che questa vostra serva che hora vedo si batte tanto forte epure e sparsa la fama della molte virtu e santita sua et io miserabile che per li miei peccati, e per l'acquisto delle sante virtu ho bisogno di fare tali penitenze ne sono cosi priva, come dunque potro piacervi e divenir vostra serva come bramo, poiche V. D. M. cosi merita?

"Stando in tal'interno colloquio, dove l'anima assai piu bene con Dio ragiona de quello si puo mai raccontare, vidi venirmi un belissimo et amabilissimo Christo Crocifisso, il quale con suoi raggi d'infinito amore mi accese di maggiori fiamme del suo divino amore, con tutto cio mi feci il segno della Santa Croce, et invocai il Santissimo nome del mio dolce Giesu, il quale pare non possi dubitare che egli non fosse quello poiche non fugi, ma ben si abazo tanto a me che uni il suo santissimo capo al mio indegno, la sua santissima faccia alla mia, il suo santissimi piedi alli miei, e tutto unito meco cosi fortemente me teneva seco in croce, che parevo con esso crocifisso, e che tutte le piaghe del suo Santissimo Corpo piagassero il mio indegno corpo, et sentendo tali dolori da essi mi sentivo tutta ardere del suavissimo amore di cosi amabilissimo signore: il quale pian piano mi elevo in alto cosi unito seco questo mio indegno corpo, al quale cosi in aria per gran pezzo fece sentire, godere, e patire de suoi dolori da capo a piedi, come in me havesse sensibilmente impresso tutte le sue santissime piaghe di tutto il suo Santissimo Corpo, ma in particolare quelle dell sue santissime mani, piedi, e costato." Pavia, Biblioteca Universitaria, MS Aldini 306 – *Passione*, ff. 3r–4r. This account is also found, with minor variants, at the beginning of bk. 2 of the *Vita*, Milan, Biblioteca Ambrosiana G.97 sussidio ff. 234v–235v.

17. "E fu veduto apparir li segni nelle mani, e piedi molto grandi, e come di color di ferro, e cosi sollevato che sembrava la forma di quei chiodi fatto a cantoni, come si suogliono mettere alli Crocifissi. Onde la sera non puotevo regermi in piedi, ne portar le patine per tal gonfiezza, e dolore, e questo fu il maggior dolore del secondo Venerdi." *Passione*, Pavia Biblioteca Universitaria, MS Aldini 306 – *Passione*, f. 84r; *Vita*, bk. 3 (letter on the Passion of Christ to Giovanni Battista Capponi), Milan, Biblioteca Ambrosiana G.97 sussidio, f. 362v. Bonaventure describes the "raised nail" form of the stigmata on the hands and feet of Francis of Assisi: "Erantque clavorum capita in manibus et pedibus rotunda et nigra, ipsa vero acuinina oblongata, retorta, et quasi repercussa, quae de ipsa carne surgentia carnem reliquam excedebant." *Vita Altera*, chap. 13, *Acta Sanctorum* (Oct. 2): 659, no. 193. Suor Beatrice's testimony is recorded by two letters, her own and one of Giovanni Battista Capponi: Milan, Biblioteca Ambrosiana G.97 sussidio ff. 372v–73r and 373v–74r.

18. *Vita*, bk. 3, Testimony of Suor Beatrice Avite Milan, Biblioteca Ambrosiana MS G.97 f. 363r.

19. "Se pure la santa gratia sia stata solo nell'anima o pure ne habbia participato anco il corpo, no lo so dire, so bene che per la rinovatione della memoria e dolore de Signore in tutti gli Venerdi, resto assai afflitta per alcuni giorni, et in questo me sentivo molta fia-

chezza corporale, e doppo la ricevuta gratia il misero corpo resta assai invigorito, e la faccia tanto accesa, che le sorelle ammiravano in tutto quel giorno, che tal rossore mi duro da dove cio m'avenisse et hebbi gratia di non partirmi mai di chiesa in tutto quel giorno, eccetto che nell'hora che andai con le altre alla communita del Reffetorio, no senti alcuna difficolta nel stare sempre in chiesa ma bensi continuo raccolimento e brama di servire e piacere a Suo Divino Maesta et alla Santissima Sua Madre." *Vita*, bk. 3, Milan, Biblioteca Ambrosiana G.97 sussidio, f. 419r; H.47 sussidio, ff. 25v–26r.

20. Bell, 13–14, 21.

21. Ibid., 170, 175–77.

22. "L'asprezza della vita, i continui digiuni, i cibi quadresimati, la ruidezza dell'habito, l'andar scalze, il dormir sopra le tavole, il fredo, e caldo si patisce, le discipline, le vigilie, il mattutino de mezza notte, l'oratione mentale, il ritiramento di secolari, e da parenti stessi, la puntual ubidienza, l'estrema poverta, et altri essercizii di fatica humili e di penitenza." *Constitutiones* of 1648, Pavia, Biblioteca Universitaria MS Aldini 502, pt. 2, f. 4r.

23. Ibid., f. 12r–v.

24. "Alla collatione, che si fa alla sera, si dia sempre ad ogn'una ugualmente in ogni tempo, quattro onze di pane, overo tre onze et un poco di frutta a chi cio vorra, ecetto ne i digiuni della Chiesa, nella quali non passerano tre onze di pane, overo due di pane, con qualche poco di frutta a chi vorra." *Constitutiones* of 1610, chap. 3, Pavia, Biblioteca Universitaria MS Aldini 502 pt. 1, f. 10r.

25. "Ma non pero ne carni ne laticinii," ibid., pt. 1, f. 9r.

26. Ibid., 125. Claire of Assisi, *Regula*, in *Sources Chrétiennes*, vol. 325, ed. Marie-France Becker, Jean-François Godet, Thaddée Matura (Paris: Les Éditions du Cerf, 1985), 130, 132.

27. Bynum, *Holy Feast and Holy Fast*, 207.

28. Bynum, "The Female Body and Religious Practice in the Later Middle Ages," in *Zone 3: Fragments for a History of the Human Body* 1 New York: Urzone, 1989): 188.

29. There are actually three extant portraits of Maria Domitilla, all woodcut impressions attached to the title pages of her works. The most common, signed "Agnellus Sculp.," is found in the only extant copy of the *Quarant'Hore di Meditatione Mentale*, Milan, Biblioteca Ambrosiana B.199 sussidio, and in these Ambrosiana copies of the *Vita*: G.97 sussidio, D.77 sussidio (which may be at least in part an autograph), A.276 sussidio, and I.41 sussidio. "Gio: Batt: Bonacina Sc." signed two different versions (one dated 1674) both of which appear in the copy of Maria Domitilla's first work, *Vero lume del modo d'osservare l'antica regola di Santa Chiara*, in Milan's Biblioteca Trivulziana, MS 491, and one in one Ambrosiana copy of the *Vita*, H.91 sussidio. A portrait by "Gan. Graminea Scul. Papie" is found in Ambrosiana H.47 sussidio, *Vita*. These impressions, which have never been studied, certainly testify to Maria Domitilla's fame in late seventeenth-century Lombardy.

30. "Considerando il contento, che la Santissima Vergine Maria haveva sentito in quel parto, che Iddio Sommo bene si fece homo nel suo santissimo ventre, fui rapita in una contentezza di Paradiso, dove parevami che la Vergine Santissimma con materno affetto mi facesse appoggiare il cappo al suo santissimo ventre, facendomi sentire, et conoscere, che dentro vi era Dio con gioia tanto innumerabile che l'anima mia conoscendosene indegna, diceva alla Vergine Santissima O Signora Santissima se fosse ancora necessario, cosa che non e, ne sera mai, che di novo Iddio si facesse homo in una Vergine, et io per sua gratia fossi quella, vo-

lentieri mi privarei di tanto bene, accio voi Meritissima Signora di novo godeste questo felicissimo gaudio, come soggetto piu capace e degno d'una tanto maesta e falicita che in Dio si ritrova." *Vita*, bk. 3, Milan, Biblioteca Ambrosiana MS G.97 sussidio, f. 419 v; also found in H.47 sussidio, f. 24r.

31. Bell, 60–61; Bynum, *Holy Feast and Holy Fast*, 165–82; Clarissa W. Atkinson, *Mystic and Pilgrim: The Book and the Life of Margery Kempe* (Ithaca, N.Y.: Cornell Univ. Press, 1983).

32. *Vita*, bk. 1, chap. 48, Milan, Biblioteca Ambrosiana MS G.97 sussidio, ff. 204v–205r. This vision, in which Maria Domitilla is actually taken into the womb of Mary, is granted as proof of the divine inspiration of her commentary on the *Rule of Saint Clare*.

33. Psalm 44:2, Vulgate.

34. "E puoi prorupe in souave pianto e disse — O Caro il mio Signore che divissione fu questa — O Padre Eterno come il vostro Sapientissimo Figlio per noi e stimato pazzione . . . O Signore spogliatemi di tutti li miei peccati — O Padre Eterno non e egli quello de che e scritto speciosus prae filliis huominum e come per noi hora e fatto spetacolo — Duri funi che legate quelle mani che l'universo fabricavano — O Padre Eterno come vi vedo compiacer in veder il vostro Figlio cosi mal tratatto — O Carita infinita . . . O buon Giesu con quanta fatcha — Ohime come potrai muovere il passo — O Pilato iniquissimo che dai tal sentenza — O che crudelta sara mai questa." Testimony of Suor Beatrice Avite in *Vita*, bk. 3, Milan, Biblioteca Ambrosiana MS G.97 sussidio, f. 365r-v.

35. "Entrando nel conoscimento di me stesso dico primo parlero al mio Dio io che so un niente. . . . Dieci. Ohime che crudelta e questa che usano nel spogliarvi dolce amor mio. Vndici. Puoi si rivolga a ministri e dice O Empii non sapete che il mio diletto e Agnello ma meritissimo? Perche gli mettete la cattena al collo? . . . Dodici . . . O ben mio che dolore sentiste nel movere gli piedi e far cosi afflitto tanti passi. Ohime come vi veddo strascinare e cadere con la faccia in terra come — Ohime — farete a levarvi, Dio mio, havendo le mani legate il corpo debole e tormentato. . . . O Padre Eterno mirate il figliolo vostro fatto obrobrio delli huomini — Haime che vedo godete sopra le pene del vostro figliolo." "Come fa l'Oratione mentale con l'affetto in che s'impiega con la raccommandatione del prossimo tutto a Sua Divina Maesta," *Vita*, bk. 1, chap. 13, Milan, Biblioteca Ambrosiana MS G.97 sussidio ff. 123v-124r.

36. "O aflittisimo Signore con qual mansuetudine ricceveste la final sentenza della morte . . . et inumerabili gente e soldati corendo tutti a vedere cosi lagrimabile spettacolo chi maledicendo e chi benedicendo la vostra gran Maesta tanto per noi abassata e maltratata — O Giesu mio chi vi spingeva chi vi sgridava chi vi percoteva chi vi tirava fango pietre et immonditie correndo tutti a gara alle porte e alle finestre per vidervi e tormentarvi e la M.V. il tutto soporto con somma patienza humilta e carita . . . quelli inhumani ministri con calzi con pugni con bastonate e col tirarvi chi per funi chi per le cattenne e chi per li santissime cappelli vi levarno nel luogo in cui v'incontraste . . . con quale unitamente vi conformaste nella volonta del Celeste Padre quali cosi haveva ordinato per la salute di noi miseri peccatori." Hora 34, Meditatio 34, "Come il Signore fu condanato alla dura Morte di Croce dal Iniquo Pilato . . ." *Quarant'Hore di Meditatione Mentale*, Milan, Biblioteca Ambrosiana MS B.199 sussidio, ff. 115v-117v.

37. Bianchi, 14–24.

38. Anna Cortese, "Suor Alma Colomba dello Spirito Santo (1592–1672); Monaca

Benedettina nel Monastero di San Felice in Pavia," *Bollettino della Societa Pavese di Storia Patria* n.s. 20–21 (1968–69): 103–77. The Biblioteca Civica of Pavia contains the following manuscripts: 11, 4 and 11, 5, writings of Alma Colomba (Caterina Regi Pinci, seventeenth-century Benedictine nun of San Felice); and 11, 6, the autobiography of Maria Marta Bicuti, a younger contemporary of Maria Domitilla who followed her from Acqui to the Capuchin house of Pavia. It is interesting to speculate how the inclusion of noncanonized holy women would change Bell's statistics about women's religious expression in post-tridentine Lombardy.

39. Romano, 21.

40. E. Ann Matter, "Per la morte di Suor Maria Domitilla Galluzzi, un inedito anonimo del Seicento pavese," *Poesia: Mensile di Cultura Poetica* 11, 12 (1989): 11–14; Romano, 119–228.

6. AN EXAMPLE OF SPIRITUAL FRIENDSHIP: THE CORRESPONDENCE BETWEEN HEINRICH OF NÖRDLINGEN AND MARGARETHA EBNER

1. Andreas Bauch, ed., *Quellen zur Geschichte der Diözese Eichstätt* 1, *Biographien der Gründungszeit* (Eichstätt: Sailer, 1962), 15.

2. Philipp Strauch, ed., *Margaretha Ebner und Heinrich von Nördlingen. Ein Beitrag zur Geschichte der deutschen Mystik* (Freiburg-im-Breisgau: Mohr, 1882; reprint, Amsterdam: Schippers N.V., 1966), 246,117–247,141 (Letter no. 43) and 246,52–54. Modern German translations of some of the letters are in Wilhelm Oehl, ed., *Deutsche Mystikerbriefe des Mittelalters 1100–1550* (Munich: Müller, 1931; reprint, Darmstadt: Wissenschaftliche Buchgesellschaft, 1972), 328. Where my German translation differs from Oehl's I do not mention this specifically.

I wish to thank Sr. Ingeborg Senkel, administrator of the Margaretha Ebner Archive at the Convent of Maria Medingen in Mödingen near Dillingen, for permitting me to use this archive.

3. Mechthild of Magdeburg, *Das fließende Licht der Gottheit*, ed. P. Gall Morel (1869; reprint, Darmstadt: Wissenschaftliche Buchgesellschaft, 1980).

4. Strauch, 16,5.

5. Ibid., 24,3–9.

6. Ibid., 24,16–18.

7. Ibid., 26,20–24.

8. Ibid., 33–34 and 290.

9. Ibid., 24,4.

10. Ibid., 237,25–27.

11. Strauch, 229,11–14; Oehl, 324.

12. Strauch, 201,116.

13. Ibid., 213,34–39; Oehl, 317.

14. Strauch, 282,55–56; Oehl, 337.

15. Strauch, 230,29.

16. Ibid., 195,53–196,2; Oehl, 312.

17. Strauch, 191,4–12.

18. Ibid., 197,4–16.

19. Ibid., 172,17; 184,27; 268,6–7 and 74–75, with further evidence; L. Zöpf, *Die Mystikerin Margaretha Ebner (ca. 1291–1351)* (1914; reprint, Hildesheim: Gerstenberg, 1974), 165.

20. Strauch, 251,36–252,60. The passage quoted is in Mechthild of Magdeburg, 11,9–29. This part of the text is already corrupted in the Einsiedeln MS 277 (the one Morel edited), which originates from Basle, and in Heinrich of Nördlingen's rendering. My own German translation is based on the new edition of *Das fließende Licht der Gottheit* by Hans Neumann (Munich: Artemis, 1990), also based on the Einsiedeln MS. It takes all extant versions into consideration. Because this edition also provides the page-numbering of Morel (M), I use this numbering in quotation.

My sincere thanks to Hans Neumann for allowing me to use the manuscript of his new edition for my quotations. Because this part of the text is strictly symmetrical in form and Neumann marks missing parts of sentences with ellipses, I have filled gaps in my translation, suiting the sense to Mechthild's language and way of thinking; these additions to the Neumann text are in []. This is a correction of pages 65–66 of my first complete modern German translation of the text (Einsiedeln: Benziger, 1955).

Further quotations from Mechthild in Heinrich of Nördlingen's correspondence are in Strauch, 242,30–33=M 13,4–5 (1,22), M 63,26–28 (3,3); Strauch, 251,33–36=M 63,26–28 (3,3) and M 12,15–17 (1,22); Strauch, 256,9–275,3=M 135,12–25 (5,6); Strauch, 257,40–41=M 20,2–6 (1,44); Strauch, 257,49–259,2=M 106,12–16 (4,12); and cf. n. 51 below. The whole of Heinrich's vocabulary needs to be investigated with respect to the influence of *Das fließende Licht der Gottheit*.

21. Strauch, 189,54.

22. Ibid., 182,31; 182,33–34.

23. Margot Schmidt, "Elemente der Schau bei Mechthild von Magdeburg und Mechthild von Hacheborn," in Dinzelbacher and Bauer, 134.

24. The German translation follows H. Urs von Balthasar, *Gregor von Nyssa: Der versiegelte Quell* (Einsiedeln: Johannes, 1983), 95. The same conclusions appear in the translation and explanation of M. Blum, *Der Aufstieg des Moses* (Freiburg-im-Breisgau: Lambertus, 1963), 11: "The soul continually rises about itself . . . in continually upward-striving flight. In its desire it leaves out no even greater height above the one it has already achieved; its flight is never ending. . . . For this reason we also say that the great Moses, becoming ever greater, neither halted in his ascent nor ever came to any end of his ascent, but . . . always climbed to the next rung and . . . never stopped because every rung was followed by another." Cf. Margot Schmidt, "'die spilende minnevlut.' Der Eros als Sein und Wirkkraft in der Trinität bei Mechthild von Magedeburg," in Schmidt and Bauer, eds., *"Eine Höhe über die nichts geht." Spezielle Glaubenserfahrung in der Frauenmystik?* (Stuttgart: Frommann-Holzboog, 1986), 71–133, esp. 85.

25. M 248,21 (8,35); Schmidt, "Elemente der Schau," 365.

26. Strauch, 281,15–25; Oehl, 324.

27. Strauch, 281,26–283,61; Oehl, 324.

28. Strauch, 218,55–57; Oehl, 324.

29. Strauch, 213,33–35 and 228,63–65; Oehl, 323.

30. Strauch, 214,25–27; Oehl, 318.

31. Strauch, 230,20–29; Oehl, 325.

32. Strauch, 205,1–11; Oehl, 314.

33. Strauch, 194,9–12.

34. Ibid., 194,12–21; Oehl, 311.

35. Strauch, 170,3–171,11; Oehl, 304.

36. Strauch, 228,72–74; Oehl, 324.

37. Strauch, 240,5–22; Oehl, 327.

38. Cf. Schmidt, "Elemente der Schau," 123–151, esp. 144; Rudolf von Biberach, *De septem itineribus aeternitatis* (1864; reprint, Stuttgart: Frommann-Holzboog, 1985), 474a, and *Die siben strassen zu got. Revidierte hochalemannische Übertragung*, ed. Schmidt (Stuttgart: Frommann-Holzboog, 1985), 27,8–18 and 322,16–19.

39. 2 Cor. 12.2–4.

40. Strauch, 183,18–20.

41. Ibid., 180,37–43.

42. Ibid., 192,6–7.

43. Ibid., 235,9–10.

44. Ibid., 207,25–26.

45. Ibid., 218,42 and 225,86–88; Oehl, 321.

46. Strauch, 173,13–15; Oehl, 307.

47. Strauch, 179,10–13.

48. Ibid., 268,1–5.

49. Strauch, 172,11–17; Oehl, 305.

50. Strauch, 188,1–2; 169,4.

51. Strauch, 76,8–21 (M 10,23): "Du bist ein lust miner gotheit, ein turst miner moenschheit" (1,19). In the autobiographical chap. 2 of book 4 Mechthild describes how two angels were put at her side during her ecstasies (M 91,36–92,3): "Der eine engel was von seraphin, under er ist ein minne brenner. . . . Der ander engel was von cherubin; der ist der gaben ein behalter und ordenet die wisheit in der minnenden sele" (4,2). The image of the "mirror of divinity" occurs several times in Mechthild, cf. Grete Luers, *Die Sprache der deutschen Mystik des Mittelalters im Werke der Mechthild von Magdeburg* (1926; reprint, Darmstadt: Wissenschaftliche Buchgesellschaft, 1966), 246–47.

52. Strauch, 197,16–198,17 and 175,59–64; Oehl, 308.

53. Strauch, 235,12.

54. Ibid., 176,11; 178,19–22; 195,34–41.

55. Ibid., 227,36.

56. Ibid., 251,29–36.

57. M 13,4–6: "Vrouwe, noch muost du uns soegen, wan dine brueste sind noch also vol, das du nut maht verdruken. Woltestu nit soegen me, so tete dir die milch vil we" (1,22). Schmidt, "Elemente der Schau," 68 and 45.

58. Strauch, 237,30.

59. Ibid., 207,13–16.

60. Ibid., 195,43; Oehl, 312.

61. Strauch, 204,1–2.

62. Ibid., 259,14.

63. *Vita* 1,61: "The same Holy Spirit that poured into John's heart when he received the profound revelation on Jesus' breast wanted her, too, to learn through the grace of his

descending to her what he [John] was allowed to express in words." *Das Leben der heiligen Hildegard*, Adelgundis Führkötter, trans. (Salzburg: Müller, 1980), 67.

64. Strauch, 24,3-4.

65. Ibid., 28,8.

66. Ibid., 231,51-52.

67. Erika Lorenz, "*Nicht alle Nonnen dürfen das.*" *Teresa von Avila und Peter Gracian. Die Geschichte einer großen Begegnung* (Freiburg-im-Breisgau: Herder, 1984).

68. In a letter to Wibert of Gembloux, Hildegard speaks about her deep pain over the death of her first correspondent and friend Volmar: "a lacrimis necdum temperare valeam, quoniam baculum consolationis meae non habeo," *Novae Epistolae, Analecta Sacra* 8, ed. J-B. Pitra (Montecassino, 1882). Cf. Ildefons Heswegen, "Les collaborateurs de sainte Hildegarde," *Revue bénédictine* 21 (1904): 199.

69. Strauch, 55.

70. Meister Eckhart, *Daz buoch der goetlîchen troestunge*, in *Die deutschen und lateinischen Werke* 5, ed. Josef Quint (Stuttgart: Kohlhammer, 1954).

71. Strauch, 54; 255,61-62.

72. Ibid., 250,12-19.

73. Ibid., 277,1-278,42; Oehl, 342. In the following year the abbot Ulrich III Niebling laid the foundation stone for the monumental basilica of Kaisheim Abbey, the largest church built in the fourteenth century, known as the Marian Cathedral of Bavarian Swabia. Cf. R. M. Libor, "800 Jahre Zisterzienserkloster und Reichsstift Kaisheim," in *Commentarii cistercienses* 35 (1984): 135-41, esp. 137.

74. Strauch, 242,31-32.

7. IN SEARCH OF MEDIEVAL WOMEN'S FRIENDSHIPS: HILDEGARD OF BINGEN'S LETTERS TO HER FEMALE CONTEMPORARIES

1. Brown, *Immodest Acts*; Monica Barz, Herta Leistner, and Ute Wild, eds., *Hättest Du gedacht, daß wir so viele sind? Lesbische Frauen in der Kirche* (Stuttgart: Kreuz, 1987); Matter, "Per la Morte di Suor Maria Domitilla Galluzzi."

2. Adrienne Rich, "Compulsory Heterosexuality and Lesbian Existence," in *Powers of Desire: The Politics of Sexuality*, ed. Anne Snitow, Christine Stansell, and Sharon Thompson (New York: Monthly Review, 1983), 177-206.

3. Christine Downing, *Psyche's Sisters* (San Francisco: Harper & Row, 1988); Haunani-Kay Trask, *Eros and Power: The Promise of Feminist Theory* (Philadelphia: Univ. of Pennsylvania Press, 1986); Carroll Smith-Rosenberg, "The Female World of Love and Ritual: Relations Between Women in Nineteenth-Century America," *Signs: Journal of Women in Culture and Society* 1 (Autumn 1975): 1-29; Janice G. Raymond, *A Passion for Friends: Toward a Philosophy of Female Affection* (Boston: Beacon, 1986).

4. "Christine de Pizan, 'Le Livre de la Cité des Dames,'" ed. Maureen Curnow. Ph.D. diss., Vanderbilt Univ., 1975.

5. Brian P. McGuire, *Friendship and Community: The Monastic Experience 350-1250* (Kalamazoo, Mich.: Cistercian, 1988), and "Love, Friendship and Sex in the Eleventh Century: The Experience of Anselm," *Studia Theologia* 28 (1974): 111-52; Jean Leclercq, "L'Amitié dans les lettres au moyen âge," *Revue du Moyen Âge Latin* 1 (1945): 391-410.

6. Michelle Zimbalist Rosaldo and Louise Lamphere, eds., *Women, Culture, and Society* (Stanford: Stanford Univ. Press, 1974).

7. Ibid., 28.

8. Ibid.

9. On the tension between love (*affectus*) for other men and spiritual growth enhanced by friendship in Aelred's *Speculum caritatis* and *De spirituali amicitia*, see McGuire, "Aelred of Rievaulx and the Limits of Friendship," in *Friendship and Community*.

10. Rosaldo and Lamphere.

11. McGuire, "Love, Friendship and Sex."

12. Nancy Chodorow, *The Reproduction of Mothering* (Berkeley: Univ. of California Press, 1978); Dorothy Dinnerstein, *The Mermaid and the Minotaur* (New York: Harper & Row, 1976); Juliet Mitchell, *Psychoanalysis and Feminism* (New York: Random House, 1974).

13. McGuire, *Friendship and Community*.

14. M. Esther Harding, *The Way of All Women* (New York: Harper & Row, 1975), 97.

15. Janet Todd, *Women's Friendship in Literature* (New York: Columbia Univ. Press, 1980).

16. Ibid., 3.

17. Ibid., 4.

18. Ibid.

19. Petroff, *Consolation of the Blessed* (Millerton, N.Y.: Alta Gaia, 1980).

20. Ibid., 34.

21. Mechthild, *Das fließende Licht*.

22. Herrad of Landsberg, *Hortus Deliciarum*, ed. Rosalie Green et al. (London: Warburg Institute, 1979).

23. Hrotsvit of Gandersheim, *Hrotsvithae Opera*, ed. Helena Homeyer (Paderborn: Schoningh, 1970).

24. Petroff, *Consolation*, 35.

25. Emmanuel Le Roi Ladurie, *Montaillou, the Promised Land of Error*, Barbara Bray, trans. (New York: Braziller, 1978).

26. Information on Gertrud's family and biography can be found in Hildegard von Bingen, *Briefwechsel*, Adelgundis Führkötter, ed. and trans. (Salzburg: Müller, 1965), 187. Hildegard's letters to Gertrud, her nuns, and Bishop Eberhard von Bamberg are in Hildegard, *Novae Epistolae, Analecta Sacra* 8, ed. J.-B. Pitra (Montecassino, 1882). This letter cycle and the following have been translated into German in *Briefwechsel*. I do not pursue here the complicated issue regarding the authenticity of the edited letters directed to Hildegard or the numerous problems of the surviving letter collections, esp. those directed to persons of high social and ecclesiastical standing. For an introduction to the issues, see Führkötter and Marianna Schrader, *Die Echtheit des Schrifttums der heiligen Hildegard of Bingen: Quellenkritische Untersuchungen* (Cologne: Böhlau, 1956). Van Acker mentions passim the correspondence with Gertrud and Elisabeth. Lieren van Acker, "Der Briefwechsel der heiligen Hildegard von Bingen," *Revue bénédictine* 98 (1988): 141–68 and 99 (1989): 118–54.

27. Todd, 4.

28. Ibid.

29. The Latin text of the correspondence with Gertrud and the sisters at Wechterswinkel is in Hildegard, *Novae Epistolae*, 548, 552–55. The quotation is from 555. Translations are mine.

30. Hildegard, *Novae Epistolae,* 55.

31. Todd, 4.

32. Hildegard consistently refused to provide petitioners with predictions about the future. On her use of the visionary mode, see David Baumgardt, "The Concept of Mysticism: Analysis of a Letter Written by Hildegard of Bingen to Guibert to Gembloux," *Review of Religion* 12 (1948): 277-86; and Barbara J. Newman, "Hildegard of Bingen: Visions and Validation," *Church History* 54 (1985): 163-75.

33. Hildegard, *Novae Epistolae,* 555.

34. Ibid., 573.

35. Among her contemporaries, Elisabeth's visionary works were much more popular than Hildegard's writings, a stark contrast to the insecurity Elisabeth projects in her relationship to the older visionary. See Kurt Köster, "Das visionäre Werk Elisabeths von Schönau," *Archiv fur mittelrheinische Kirchengeschichte* 4 (1952): 79-119. Elisabeth's letters to Hildegard are printed in Elisabeth von Schönau, *Die Visionen und die Briefe der heiligen Elisabeth von Schönau und die Schriften der Äbte Ekbert und Emecho von Schönau,* ed. F. W. E. Roth (Brünn: Studien aus dem Benedictiner- und Cistercienser-Orden, 1984), 70 ff. Hildegard's first letter to Elisabeth is in Hildegard, *Opera omnia,* 216-18; for the second letter, see J. May, *Die heilige Hildegard von Bingen* (Munich, 1911), 512-14.

36. Marina Warner, *Joan of Arc: The Image of Female Heroism* (New York: Random House, 1982).

37. Brown, *Immodest Acts.*

38. Todd, 4.

39. Rosaldo and Lamphere, 36.

40. Elisabeth von Schönau, *Die Visionen,* 74.

41. May, 512.

42. Ibid., 514.

43. Walt Whitman, *Leaves of Grass* (New York: Signet, 1980).

44. Gottfried of Saint Disibod and Dieter of Echternach, *Vitae Sanctae Hildegardis,* in *PL* 197, 91-130. The Latin text has been critically edited in part by Dronke, *Women Writers of the Middle Ages,* 231-40. This quotation and the following translations, if not otherwise credited, are Dronke's.

45. Information on Richardis from Hildegard, *Briefwechsel,* 94-104; Führkötter and Schrader, 131-42; Dronke, "Hildegard of Bingen," in *Women Writers of the Middle Ages,* esp. 154-59. Newman suggests that the role of Castitas in Hildegard's *Ordo Virtutum* was written in memory of Richardis (*Sister of Wisdom,* 222-23). Most of the letters pertaining to the friendship and Hildegard's attempt to regain Richardis are in Hildegard, *Opera omnia,* 156-63, 317-18; the letter to Richardis's mother and Richardis in Führkötter and Schrader, 135, 137; for the letters between Hartwig of Bremen, Richardis's brother, her mother, and Hildegard, see also "Epistolae Sanctae Hildegardis secundum codicem Stuttgartensem," ed. Francis Haug, *Revue Bénédictine* 43 (1931): 59-71.

46. See Gottfried of Saint Disibod and Dieter of Echternach.

47. Ibid.

48. Ibid.

49. Ibid.

50. The Latin text of the letter is critically edited in Führkötter and Schrader, 131-41.

51. Ibid. See also Dronke, *Women Writers of the Middle Ages*, 156. Translation mine.

52. See Gottfried of Saint Disibod and Dieter of Echternach.

53. Dronke, *Women Writers of the Middle Ages*, 156.

54. Ibid.

55. Ibid.

56. Hildegard, *Opera omnia*, 162D-63A. Translation mine.

57. Ibid., 166B, the Latin text. Translation mine.

58. Latin text in Führkötter and Schrader, 131-41. Translation mine.

59. Gottfried of Saint Disibod and Dieter of Echternach, 103AB.

60. Hildegard to Archbishop Hartwig of Bremen, *Opera omnia*, 162D-63.

61. Führkötter and Schrader, 131-41.

62. Raymond, 3.

63. Todd, 3.

8. REALITY AS IMITATION:
THE ROLE OF RELIGIOUS IMAGERY AMONG THE BEGUINES IN THE LOW COUNTRIES

1. I elaborate the *Pietà* and its relation to the Beguines in my book *Sculpture of Compassion: The Pietà and the Beguines in the Southern Low Countries, ca. 1300-ca. 1600* (Rome: Belgian Historical Institute, forthcoming).

2. Joanna E. Ziegler, "The *curtis* beguinages in the Southern Low Countries and art patronage: interpretation and historiography," *Bulletin de l'Institut Historique Belge de Rome* 57 (1987): 31-70; Walter Simons, "The Beguine Movement in the Southern Low Countries: A Reassessment," *Bulletin de l'Institut Historique Belge de Rome* 59 (1990): 63-105.

3. M. Erbstösser, *Sozialreligiöse Strömungen im späten Mittelalter: Geissler, Freigeister und Waldenser im 14. Jahrhundert* (Berlin: Akademie, 1970); I. Wormgoor, "De Verfolging van de Vrijen van Geest, de Begijnen en Begarden," *Nederlands Archief voor Kerkgeschiedenis* n.s. 65 (1985): 107-30; Ziegler, "*curtis* beguinages," 55-70.

4. McNamara, "The Rhetoric of Orthodoxy," this volume; Ziegler, "Secular Canonesses and Beguines: An Introduction to Some Older Views," in *Studies in Medieval and Renaissance History*, ed. J. S. A. Evans and R. W. Unger (New York: AMS Press, 1991), 117-35.

5. Ibid.

6. Ibid.

7. The translation of the rules presented here is my own. A transcription of Bishop Robert's statutes for Liège is in L. J. H. Philippen, *De Begijnhoven, Oorsprong, Geschiedenis, Inrichting* (Antwerp: Veritas, 1918), 303-8; and H. Nimal, "Les Béguinages," *Annales de la Société Archéologique de l'arrondissement de Nivelles* 9 (1908): 57-69, although Nimal is not altogether reliable.

8. McNamara, "The Rhetoric of Orthodoxy," this volume.

9. Philippen, 307.

10. J. Béthune, ed., *Cartulaire du béguinage de Sainte Élisabeth à Gand* (Bruges: De Zuttère, 1893), 74; P. Fredericq, ed., *Corpus documentorum inquisitionis hæreticæ pravitatis Neerlandicæ* 1 (Ghent: Vuylsteke, 1889-1906), 176.

11. R. Hoornaert, "La plus ancienne règle du béguinage de Bruges," *Annales de la*

Société d'Émulation de Bruges 72 (1929): 17-79. I wish to thank Judith E. Tolnick for her help with this translation.

12. "Vita Mariæ Oigniacensis," ed. D. Papebroeck, *Acta Sanctorum* (1867): 542-72; *The Life of Marie d'Oignies by Jacques de Vitry*, Margot H. King, trans. (Saskatoon, Canada: Peregrina, 1987).

13. Ibid., 40.

14. Hoornaert.

15. McNamara, "The Rhetoric of Orthodoxy."

16. Kieckhefer.

17. McNamara, "The Rhetoric of Orthodoxy."

18. Simons and Ziegler, "Phenomenal Religion in the Thirteenth Century and Its Image: Elisabeth of Spalbeek and the Passion Cult," in *Women in the Church*, ed. W. J. Sheils and Diana Woods (Oxford: Blackwell, 1990), 116-26.

19. A. H. Bredero, "De Delftse begijn Gertrui von Oosten (ca. 1320-1358) en haar niet-erkende heiligheid," in *De Nederlanden in de Late Middeleeuwen*, ed. D. E. H. de Boer and G. W. Marsilje (Utrecht: Het Spectrum, 1987), 83-97, raises questions about the role of another stigmatized Beguine, Gertrude of Delft, who after her death quickly fell into obscurity. Her spiritual activities had been viewed even by her sister Beguines as something of a liability. Bredero's test case in Gertrude has broader applications for the fourteenth century, where he suggests hers became the norm.

20. I have chosen not to treat illustrated texts here because such texts have a comparatively precise and prespecified function. Text or use and imagery may be correlated. J. Oliver, *Gothic Manuscript Illumination in the Diocese of Liège (c.1250-c.1330)* (Louvain: Vitgeverij Peeters, 1988), discusses psalters in a Beguine context. Devotional or religious sculpture, the focus here, has no documented liturgical or official role, except for Virgin objects processed on certain feast days (Ziegler, "The Medieval Virgin as Object: Art or Anthropology?" *Historical Relections* 16, no. 2/3 [1989]: 251-64). For a more elaborate discussion of Beguine art, see my entry on "Beguines" in *The Dictionary of Art* (London: 1992).

21. H. Wentzel, "Christkind," *Reallexikon zur deutschen Kunstgeschichte* 3 (1954), cols. 590-608; E. Legros, "Sur les *repos de Jésus* tournaisiens (et sur quelques autres faits attestés par les testaments de Tournai)," *La Vie Wallonne* 33 (1959): 212-17; R. de Roo, "Mechelse beeldhouwkunst," in *Aspecten van de Laatgotiek in Brabant* (Louvain: Stedelijk Museum, 1971), 432. I wish to thank Rosemary Hale for sharing with me her research on Christ child imagery.

22. J. Vols, "Maria-vereering te Tongeren door de eeuwen heen," *Limburg* 26 (1946): 131-40.

23. Ernest W. McDonnell, *The Beguines and Beghards in Medieval Culture with Special Emphasis on the Belgian Scene* (New Brunswick, N.J.: Rutgers Univ. Press, 1954), 295-96.

24. Ziegler, "Virgin as Object."

25. M. English, "Middeleeuwsche Mariabeelden te Brugge," *Kunst Adelt* 7, no. 3/4 (1929): 16-17.

26. J. Moors, *De oorkondentaal in Belgisch-Limburg van circa 1350 tot 1400* (Brussels: Belgisch Inter-Universitaire Centrum, 1952), 301-2.

27. It is not unlikely that the Virgin referred to in this document is the same one now

in the collection of the Metropolitan Museum of Art in New York City. R. Van de Ven, "De Kunstinboedel van de Sint-Catherina of Begijnhofkerk tijdens de 15de en 16de eeuw," in *Kunstschatten uit het Diestse begijnhof* (Diest: Stedelijk Museum, 1988), 134; and cat. no. 43, 70–72.

28. Ziegler, "Virgin as Object."

29. 12 September 1362 (Douai, Archives municipales, GG 191, seventeenth-century copy).

30. *Kunstschatten uit het Diestse begijnhof,* 73–75.

31. J. Paquay, ed., *Cartulaire de la collégiale Notre-Dame à Tongres, jusqu'au XV^e siècle* 1 (Tongeren, 1909), 507; E. Persoons, *Prieuré de Ter-Nood-Gods à Tongres, Monasticon Belge* 6 (Liège: Centre national de Recherches d'histoire religieuse, 1979), 267–76.

32. Simons and Ziegler, "Phenomenal Religion."

33. J. Paquay, ed., *Visites archidiaconales et descriptions des églises du Concile de Tongres 1477–1763 à Tongres* (Liège, 1935), 57.

34. Since 1913 this statue has been in the collection of the Franciscans in Tongeren, Belgium. See Ziegler, *Sculpture of Compassion,* inv. no. 84, plate 77.

35. Ziegler, "Virgin as Object."

36. McNamara, "The Rhetoric of Orthodoxy."

37. Legros; de Roo.

9. TEXT AND CONTEXT IN HILDEGARD OF BINGEN'S *ORDO VIRTUTUM*

1. Hildegard of Bingen, *Ordo Virtutum,* Peter Dronke, trans., in "Notes in Deutsche Harmonia Mundi 19-9942-3" (Cologne: West Deutscher Rundfunk, 1982).

2. Hildegard of Bingen, *Scivias,* Mother Columba Hart and Jane Bishop, trans. (New York: Paulist, 1990).

3. Renata Craine, "The Role of Experience in Hildegard of Bingen's Spirituality," paper, 8–9.

4. Hildegard of Bingen, *Ordo Virtutum,* ed. Audrey Ekdahl Davidson (Kalamazoo, Mich.: Medieval Institute, 1985).

5. M. Immaculata Ritscher, "Zur Musik der Heiligen Hildegard von Bingen," in *Hildegard von Bingen 1179–1979,* ed. Anton Bruck (Mainz: Gesellschaft für mittelrheinische Kirchengeschichte, 1979), 195.

6. Fletcher Collins, Jr., *The Production of Medieval Church Music-Drama* (Charlottesville: Univ. Press of Virginia, 1972), 10.

7. Dronke, *Poetic Individuality in the Middle Ages* (Oxford: Clarendon, 1970), 179.

8. Willi Apel, *Gregorian Chant* (Bloomington: Indiana Univ. Press, 1958), 344.

9. *Ordo,* tr. Dronke.

10. *Ordo,* ed. Davidson, 37.

11. Hildegard, *Hildegard von Bingen: Lieder,* ed. Prudentia Barth, M. Immaculata Ritscher, and Joseph Schmitt-Görg (Salzburg: Müller, 1969), nos. 58, 31.

12. Ibid., nos. 32, 33.

13. Ibid., no. 21.

14. Apel, 345–62.

15. Oliver Strunk, *Source Readings in Music History: Antiquity and the Middle Ages* (New York: Norton, 1965), 93.

16. *Ordo*, ed. Davidson, 1.

17. William Mahrt, "Hildegard's Art of Melody," paper, 9.

18. *Liber Usualis*, ed. The Benedictines of Solesmes (Toledo, Ohio: Gregorian Institute of America, 1954), 1071. (Henceforth *LU*.)

19. *Ordo*, ed. Davidson, 14.

20. Ibid., 2 and *LU* 704.

21. *Ordo*, tr. Dronke.

22. *LU* 704.

23. Ritscher, 196.

24. Dante, *The Comedy of Dante Alighiere, the Florentine: Cantica* 1, *L'Inferno*, Dorothy L. Sayers, trans. (New York: Penguin, 1949).

25. *Ordo*, tr. Dronke.

26. Ibid.

27. Ibid.

28. Richard Axton, *European Drama of the Early Middle Ages* (London: Hutchison, 1974), 96.

29. Dronke, *Poetic Individuality*, 171.

30. *Ordo*, tr. Dronke.

31. Newman, *Sister of Wisdom*, 221-22.

32. Ibid., 223.

33. *Ordo*, tr. Dronke.

34. Ibid.

35. Ibid.

36. Bruce W. Hozeski, "Hildegard of Bingen's *Ordo Virtutum:* The Earliest Discovered Liturgical Morality Play," *American Benedictine Review* 26 (1975): 254-55.

37. Donke, *Poetic Individuality*, 169-70.

38. Arnold Williams, *The Drama of Medieval England* (East Lansing: Michigan State Univ. Press, 1961), 142.

39. O. B. Hardison, Jr., *Christian Rite and Christian Drama in the Middle Ages* (Baltimore: Johns Hopkins Univ. Press, 1965), 289.

40. Axton, 11.

41. M. R. James, ed., *The Apocryphal New Testament* (Oxford: Clarendon, 1955).

42. Axton, 61-62.

43. James, 133-39.

44. Axton, 62.

45. Karl Young, *The Drama of the Medieval Church* 1 (Oxford: Clarendon, 1933), 103-4.

46. Newman, *"Symphonia," by Saint Hildegard of Bingen* (Ithaca, N.Y.: Cornell Univ. Press, 1988), 250-55.

47. *Ordo*, tr. Dronke.

48. Ibid.

49. Ibid.

50. Ibid.

51. Ibid.
52. Ibid.
53. Ibid.
54. Dronke, *Poetic Individuality,* 175.
55. Axton, 58.
56. Ibid., 98.
57. James, 253–54.
58. Thomas Mann, *Doktor Faustus* (Stockholm: Bermann-Fischer, 1947), 347.
59. Hildegard, *Scivias,* tr. Hart and Bishop, 533.
60. Oskar Söhngen, "Music and Theology: A Systematic Approach," Joyce Irwin, trans., in *Sacred Sound: Music in Religious Thought and Practice* (Chico, Calif.: Scholars, 1983), 2.
61. John 2:19–22.
62. Craine, 8.
63. *Ordo,* tr. Dronke.
64. Ibid.
65. Ibid.
66. Ritscher, 193.
67. Hildegard, *Scivias,* tr. Hart and Bishop, 533.
68. Ibid., 534.
69. Ibid., 533.
70. Albert Seay, *Music in the Medieval World,* 2d ed. (Englewood Cliffs, N.J.: Prentice-Hall, 1975), 19.
71. Ibid., 19–20.
72. *Ordo,* ed. Davidson, nos. 2 (2x), 5, 35, 36 (2x), 44 (2x), 47, 57 (2x), 64, 69, 71 (3x), 75, 82 (2x), 84, and 85 (2x).
73. Ibid., nos. 82 (2x) and 84.
74. Ibid., 3.
75. *Ordo,* tr. Dronke.
76. *Ordo,* ed. Davidson, 33.
77. *Ordo,* tr. Dronke.
78. Newman, *Sister of Wisdom,* 180.
79. Hildegard, *Lieder,* 224.
80. Newman, *Sister of Wisdom,* 180.
81. Ibid., 181.
82. Bernard of Clairvaux, *On the Song of Songs* 1, Kilian Walsh, trans. (Kalamazoo, Mich.: Cistercian, 1981), 6.
83. Ibid., 6–7.
84. John Stevens, *Words and Music in the Middle Ages: Song, Narrative, Dance and Drama, 1050–1350* (New York: Cambridge Univ. Press, 1986), 399.
85. James A. Hall, "Personal Transformation: The Inner Image of Initiation," in *Betwixt and Between: Patterns of Masculine and Feminine Initiation,* ed. Louise Carus Mahdi, Stephen Foster, and Meredith Little (LaSalle, Ill.: Open Court, 1987), 330.
86. 2 Kings 3:15.
87. 1 Sam. 1:5–6.

88. Dante, *The Comedy, Cantica* 3, *Il Paradiso,* Dorothy L. Sayers and Barbara Reynolds, trans. (New York: Penguin, 1962), 347.

89. Gretchen L. Finney, "Ecstasy and Music in Seventeenth-Century England," *Journal of the History of Ideas* 8 (1947): 157.

90. Edgar De Bruyne, *The Esthetics of the Middle Ages,* Eileen B. Hennessy, trans. (New York: Ungar, 1969), 195–96.

91. Barbara Grant, "Five Liturgical Songs of Hildegard of Bingen," *Signs* 5 (Spring 1980): 558.

92. Barbara J. Jeskalian, "Hildegard of Bingen: Her Times and Music," *Anima* 10, no. 1 (Fall 1983): 13.

93. Axton, 99.

BIBLIOGRAPHY

PRIMARY SOURCES

Aelred of Rievaulx. "Aelredi Rievallensis Opera Omnia." In *Corpus Christianorum, Continuatio Medievalis* 1, edited by A. Hoste and C. H. Talbot. Turnhout: Brepols, 1971.

———. "A Rule of Life for a Recluse." In: *Treatises and the Pastoral Prayer*, translated by Mary Paul MacPherson and edited by David Knowles. Kalamazoo, Mich.: Cistercian, 1971.

———. *Spiritual Friendship*. Translated by Mary Eugenia Laker. Kalamazoo, Mich.: Cistercian, 1977.

———. *Treatises and the Pastoral Rule*. Translated by R. Penelope Lawson et al. and edited by M. Basil Pennington. Spencer, Mass.: Cistercian, 1971.

Anna von Munzingen. "Die Chronik der Anna von Munzingen." Edited by J. König. *Freiburger Diözesan Archiv* 13 (1880): 129–236.

The Apocryphal New Testament. Edited by M. R. James. Oxford: Clarendon, 1955.

Augustine. *Confessions*. Translated by R. S. Pine-Coffin. New York: Penguin, 1961.

———. *Sancti Augustini Opera*. In *Corpus Christianorum, Series Latina* 27. Turnhout: Brepols, 1962.

Bernard of Clairvaux. *The Works of Bernard of Clairvaux* 2. On the *Song of Songs* 1. Translated by Kilian Walsh. Kalamazoo, Mich.: Cistercian, 1981.

Birgitta de Regno Suetiae. *Den heliga Birgittas Revelaciones Extravagantes*. Edited by L. Hollman. *Samlingar Utgivna av Svenska Fornskrifts' allskapet* ser. 2, no. 5 (1956).

———. *Regula Sancti Salvatoris, Revelationes S. Brigittae Card. Turrneremata*. Edited by Consalvus Durantus, 754–70. Rome: Stephanus Paulinus, 1606.

Cartulaire du béguinage de Sainte Elisabeth à Gand. Edited by J. Béthune. Bruges: De Zuttère, 1893.

Cartulaire de la collégiale Notre-Dame à Tongres, jusqu'au XVe siècle 1. Edited by J. Paquay. Tongeren, 1909.

Christine de Pizan. "The 'Livre de la Cité des Dames': A Critical Edition." Edited by Maureen Curnow. Ph.D. diss., Vanderbilt Univ., 1975.

Claire of Assisi. "Regula." In *Écrits*, edited by Marie-France Becker, Jean-Francois Godet, and Thaddée Matura, 120–65. *Sources Chrétiennes* 325. Paris: Les Éditions du Cerf, 1985.

Corpus documentorum inquisitionis haereticae pravitatis Neerlandicae 1. Edited by P. Fredericq. Ghent: Vuylsteke, 1889, 1906.

Dante Alighieri. *The Comedy of Dante Alighieri, the Florentine: Cantica 3 Il Paradiso.* Translated by Dorothy L. Sayers and Barbara Reynolds. New York: Penguin, 1962.

Deutsche Mystikerbriefe des Mittelalters 1100–1550. Edited by Wilhelm Oehl. Munich: Müller, 1931. Reprint. Darmstadt: Wissenschaftliche Buchgesellschaft, 1972.

Elisabeth of Schönau. *Die Visionen der heiligen Elisabeth und die Schriften der Äbte Ekbert und Emecho von Schönau.* Edited by F. W. E. Roth. Brünn: Studien aus dem Benedictiner- und Cistercienser-Orden, 1984.

Gerson, Johannes. *Oeuvres Complètes.* 11 vols. Edited by P. Glorieux. Paris: Declée, 1960–73.

Gottfried of Saint Disibod and Dieter of Echternach. *Vita Sanctae Hildegardis.* *Patrologiae cursus completus: Series latina* 197, edited by J.-P. Migne, 91–130. Paris, 1855. Reprint. 1966.

Herrad of Landsberg (Herrad of Hohenbourg). *Hortus Deliciarum.* Edited by Rosalie Green et al. London: Warburg Institute, 1979.

Hildegard of Bingen. *Briefwechsel.* Translated and edited by Adelgundis Führkötter, OSB. Salzburg: Müller, 1980.

————. *Epistolae St Hildegardis secundum codicem Stuttgartensem.* Edited by Francis Haug. *Revue Bénédictine* 43 (1931): 59–71.

————. *Hildegard von Bingen: Lieder.* Edited by Prudentia Barth, M. Immaculata Ritscher, and Joseph Schmitt-Görg. Salzburg: Müller, 1969.

————. *Hildegard von Bingen: Lieder.* Translated and edited by Adelgundis Führkötter, OSB. Salzburg: Müller, 1969.

————. *Das Leben der heiligen Hildegard.* Translated and edited by Adelgundis Führkötter, OSB. Salzburg: Müller, 1980.

————. *Novae Epistolae, Epistolarum altera series nova. Analecta Sacra* 8. Edited by J. B. Pitra. Monte Cassino, 1882.

————. *Opera Omnia. Patrologiae cursus completus: Series latina* 197. Edited by J.-P. Migne. Paris, 1855. Reprint. 1966.

————. *Ordo Virtutum.* Edited by Audrey Ekdahl Davidson. Kalamazoo, Mich.: Medieval Institute, 1985.

————. *Ordo Virtutum.* Translated by Peter Dronke. In "Notes in Deutsche *Harmonia Mundi* 19-9942-3." Cologne: West Deutscher Rundfunk, 1982.

————. *Scivias.* Translated by Mother Columbia Hart and Jane Bishop. New York: Paulist Press, 1990.

Hrotsvit of Gandersheim. *Hrotsvithae Opera.* Edited by Helene Homeyer. München: Schöningh, 1970.

Hugo of Floreffe. "De B. Yvetta vidua reclusa Hui in Belgio." *Acta Sanctorum* 13 (1643): 863–86.

Jacques de Vitry. *The Life of Marie d'Oignies.* Translated by Margot H. King. Saskatoon, Canada: Peregrina, 1987.

————. "Vita Mariae Oigniacensis." In *Acta Sanctorum* (June 5, 1867), edited by D. Papebroeck: 542–72.

The Jerusalem Bible. Edited by Alexander Jones. Garden City, N.Y.: Doubleday, 1966.

Jonas of Bobbio. *Vita S. Columbani abbatis discipulorumque eius.* Edited by B. Krusch. *Monumenta Germaniae Historica, Rerum Merovingicarum Scriptorum* 4 (1888): 119–43. Hannover: Hahn.

Jordan of Saxony. *Libellus de principiis ordinis Praedicatorum.* In *Monumenta Ordinis fratrum Praedicatorum Historica* 16, edited by H. C. Scheeben, 1–88. Rome, 1935.

Julian of Norwich. *A Book of Showings to the Anchoress Julian of Norwich.* Edited by Edmund Colledge and James Walsh. Studies and Texts 35. Toronto: Pontifical Institute of Medieval Studies, 1978.

————. *Showings.* Edited by Edmund Colledge and James Walsh. New York: Paulist Press, 1978.

Juliana of Mont-Cornillon. *The Life of Blessed Juliana of Mont-Cornillon.* Translated by Barbara J. Newman. Toronto: Peregrina, 1988.

Kempe, Margery. *The Book of Margery Kempe.* Edited by Sanford Meech, Hope Emily Allen, and William Butler-Bowden. Early English Text Society 212. London: Oxford Univ. Press, 1940.

————. *The Book of Margery Kempe.* Edited by W. Butler-Bowdon. New York: Devin-Adair, 1944.

————. *The Book of Margery Kempe.* Translated by B. A. Windeatt. New York: Penguin, 1985.

Liber Usualis. Edited by the Benedictines of Solesmes. Toledo, Ohio: Gregorian Institute of America, 1954.

Mechthild of Magdeburg. *Das fließende Licht der Gottheit.* Edited by Hans Neumann. Munich: Artemis, 1990.

————. *Das fließende Licht der Gottheit.* Translated by Margot Schmidt. Einsiedeln: Benziger Verlag, 1955.

————. *Offenbarungen der Schwester Mechthild von Magdeburg oder Das Fließende Licht der Gottheit.* Edited by P. Gall Morel. Regensburg, 1869. Reprint. Darmstadt: Wissenschaftliche Buchgesellschaft, 1980.

Meister Eckhart. *Daz buoch der goetlîchen troestunge.* In *Die deutschen und lateinischen Werke* 5, edited by Josef Quint. Stuttgart: Kohlhammer, 1954.

Middle English Sermons. Edited by Woodburn O. Ross, Hope Emily Allen, and Sanford Meech. New York: Oxford Univ. Press, 1960.

Nonne von Engelthal. *Büchlein von der Gnaden Überlast.* Edited by Karl Schröder. Tübingen: Bibliothek des Litterarischen Vereins, 1871.

"Die Nonne von St. Katharinenthal bei Dieszenhofen." Edited by A. Birlinger. Das Leben Heiliger Alemannischer Frauen des Mittelalters. *Alemannia* 15 (1887): 151–83.

Peter of Dacia. *De gratia naturam ditante sive de virtutibus Christinae Stumbelensis.* Edited by Monika Askalos. Stockholm: Univ. of Stockholm Press, 1982.

Quellen zur Geschichte der Diözese Eichstätt 1, Biographien der Gründungszeit. Edited by Andreas Bauch. Eichstätt: Sailer, 1962.

A Revelation of Purgatory by an Unknown Fifteenth-Century Visionary: Introduction, Critical Text and Translation. Edited by Marta Powell Harley. Lewiston, N.Y.: Mellen, 1985.

Rudolf von Biberach. *De septem itineribus aeternitatis.* 1864. Reprint. *Mystik in Geschichte und Gegenwart* 1, no. 2. Stuttgart: Frommann-Holzboog, 1985.

———. *Die siben strassen zu got. Revidierte hochalemannische Übertragung.* Edited by Margot Schmidt. *Mystik in Geschichte und Gegenwart* 1, no. 2. Stuttgart: Frommann-Holzboog, 1985.

Sanctorum Conciliorum: Nova et Amplissima Collecto. Edited by J. D. Mansi. Venice: Zatta, 1925.

Der sogenannte Libellus de dictis quattuor ancillarum s. Elisabeth confectus. Edited by A. Huyskens. Marburg: Elwert, 1911.

Stagel, Elsbet. *Das Leben der Schwestern zu Töss.* Edited by F. Vetter. Berlin: Weidmann, 1906.

Statuta capitulorum generalium ordinis cisterciensis ab anno 1116 ad annum 1786. Vol. 5. Edited by S. Canivez, Louvain: Bureaux de la Revue d'Histoire écclésiastique, 1933–1941.

Suso, Heinrich. *Life of Heinrich Suso.* Edited by N. Heller. Translated by Sr. M. Ann Edward. Dubuque, Iowa: Priory, 1962.

Thomas de Cantimpré. *Life of Lutgard of Aywières.* Edited and translated by Martinus Cawley. Lafayette, Oreg.: Guadalupe Translations, 1987.

Visites archidiaconales et descriptions des églises du Concile de Tongres 1477–1763 à Tongres. Edited by J. Paquay. Liège, 1935.

"Les *Vitae sororum* d'Unterlinden: Édition critique du manuscrit 508 de la Bibliothèque de Colmar." Edited by Jeanne Ancelet-Hustache. *Archives d'histoire doctrinale et littéraire du moyen âge* 5 (1930): 317–509.

SECONDARY SOURCES

Abels, Richard, and Ellen Harrison. "The Participation of Women in Languedocian Catharism." *Medieval Studies* 41 (1979): 215–51.

Allen, Prudence. "Hildegard of Bingen's Philosophy of Sex Identity." *Thought* 64 (1989): 231–41.

Ancelet-Hustache, Jeanne. *La vie mystique d'un monastère de dominicaines d'après la chronique de Töss.* Paris: Perrin et Cie, 1928.

Anderson, M. D. *Drama and Imagery in English Medieval Churches.* Cambridge: Cambridge Univ. Press, 1963.

Apel, Willi. *Gregorian Chant.* Bloomington: Indiana Univ. Press, 1958.

Atkinson, Clarissa W. *Mystic and Pilgrim: The Book and the Life of Margery Kempe.* Ithaca, N.Y.: Cornell Univ. Press, 1983.

Axton, Richard. *European Drama of the Early Middle Ages.* London: Hutchinson, 1974.

Baker, Derek, ed. *Medieval Women.* Oxford: Blackwell, 1978.

Bakhtin, M. M. *The Dialogic Imagination.* Translated by Caryl Emerson and Michael Holquist. Austin: Univ. of Texas Press, 1981.

———. *Rabelais and His World.* Translated by H. Iswolsky. Cambridge, Mass.: MIT Press, 1968.

Balthasar, H. Urs von. *Gregor von Nyssa: Der versiegelte Quell.* Einsiedeln: Johannes, 1983.

Barz, Monica, Herta Leistner, and Ute Wild, eds. *Hättest Du gedacht, daß wir so viele sind? Lesbische Frauen in der Kirche.* Stuttgart: Kreuz Verlag, 1987.

Baumgardt, David. "The Concept of Mysticism: Analysis of a Letter Written by Hildegard of Bingen to Guibert of Gembloux." *Review of Religion* 12 (1984): 277–86.

Bell, Rudolph M. *Holy Anorexia.* Chicago: Univ. of Chicago Press, 1985.

Bennett, Judith M., Elizabeth A. Clark, and Sarah Westphal-Wihl, eds. "Working Together in the Middle Ages: Perspectives on Women's Communities." *Signs* 14, no. 2 (Winter 1989).

Bianchi, Maria Grazia. "Una 'illuminata' del secolo XVII: Suor Maria Domitilla Galluzzi, Cappuccina a Pavia." *Bollettino della Societa Pavese di Storia Patria* n.s. (1968–69): 3–69.

Bloch, Howard. "Medieval Misogyny." *Representations* 20 (1987): 1–24.

Blum, M. *Der Aufstieg des Moses.* Freiburg-i.-Br.: Lambertus, 1963.

Boland, Paschal. *The Concept of Discretio Spirituum in John Gerson's 'De probatione spirituum' and 'De distinctione verarum Visionna falsisi.'* Washington, D.C.: Catholic Univ. of America Press, 1959.

Borenius, Tancred, and E. W. Tristam. *English Medieval Painting.* New York: Hacker, 1976.

Braswell, Mary F. *The Medieval Sinner: Characterization and Confession in the Literature of the English Middle Ages.* Toronto: Associated Univ. Presses, 1983.

Bredero, A.H. "De Delftse begijn Gertrui van Oosten (circa 1320-1358) en haar niet-erkende heiligheid." In *De Nederlanden in de late Middeleeuwen,* edited by D. E. H. de Boer and G. W. Marsije, 83-97. Utrecht: Spectrum, 1987.

Brown, Judith C. *Immodest Acts: The Life of a Lesbian Nun in Renaissance Italy.* New York: Oxford Univ. Press, 1986.

———. "Lesbian Sexuality in Renaissance Italy: The Case of Sister Benedetta Carlini," *Signs* 9, no. 4 (1984): 751-58.

Bruyne, Edgar de. *The Esthetics of the Middle Ages.* Translated by Eileen B. Hennessy. New York: Ungar, 1969.

Bugge, John. *Virginitas: An Essay in the History of a Medieval Ideal.* The Hague: Martinus Nijhoff, 1975.

Bullough, Vern, Brenda Shelton, and Sarah Slavin. *The Subordinated Sex: A History of Attitudes Toward Women.* Athens, Ga.: Univ. of Georgia Press, 1988.

Buyle, M. "De muurschilderingen in de begijnhofkerk te Sint-Truiden." In *Bijdragen tot de geschiedenis van de Kunst der Nederlanden opgedragen aan Prof. Em. Dr. J. K. Steppe.* 1-14. Louvain, 1981.

———. "Het begijnhof te Sint-Truiden en de oude muurschilderingen in de kerk." *Kunsten Oudheden in Limburg* 4 (1974).

Bynum, Caroline Walker. "The Female Body and Religious Practice in the Later Middle Ages." In *Zone 3: Fragments for a History of the Human Body* 1, 160-219. New York: Urzone, 1989.

———. *Holy Feast and Holy Fast: The Religious Significance of Food to Medieval Women.* Berkeley: Univ. of California Press, 1987.

———. *Jesus as Mother: Studies in the Spirituality of the High Middle Ages.* Berkeley: Univ. of California Press, 1982.

———. "Women Mystics in the Thirteenth Century: The Case of the Nuns of Helfta." In *Jesus as Mother: Studies in the Spirituality of High Middle Ages,* edited by Caroline Walker Bynum, 170-261. Berkeley: Univ. of California Press, 1982.

Chodorow, Nancy. *The Reproduction of Mothering.* Berkeley: University of California Press, 1978.

Coleman, Janet. *Medieval Readers and Writers 1350-1400.* New York: Columbia Univ. Press, 1981.

Collins, Fletcher, Jr. *The Production of Medieval Church Music-Drama.* Charlottesville: Univ. Press of Virginia, 1972.

Cortese, Anna. "Suor Alma Colomba dello Spirito Santo (1592-1678); Monaca Benedettina nel Monastero di San Felice in Pavia." *Bollettino della Societa Pavese di Storia Patria* n.s. 20-21 (1968-69): 103-77.

Craine, Renata. "The Role of Experience in Hildegard of Bingen's Spirituality." Unpublished paper.

DeCerteau, Michel. "The Institution of Rot." Translated by Brian Massumi. In *Heterologies: Discourse on the Other*. Theory and History of Literature, vol. 12, 35–46. Minneapolis: Univ. of Minnesota Press, 1986.

———. "Mystic Speech." Translated by Brian Massumi. In *Heterologies: Discourse on the Other*. Theory and History of Literature, vol. 17, 80–101. Minneapolis: Univ. of Minnesota Press, 1986.

———. *The Practice of Everyday Life*. Translated by Steven F. Randall. Berkeley: Univ. of California Press, 1986.

Delany, Sheila. "Mothers to Think Back Through." In *Medieval Texts and Contemporary Readers*, edited by Laurie A. Finke and Martin B. Schichtman, 177–97. Ithaca, N.Y.: Cornell Univ. Press, 1987.

Delmaire, B. "Les béguines dans le Nord de la France au premier siècle de leur histoire (vers 1230 vers 1350)." In *Les religieuses en France au XIIIe siècle*, edited by M. Parisse, 121–62. Nancy: Presses Universitaires de Nancy, 1985.

Demaitre, Luke. "The Description and Diagnosis of Leprosy by Fourteenth-Century Physicians." *Bulletin of the History of Medicine* 59 (1985): 327–44.

Dinnerstein, Dorothy. *The Mermaid and the Minotaur*. New York: Harper & Row, 1976.

Dinzelbacher, Peter, and Dieter Bauer, eds. *Frauenmystik im Mittelalter*. Ostfildern bei Stuttgart: Schwabenverlag, 1985.

Downing, Christine. *Psyche's Sisters*. San Francisco: Harper & Row, 1988.

Dreyfus, Hubert L., and Paul Rabinow. *Michel Foucault: Beyond Structuralism and Hermeneutics*. Chicago: Univ. of Chicago Press, 1982.

Dronke, Peter. *Poetic Individuality in the Middle Ages*. Oxford: Clarendon Press, 1970.

———. *Women Writers of the Middle Ages: A Critical Study of Texts from Perpetua (203) to Marguerite Porete (1301)*. Cambridge: Cambridge Univ. Press, 1984.

Eckenstein, Lina. *Women under Monasticism, 500–1500*. Cambridge: Cambridge Univ. Press, 1896.

Ell, Stephen R. "Blood and Sexuality in Medieval Leprosy," *Janus: Revue internationale de l'histoire des sciences de la médicine, de la pharmacie et de la technique* 71 (1984): 157–63.

English, M. "Middeleeuwsche Mariabeelden te Brugge." *Kunst Adelt* 7 no. 3-4 (1929): 16–17.

Erbstösser, M. *Sozialreligiöse Strömungen im späten Mittelalter: Geissler, Freigeister und Waldenser im 14. Jahrhundert*. Berlin: Akademie Verlag, 1970.

Finke, Laurie A., and Martin B. Shichtman, eds. *Medieval Texts and Contemporary Readers*. Ithaca, N.Y.: Cornell Univ. Press, 1987.

Fletcher, Alan J. "The Sermon Booklets of Friar Nicholas Philip." *Medium Aevum* 55 (1986): 188–202.

Finney, Gretchen L. "Ecstasy and Music in Seventeenth-Century England." *Journal of the History of Ideas* 8 (1947): 153–86.

Foucault, Michel. *Discipline and Punishment: The Birth of the Prison.* Translated by Alan Sheridan. New York: Vintage, 1979.

Fox, Matthew. *Illuminations of Hildegard of Bingen.* Santa Fe, N.M.: Bear, 1985.

Fox, Robin Lane. *Pagans and Christians.* New York: Knopf, 1987.

Führkötter, Adelgundis, OSB, and Marianna Schrader. *Die Echtheit des Schrifttums der heiligen Hildegard von Bingen: Quellenkritische Untersuchungen.* Cologne: Böhlau, 1956.

Gold, Penny Schine. "Male/Female Cooperation: The Example of Fontevrault." In *Distant Echoes: Medieval Religious Women* 1, edited by John A. Nichols and Lillian Thomas Shank. 151–69. Kalamazoo, Mich.: Cistercian, 1984.

Grant, Barbara. "Five Liturgical Songs of Hildegard of Bingen." *Signs* 5 (Spring 1980): 557–67.

Gray, Douglas. *Themes and Images in the Medieval English Religious Lyrics.* Boston: Routledge & Kegan Paul, 1972.

Grundmann, Herbert. *Religiöse Bewegungen im Mittelalter: Untersuchungen über die geschichtlichen Zusammenhänge zwischen der Ketzerei, den Bettelorden und der religiösen Frauenbewegung im 12. und 13. Jahrhundert.* Historische Studien, 267. Berlin: Olms Verlag, 1935.

Hall, James A. "Personal Transformation: The Inner Image of Initiation." In *Betwixt & Between: Patterns of Masculine and Feminine Initiation,* edited by Louise Carus Mahdi, Steven Foster, and Meredith Little, 327–37. LaSalle, Ill.: Open Court, 1987.

Hamburger, Jeffrey. "The Use of Images in the Pastoral Care of Nuns: The Case of Heinrich Suso and the Dominicans." *Art Bulletin* 71, no. 1 (March 1989): 20–46.

Harding, M. Esther. *The Way of All Women: A Psychological Interpretation.* New York: Putnam, 1970. Reprint. New York: Harper & Row, 1975.

Hardison, O. B., Jr. *Christian Rite and Christian Drama in the Middle Ages.* Baltimore: Johns Hopkins Univ. Press, 1965.

Herwegen, Ildefons "Les collaborateurs de sainte Hildegarde." *Revue bénédictine* 21 (1904): 192–203; 302–15; 381–403.

Hirsch, John. "Prayer and Meditation in Late Medieval England: MS Bodley 789." *Medium Aevum* 48 (1979): 55–66.

Hoornaert, R. "La plus ancienne règle du béguinage de Bruges." *Annales de la Société d'Émulation de Bruges* 72 (1929): 17–79.

Howard, Donald R. *Writers and Pilgrims: Medieval Pilgrimage Narratives and Their Posterity.* Berkeley: Univ. of California Press, 1980.

Hozeski, Bruce W. "Hildegard of Bingen's Ordo Virtutum: The Earliest Discovered Liturgical Morality Play." *American Benedictine Review* 26 (Sept. 1975): 251–59.

———. *"Ordo Virtutum": Hildegard of Bingen's Liturgical Morality Play.* Ph.D. diss., Michigan State Univ., 1960.

Irigaray, Luce. *Speculum of the Other Woman.* Translated by Gillian C. Gill. Ithaca, N.Y.: Cornell Univ. Press, 1985.

Jeskalian, Barbara J. "Hildegard of Bingen: Her Times and Music." *Anima* 10 no. 1 (Fall 1983): 7–13.

Kerby-Fulton, Kathryn, and Dyan Elliott. "Self-Image and the Visionary Role in Two Letters from the Correspondence of Elizabeth of Schönau and Hildegard of Bingen." *Vox Benedictina* 2 no. 3 (1985): 204–23.

Kieckhefer, Richard. *Unquiet Souls: Fourteenth-Century Saints and Their Religious Milieu.* Chicago: Univ. of Chicago Press, 1984.

Köster, Kurt. "Das visionäre Werk Elisabeths von Schönau." *Archiv für mittelrheinische Kirchengeschichte* 4 (1952): 79–119.

Ladurie, Emmanuel Le Roi. *Montaillou, the Promised Land of Error.* Translated by Barbara Bray. New York: Braziller, 1978.

Lauwers, M., and W. Simons. "Expériences et communautés béguinales au moyen age. Tournai, XIIIe–XIVe siècles." *Tornacum* 3 (1991): 391–410.

Lea, Henry Charles. *A History of the Inquisition of the Middle Ages.* 2 vols. New York: Russell & Russell, 1958.

Leclerq, Jean. "L'Amitié dans les Lettres au Moyen Âge" *Revue du Moyen Âge Latin* 1 (1945): 391–410.

Le Goff, Jacques. *The Birth of Purgatory.* Translated by Arthur Goldhammer. (Orig. publ. as *La naissance du Purgatoire.* Paris: Gallimard, 1981). Chicago: Univ. of Chicago Press, 1984.

Legros, E. "Sur les repos de Jésus tournaisiens (et sur quelques autres faits attestées par les testaments de Tournai)." *La Vie Wallonne* 33 (1959): 212–17.

Lerner, Robert E. *The Heresy of the Free Spirit in the Later Middle Ages.* Berkeley: Univ. of California Press, 1972.

Libor, R. M. "800 Jahre Zisterzienserkloster und Reichsstift Kaisheim." *Commentarii Cistercienses* 35 (1984): 135–41.

Lloyd, Genevieve. *The Man of Reason: "Male" and "Female" in Western Philosophy.* Minneapolis: Univ. of Minnesota Press, 1984.

Lorenz, Erika. *"Nicht alle Nonnen dürfen das." Teresa von Avila und Peter Gracian. Die Geschichte einer großen Begegnung.* Freiburg-i.-Br.: Herder, 1984.

Luers, Grete. *Die Sprache der deutschen Mystik des Mittelalters im Werke der Mechthild von Magdeburg.* 1926. Reprint. Darmstadt: Wissenschaftliche Buchgesellschaft, 1966.

McDonnell, Ernest W. *The Beguines and Beghards in Medieval Culture with Special Emphasis on the Belgian Scene.* New Brunswick: N.J.: Rutgers Univ. Press, 1954.

McGuire, Brian P. "The Cistercians and the Transformation of Monastic Friendships." *Analecta Cisterciensa* 37 (1981): 1–63.

———. *Friendship and Community: The Monastic Experience 350–1250.* Kalamazoo, Mich.: Cistercian, 1988.

———. "Love, Friendship and Sex in the Eleventh Century: The Experience of Anselm." *Studia Theologia* 28 (1974): 111–52.

———. "Monastic Friendship and Toleration." In *Monks, Hermits, and the Ascetic Tradition,* edited by W. J. Sheils, 147–60. Oxford: Blackwell, 1985.

McNamara, Jo Ann. "The Need to Give: Economic Restrictions and Penitential Piety among Medieval Nuns." In *Images of Sainthood in Medieval and Renaissance Europe,* edited by Timea Szell and Renate Blumenfeld-Kosinski, 199–221. Ithaca: N.Y.: Cornell Univ. Press, 1990.

———. "De Quibusdam Mulieres: Reading Women's History from Hostile Sources." In *Medieval Women and the Sources of Medieval History,* edited by Joel Rosenthal, 237–58. Athens, Ga.: Univ. of Georgia Press, 1990.

———, and Suzanne F. Wemple. "Sanctity and Power: The Dual Pursuit of Medieval Women." In *Becoming Visible: Women in European History,* edited by Renate Bridenthal, Claudia Koontz, and Susan M. Stuard, 96–109. Boston: Houghton Mifflin, 1977.

Mahrt, William. "Hildegard's Art of Melody." Unpublished paper.

Maiocchi, Rodolfo. "Le Chiese di Pavia." *Notizie* 2 (1903): 31–43.

Mann, Thomas. *Doktor Faustus.* Stockholm: Bermann-Fischer, 1947.

Matter, Ann E. "Discourses of Desire: Sexuality and Christian Women's Visionary Narrative." *Journal of Homosexuality* 18 (1989): 119–31.

———. "My Sister, My Spouse: Woman-Identified Women in Medieval Christianity." In *Weaving the Visions: New Patterns in Feminist Spirituality,* edited by Judith Plaskow and Carol P. Christ, 51–63. San Francisco: Harper & Row, 1989.

———. "Per la morte di Suor Maria Domitilla Galluzzi, un inedito anonimo del Seicento pavese." *Poesia: Mensile di Cultura Poetica* 11/12 (1989): 11–14.

———. "The Virgin Mary: A Goddess?" In *The Book of the Goddess. Past and Present,* edited by Carl Olson, 80–97. New York: Crossroad, 1985.

May, J. *Die heilige Hildegard von Bingen.* Munich: n.p., 1911.

Miles, Margaret. *Image as Insight: Visual Understanding in Western Christianity and Secular Culture.* Boston: Beacon Press, 1985.

Mitchell, Juliet. *Psychoanalysis and Feminism.* New York: Random House, 1974.

Moorman, John. *A History of the Franciscan Order From Its Origins to the Year 1517.* Oxford: Clarendon Press, 1968.

Moors, J. *De oorkondentaal in Belgisch-Limburg van circa 1350 to 1400.* Brussels: Belgisch Inter. Universitaire Centrum, 1952.

Neel, Carol. "The Origins of the Beguines." *Signs* 14, no. 2 (Winter 1989): 321–42.

Newman, Barbara J. "Hildegard of Bingen: Visions and Validation." *Church History* 54 (1985): 163–75.

———. *O Feminea Forma: God and Woman in the Works of Hildegard (1098–1179).* Ph.D. diss., Yale Univ., 1981.

———. *Sister of Wisdom: St. Hildegard's Theology of the Feminine.* Berkeley: Univ. of California Press, 1987.

Nichols, John A., and Lillian Thomas Shank, eds. *Distant Echoes.* Vol. 1 of *Medieval Religious Women.* Kalamazoo, Mich.: Cistercian, 1984.

———. *Peace Weavers.* Vol. 2 of *Medieval Religious Women.* Kalamazoo, Mich.: Cistercian, 1987.

Nimal, H. "Les Béguinages." *Annales de la Société Archéologique de l'Arrondissement de Nivelles* 9 (1908): 57–69.

Nubel, O. *Mittelalterliche Beginen-und Sozialsiedlungen in den Niederlanden.* Tübingen, 1970.

Oexle, Otto G. "Armut und Armenfürsorge um 1200." In *Sankt Elisabeth: Fürstin, Dienerin, Heilige.* Edited by Philipps-Universität Marburg in Verbindung mit dem Hessischen Landesamt für Geschichtliche Landeskunde, 78–100. Sigmaringen: Thorbecke, 1981.

O'Faolain, Julia, and Lauro Martinez, eds. *Not in God's Image: Women in History from the Greeks to the Victorians.* New York: Harper & Row, 1973.

Oliver, J. *Gothic Manuscript Illumination in the Diocese of Liège (c. 1250–c. 1330).* Louvain: Uitgeverij Peeters, 1988.

Owst, G. R. *Literature and Pulpit in Medieval England.* 2d ed. Oxford: Blackwell, 1926.

———. *Preaching and Medieval England.* Cambridge: Cambridge Univ. Press, 1926.

Pagels, Elaine. *Adam, Eve, and the Serpent.* New York: Random House, 1988.

Pantin, W. A. *The English Church in the Fourteenth Century.* Buffalo, N.Y.: Univ. of Toronto Press, 1980.

Pascoe, Louis B. *Jean Gerson: Principles of Church Reform.* Vol. 7 of *Studies in Medieval and Reformation Thought.* Leiden: E. J. Brill, 1973.

Pelikan, Jaroslav. *Jesus Through the Centuries.* New York: Harper & Row, 1985.

Persoons, E. *Prieuré de Ter-Nood-Gods à Tongeren.* Vol. 6 of *Monasticon Belge,* 267–76. Liège: Centre National de Recherches d'Histoire Religieuse, 1976.

Petroff, Elizabeth Alvida. *Consolation of the Blessed.* Millerton, N.Y.: Alta Gaia, 1980.

———, ed. *Medieval Women's Visionary Literature.* New York: Oxford Univ. Press, 1986.

Philippe, Joseph. "La peinture murale du XIIIe siècle en Belgique." *Annales du XXXVIe Congrès de la Fédération Archéologique et Historique de Belgique* 2 (1956): 335-75.

Philippen, L. J. M. *De Begijnhoven, Oorsprong, Geschiedenis, Inrichting.* Antwerp: Veritas, 1918.

Preger, W. *Geschichte der deutschen Mystik im Mittelalter.* 1874-93. Reprint. Osnabrück: Zeller, 1962.

Provinciaal Dienst voor Religieuze Kunst (Province of Limburg). *Kunstschatten uit het Diestse Begijnhof.* Diest: Stedelijk Museum, 1988.

Rader, Rosemary. *Breaking Boundaries. Male/Female Friendship in Early Christian Communities.* New York: Paulist Press, 1983.

Rapp, Francis. *L'église et la vie religieuse en Occident à la fin du Moyen Âge.* Paris: Presses Universitaires de France, 1971.

Raymond, Janice G. *A Passion for Friends: Toward a Philosophy of Female Affection.* Boston: Beacon Press, 1986.

Rich, Adrienne. "Compulsory Heterosexuality and Lesbian Existence." 1980. Reprint. In *Powers of Desire: The Politics of Sexuality,* edited by Ann Snitow, Christine Stansell, and Sharon Thompson, 177-206. New York: Monthly Review, 1983.

Ritscher, M. Immaculata. "Zur Musik der Heiligen Hildegard von Bingen." In *Hildegard von Bingen 1179-1979,* edited by Anton Bruck, 189-209. Mainz: Gesellschaft für Mittelrheinische Kirchengeschichte, 1979.

Roisin, Simone. *L'hagiographie cistercienne dans le diocèse de Liège au XIIIe siècle.* Louvain: Bibliothèque de l'Université, 1947.

Romano, Gaetano. "Suor Maria Domitilla d'Acqui: Cappuccina in Pavia." *Bollettino Storico Pavese* 1 (1893): 9-40, 119-50, 197-238.

Roo, R. de. "Mechese beeldhouwkunst." *Aspecten van de Laatgotiek in Brabant.* Louvain: Stedelijk Museum, 1971.

Rosaldo, Michelle Zimbalist, and Louise Lamphere, eds. *Women, Culture, and Society.* Stanford: Stanford Univ. Press, 1974.

Ruh, Kurt, ed. *Abendländische Mystik im Mittelalter.* Stuttgart: J. B. Metzlersche Verlagshandlung, 1986.

Scarry, Elaine. *The Body in Pain: The Making and Unmaking of the World.* New York: Oxford Univ. Press, 1985.

Schiller, Gertrud. *Ikonographie der christlichen Kunst.* Gütersloh: Humphries, 1971-1972.

Schmidt, Margot. "Elemente der Schau bei Mechthild von Magdeburg and Mechthild von Hackeborn." In *Frauenmystik im Mittelalter,* edited by Peter Dinzelbacher and Dieter R. Bauer, 123-52. Ostfildern-bei-Stuttgart: Schwabenverlag, 1985.

————, and Dieter Bauer, eds. *"Eine Höhe, über die nichts geht." Spezielle Glaubens-*

erfahrung in der Frauenmystik? Mystik in Geschichte und Gegenwart 1, 4. Stuttgart: Frommann-Holzboog, 1986.

——. "Die spilende minnevlut." Der Eros als Sein und Wirkkraft in der Trinität bei Mechthild von Magdeburg." In *Eine Höhe,* edited by Margot Schmidt and Dieter R. Bauer, 71–133. Stuttgart: Frommann-Holzboog, 1986.

——, and Dieter Bauer, eds. *Grundfragen christlicher Mystik.* Stuttgart: Frommann-Holzboog, 1987.

Schmitt, Jean-Claude. *Mort d'une héresie.* Collection Civilisations et Sociétés 56. Paris: Mouton, 1978.

Schneider, M. Roswitha, OP. *Die Selige Margaretha Ebner.* St. Ottilien: EOS Verlag Erzabtei, 1985.

Seay, Albert. *Music in the Medieval World.* 2d ed. Englewood Cliffs, N.J.: Prentice-Hall, 1975.

Simons, Walter. "The Beguine Movement in the Southern Low Countries: A Reassessment." *Bulletin de L'Institut Historique Belge de Rome* 59 (1990): 63–105.

——, and Joanna E. Ziegler. "Phenomenal Religion in the Thirteenth Century and Its Image: Elisabeth of Spalbeek and the Passion Cult." In *Women in the Church,* edited by W. J. Scheils and Diana Woods, 116–26. Oxford: Blackwell, 1990.

Smith-Rosenberg, Carroll. "The Female World of Love and Ritual: Relations between Women in Nineteenth-Century America." *Signs* 1 (Autumn 1975): 1–29.

Söhngen, Oskar. "Music and Theology: A Systematic Approach." Translated by Joyce Irwin. *JAAR Thematic Studies.* In *Sacred Sound: Music in Religious Thought and Practice,* 50, no. 1. Chico, Calif.: Scholars Press, 1983.

Stalleybrass, Peter, and Allon White. *The Politics and Poetics of Transgression.* Ithaca, N.Y.: Cornell Univ. Press, 1986.

Stevens, John. *Words and Music in the Middle Ages: Songs, Narrative, Dance and Drama, 1050–1350.* New York: Cambridge Univ. Press, 1986.

Strauch, Philipp, ed. *Margaretha Ebner und Heinrich von Nördlingen: Ein Beitrag zur Geschichte der Deutschen Mystik.* Freiburg-i.-Br.: 1882. Reprint. Amsterdam: P. Schippers, 1966.

Strunk, Oliver. *Source Readings in Music History: Antiquity and the Middle Ages.* New York: Norton, 1965.

Stuard, Susan M. "The Dominion of Gender: Women's Fortunes in the High Middle Ages." In *Becoming Visible: Women in European History,* edited by Renate Bridenthal, Claudia Koontz, and Susan M. Stuard, 153–75. 2d ed. Boston: Houghton Mifflin, 1987.

——, ed. *Women in Medieval Society.* Philadelphia: Univ. of Pennsylvania Press, 1976.

Tentler, Thomas N. *Sin and Confession on the Eve of the Reformation*. Princeton: Princeton Univ. Press, 1977.

Thiele, Johannes, ed. *Mein Herz schmilzt wie Eis am Feuer: Die religiöse Frauenbewegung des Mittelalters in Porträts*. Stuttgart: Kreuz Verlag, 1988.

Todd, Janet. *Women's Friendshp in Literature*. New York: Columbia Univ. Press, 1980.

Trask, Haunani-Kay. *Eros and Power: The Promise of Feminist Theory*. Philadelphia: Univ. of Pennsylvania Press, 1986.

Underhill, Evelyn. *The Essentials of Mysticism*. New York: Dutton, 1960.

van Acker, Lieren. "Der Briefwechsel der heiligen Hildegard von Bingen." *Revue bénédictine* 98 (1988): 141–68 and 99 (1989): 118–54.

Van de Ven, R. "De kunstingoedel van de Sint-Catherina of Begijnhofkerk tijdens de 15de en 16de eeuw." In *Kunstschatten uit het Diestse Begijnhof*. Diest: Stedelijk Museum, 1988.

Vauchez, André. "La pauvreté volontaire au moyen âge." In *Religion et Société: Essais par André Vauchez*. Turin: Bottega d'Erasmo, 1980.

Vols, J. "Maria-veteering te Tongeren door de eeuwen heen." *Limburg* 26 (1946): 131–40.

Warner, Marina. *Joan of Arc: The Image of Female Heroism*. New York: Random House, 1982.

Weaver, Mary Jo. "Who Is the Goddess and Where Does She Get Us?" *Journal of Feminist Studies in Religion* 5, no. 1 (Spring 1989): 49–65.

Wentzel, H. "Christkind." *Reallexikon zur deutschen Kunstgeschichte* 3 (1954): cols. 590–608.

Werner, Matthias. "Die heilige Elisabeth und die Anfänge des deutschen Ordens in Marburg." In *Marburger Geschichte*, edited by E. Dettmering and R. Grenz, 121–64. Marburg: Der Magistrat, 1980.

Wessley, Stephen E. "The Thirteenth-Century Guglielmites: Salvation through Women." In *Medieval Women*, edited by Derek Baker, 289–303. Oxford: Blackwell, 1978.

Wiethaus, Ulrike. "Cathar Influences in Hildegard of Bingen's Play 'Ordo Virtutum.'" *American Benedictine Review* 38, no. 2 (1987): 192–203.

———. "Suffering, Love, and Transformation in Mechthild of Magdeburg." *Listening* 22 (1987): 139–51.

Williams, Arnold. *The Drama of Medieval England*. East Lansing: Michigan State Univ. Press, 1961.

Wilson, Katharina M., ed. *Medieval Women Writers*. Athens: Univ. of Georgia Press, 1984.

Woolf, Rosemary. *The English Religious Lyric in the Middle Ages*. Oxford: Clarendon Press, 1968.

Wormgoor, I. "De Vervolging van de Vrijen van Geest, de Begijinen en Begarden." *Nederlands Archief voor Kerkgeschiedenis*, 65 (1985): 107–30.

Ziegler, Joanna E. "Beguines." *The Dictionary of Art*, London, 1992.

———. *Sculpture of Compassion: The Pietà and the Beguines in the Southern Low Countries, ca. 1300–ca. 1600*. Rome: Belgian Historical Institute of Rome, forthcoming.

———. "Secular Canonesses and Beguines: An Introduction to Some Older Views." In *Studies in Medieval and Renaissance History*, edited by J. S. A. Evans and R. W. Unger, 117–35. New York: AMS Press, 1991.

———. "The Virgin as Object: Art or Anthropology?" *Historical Reflections* 16, no. 2-3 (1990): 215–64.

Zöpf, L. *Die Mystikerin Margaretha Ebner (ca. 1291–1351)*. 1914. Reprint. Hildesheim, Gerstenberg, 1974.

INDEX

199

Maps of Flesh and Light

was composed in 10 on 13 Palatino
on Digital Compugraphic equipment
by Metricomp;
with display type set in Lydian
by Dix Type Inc.;
printed by sheet-fed offset on 50-pound, acid-free Antique Cream
and Smyth-sewn and bound over binder's boards in Holliston Roxite B
by Maple-Vail Book Manufacturing Group, Inc.;
with dust jackets printed in 2 colors
by Johnson City Publishing Co., Inc.;
and published by
Syracuse University Press
Syracuse, New York 13244-5160